STRENGTH&
COMPASSION

To my family, who taught me

to love with strength and to care with courage.

Strength and Compassion
Photographs and Essays by Eric Greitens

Copyright © 2008 by Eric Greitens

All rights reserved. No part of this book may be reproduced or transmitted in any form or by any means, electronic or mechanical, including photocopying, recording, or by any information storage and retrieval systems, without permission in writing from the publisher.

Limited First Edition, 2008 by Leading Authorities Press, Washington, DC

ISBN: 978-0-9710078-0-2

Library of Congress Cataloging-in-Publication Data
Greitens, Eric, 1974–
 Strength & compassion : photographs and essays / by Eric Greitens ; foreword by Paul Rusesabagina ; introduction by Bobby Muller. – Limited 1st ed.
 p. cm.
 Includes bibliographical references and index.
 ISBN 978-0-9710078-0-2 (hard cover : alk. paper)
 1. Documentary photography. 2. Greitens, Eric, 1974–
I. Title. II. Title: Strength and compassion.

TR820.5.G7435 2009
779.092–dc22
 2008025648

To order books or for more information, please visit our website at:

www.StrengthandCompassion.com

Limited editions of select photographs from *Strength and Compassion* are available for purchase through www.StrengthandCompassion.com.

Editorial Assistant: Rachel Wald
Book Design: Beth Singer Design, LLC, Arlington, VA
Display typefaces: Memphis, Akzidenz Grotesk and Gotham
Text typeface: Cheltenhan
Paper: Grycksbo Matte Art
Printer and binder: TWP America

Printed in Singapore

Leading Authorities Press
1220 L Street, N.W., Suite 850
Washington, DC 20005-4070
202-783-0300
www.leadingauthorities.com

STRENGTH & COMPASSION

Photographs
and Essays by
Eric Greitens

Limited First Edition

Leading
Authorities Press

Washington, DC

ACKNOWLEDGMENTS

It was about midnight in Varanasi, India. I had arrived late at the train station. I bought a ticket to Calcutta and ran to catch the last train of the night. I jumped on a train that looked as if it were about to pull away. An elderly man climbed on after me and yanked me out of the car and onto the platform. He told me quickly that I was mistaken, that the train for Calcutta was two platforms away. As he pointed, my train started to pull away. I ran for it, and, for the first and only time in my life, leapt onto a moving train. There were many trains that night, many passengers. I have no idea how he knew me or how he knew where I meant to go, but he saved me from traveling all night in the wrong direction.

This book took shape over the course of fifteen years, and along the way, there have been hundreds of people who have pointed me in the right direction. Whatever service I have been able to offer and whatever wisdom I have found, it has all been due to the patient efforts of others who have helped me in a thousand ways that I can never repay. I cannot possibly name here every person who has helped to guide me along the way, but there are a few who I want to acknowledge for their special efforts with this book:

Audrey Leventhal, Barbara Osburg, and Marc Greitens often knew better than I did exactly what I was trying to say; they made these essays stronger.

Margaret Sartor was my first and very patient teacher of photography, and I'm grateful for her keen eye and her friendship. Neil Boothby and Jason and Caroline Bernhardt-Lanier were and are examples of service that inspire, and I will be forever grateful that they welcomed me into their work. Erin Conter provided valuable assistance with grant applications, correspondence, and writing. Matt Jones and Mark French at Leading Authorities were great supporters of this project; I thank them for their vision, support, and guidance. Iris Tillman Hill at the Center for Documentary Studies is a marvelous sequencer who provided thoughtful, artistic support throughout. Beth Singer, Lisa DiConsiglio, Deborah Eckbreth, and the rest of their team at Beth Singer Design are masterful; I thank them for their inspired and joyful work on the design of the book. Rachel Wald worked expertly for over a year to manage this project, and through her efforts, this book moved from a vision in my mind to a book that could be shared.

Special thanks also to the Benenson Institute for the Arts and the Center for Documentary Studies at Duke University, Rhodes House, Lady Margaret Hall College, Queen Elizabeth House at the University of Oxford, and the Puffin Foundation for generous financial assistance that made this work possible.

CONTENTS

FOREWORD

I have seen Rwanda through many eyes. Because of my experience in the genocide there, I believe in the practical necessity to confront evil. I believe in the strength of human beings, and I believe in the human capacity for love. I believe that we must dream and that we must find the courage to make our dreams a reality. Eric's photographs and essays speak to me, in a way like no other. Eric has the spirit of a true artist. He sees us all clearly as human beings; none of us perfect, each of us flawed, yet all of us with the potential to contribute to building a better world.

My name is Paul Rusesabagina. When, on April 6, 1994, a campaign of mass murder began in Rwanda, I was the manager of the Hotel Mille Collines. The genocide took more than 800,000 lives. Across the country, people were hacked to death with machetes. Yet our hotel became a refuge from the violence just outside our gate. Over the one hundred days of the genocide, I managed to keep 1,268 people safe in the hotel. Miraculously, we lost not a single life. Our story was told to the world in the movie, *Hotel Rwanda*.

The Mille Collines had 113 rooms. There were forty people living in my own room in the hotel. No space in the hotel was left unused, from the hallways to the pantries. Looking out from our hotel rooms we could see corpses piled in the streets. How easy it would have been for the militia to have killed me, my family, and all of the people who became refugees in the hotel. The killers had guns and machetes. What did we have? We had only words.

When the militia and the army came with orders to kill my guests, I invited them into my office and I treated them like friends. Many of these life-saving conversations took place as I sat down with my potential killers and served them whiskey and beer from the hotel bar. I tried to see the vanity and insecurity and even the ghost of common decency inside the minds of killers that would allow me to save lives.

If we believe that everyone has the potential to do what is humane and right, it helps us to act with strength. An individual who possesses the unyielding belief that common decency will always triumph has a powerful weapon in his or her arsenal. My experience is that there is a good place in every person. My ability to see into people and reach that place was the only power I had in Rwanda. There is really no such thing as a completely good person or a completely evil person. To defeat evil, you sometimes have to interact directly with evil people in your world. There is always a soft side to be discovered in even the worst people. With patience, you can touch that soft part, shape it, and by doing so, accomplish the good you wish to find. It was the soft that I was trying to locate inside them. If sitting down with abhorrent people and treating them as friends is what it took to save lives, then I was more than happy to pour the Scotch.

The experience strengthened us all. There were elderly people who spoke with vigor, young people—children, really—who knew how to encourage us adults. There were several neighbors who made a pact with me and Tatiana to take care

of our children if we should die. We swore an oath together, and their courage helped to strengthen my spirits.

I love Eric's photographs because he has been able to capture on film, the way that I see the people of Rwanda in my heart. Eric has taken a clear-headed look at the evil of genocide; yet, it has not overwhelmed him as it has so many others. Despite the unmistakable evidence of murder, the desperation of the refugee camps, the plight of orphaned children, he has still managed to capture our strength, our creativity, our curiosity. He has managed, even, to see joy. This is what makes these photographs so beautiful. Eric looks unflinchingly at the facts, yet the photographs remain optimistic. He has walked in places where human beings have committed the most evil acts, and yet he has retained an affection for people. These photographs are all so truly human that we recognize others not only as our brother and sisters, but as our *beautiful* brothers and sisters. People are sometimes fragile, often weak, capable of doing harm, yet they also have an incredible potential to love one another and to be strong in struggle and strong in the face of evil.

For the people of Rwanda to heal, there must be a place for truth and reconciliation. I was once asked what it is that scares me the most about Rwanda. For me, I am scared when my countrymen are not talking. Without continuous dialogue, one does not know what the other is thinking, and that is the perfect opportunity for anger and resentment to grow and boil within a person until he or she bursts. For peace to be possible, we have to acknowledge the past and see each other clearly

and with love. That is what Eric has accomplished in his photographs. I think that he helps all of us to see our own potential for good.

If we are going to teach our children compassion instead of intolerance, and love instead of hate, then we have to show them how to look at the world. They have to be strong enough to see the truth, smart enough to protect themselves, and open enough to take the risks that we all must take in order to love another. This is a tall order, but I think that Eric's book is a good beginning for us all.

Words do seem like a weak defense, or even no defense at all, when pitted against people wielding machetes and guns, but I know what words can do and so I recommend these words and photographs to you. I hope that they touch you as they have touched me. Seeing Eric's images brings me back to the Rwanda I remember. The Rwanda I know and love. It is time to start seeing people as Eric sees them through his eyes and captures them in his photographs. These are real people, full of hope, strength, and dignity.

This is a special book. Eric's images and essays bring us to see others, and to see ourselves, in a new way. His essays on strength, pity, dignity, courage, faith, time, hope, and compassion have each touched me. This is a book that is as challenging as it is enlightening, and it contains a vision that is as honest as it is hopeful. I hope that you will be able to take this beautiful book into your heart and let it become a part of your own strength. God bless.

—Paul Rusesabagina

INTRODUCTION

Many people who meet me assume that the most significant moment in my life took place in 1969, when I was wounded while serving as a Marine lieutenant in Vietnam. That incident confined me to a wheelchair. Certainly, my experience in Vietnam was formative, but nothing had as profound an impact in my life as my visit to Cambodia. I first visited that country in 1984 with a group of Vietnam veterans. What I saw was emotionally overwhelming.

In April of 1975, after years of war, the Khmer Rouge had marched into Phnom Penh and took control of the Cambodian government. The victorious Khmer Rouge immediately imposed a radical form of agrarian communism throughout the nation, sending millions of people into the countryside. Over the next years, Cambodia lived through a national nightmare, suffering an unspeakable genocide of execution, starvation, and forced labor that took the lives of two million people—nearly one-quarter of Cambodia's entire population. Enemies of the Khmer Rouge were systematically liquidated, victims of the notorious torture chambers at Tuol Sleng. I will never forget my visit to Tuol Sleng prison—the images of its victims are with me still. Nor can I shake the feelings that I had while looking out over Cambodia's killing fields, where literally thousands of human bones lay in the sun. How could such a thing have happened? How is it possible to explain such evil?

The genocide ended in 1979, when Vietnam invaded Cambodia and deposed the Khmer Rouge government. But the nation continued to suffer: the Cambodian people remained among the poorest in the world; its most important institutions had simply ceased to exist. Cambodia was a nation in name only: there were no schools, no hospitals, no industry—no public institutions of any kind. And there was no peace. While the Khmer Rouge had been removed from Phnom Penh, they continued to wage a low-level, but bloody, conflict against the new Cambodian government from their sanctuaries along the border with Thailand. Even in places where the shooting had stopped, landmines continued to kill and maim every day.

In 1991, the organization that I formed—Vietnam Veterans of America Foundation—opened a landmine clinic just outside of Phnom Penh. We established our clinic on an island in the Mekong River that had once served as a dumping ground for the thousands of Cambodian amputees whom the government could not help, but did not want to see. The Kien Khleang National Rehabilitation Center soon became one of the world's premier rehabilitation clinics, providing services for tens of thousands of Cambodians, thousands of whom were still injured, and dying, from the effect of the millions of landmines hidden in Cambodia's fields. We provided limbs—and food. But most important of all, we provided hope.

During my time in Cambodia, I became acutely aware of just how terrible landmines are and how devastating they are to civilian populations. Landmines maim and kill. They make farming dangerous or impossible. They destroy lives and livelihoods. Just one year after we opened our clinic in Cambodia, I cofounded the International Campaign to Ban Landmines, which calls for an international ban on the use, production, stockpiling, and transfer of antipersonnel landmines, and for increased international resources for humanitarian mine clearance and mine victim assistance programs. In 1997, the campaign was honored with a Nobel Peace Prize. While it was a great honor to win this award, our work is not complete. The suffering caused by landmines has not ended. Each year, landmines maim or kill approximately 26,000 civilians, including roughly 9,000 children. There are many children in Cambodia who have been disabled by landmines. The evidence is everywhere. Eric's photographs show us the reality of Cambodia's pervasive landmine problem, and they also illustrate the deeper reality that human beings have created this problem, and human beings have enough intelligence, energy, and courage to solve this problem.

Eric brings new insights to old challenges: his work has the power to awaken each of us, as it awakened me. He provides us with positive ways to look at situations that have become distressingly familiar, particularly to those who have been exposed to the horrors that humans inflict on each other. I am gratified by what Eric has done here, because I know that it is easy to be overwhelmed, even discouraged, by the tragedy that so often surrounds us. He has seen what we have all seen, but instead of finding alienation and disenchantment in these experiences, he discovers extraordinary humanity. I have often wondered how those who have experienced the worst of human genocide find the will to go on. Eric has shown the way forward and, in so doing, has renewed my faith in my fellow man.

Eric's book gives us a vision of hope. The message here is powerful: in the midst of war, tragedy, and even in the aftermath of genocide, there is one thing that we all still have. We have each other. These photographs and essays are, at once, challenging and powerful; they help to move us from pity to dignity, from charitable handouts to shared action rooted in respect. Our experience of hope can change the world. To share in Eric's book is an incredible experience, and I think that we all emerge from it with a vision of what the world can be if we come together to save it.

— **Bobby Muller**

RWANDA

During the genocide in Rwanda, the thugs of the Interahamwe marched across the countryside and drove through villages, littering death, rape, and chaos all around them. Thousands of people picked up their children and ran to churches in search of sanctuary.

The Interahamwe waited for the churches to fill with the panicked and then broke holes in the mud walls and tossed in grenades. They entered with machetes, and most of the killing was done by hand.

Some of the survivors in Rwanda lay on the dirt floor of churches under dead bodies and pretended that they too were dead. A woman whose arm had been lost to a machete attack told an aid worker that she had been mistaken for dead and thrown in a pile of corpses by the side of the road. There she waited all night until the Interahamwe—exhausted by rape and alcohol and the hard labor of hacking human beings to death—fell into a drunken sleep in the early morning.

Everyone in the country had been touched. I remember sitting on a bench in Kigali with a man my age—I was twenty at the time—who had lost both parents, a sister, and two brothers.

Most of the stories that I heard about the genocide were—at heart—stories about neighbors. There were neighbors who said they couldn't help for fear that they would endanger their own families; neighbors who sought favor with the Interahamwe and passed on information about the whereabouts and activities of others; neighbors who became murderers themselves, torturing and killing people with whom they'd lived—side-by-side— for years. And then there were neighbors who provided sanctuary, and neighbors who sneaked food and water to those in hiding.

There were neighbors who risked their lives and the lives of their families for months on end to hide other neighbors behind false walls, all the time praying that not a single sound escaped at the wrong moment.

Much of the popular analysis of the genocide in Rwanda has been done through the lens of politics and culture. People analyze colonial history, twisted notions of race and ethnicity, and the failure of the United Nations. I've come to believe that such situations turn on two things. They turn on the decisions of a few key leaders who face the test of their lives, and they turn on the decisions of thousands of individuals who make decisions of conscience at critical moments.

Where do people find the strength to make the right decision at the critical moment? Where do we find our strength?

There were months of inaction as the international community watched the genocide in Rwanda. Ultimately, the advance of the Rwandan Patriotic Front—a Tutsi army that swept down from Uganda—finally brought an end to the genocide, yet it also led to a massive refugee movement. Refugees fled in many directions, but more than 1.2 million refugees walked in long caravans to Zaire, where they were herded onto a rocky, volcanic plain near the city of Goma. In crowded and unsanitary conditions with no clean water, people began to die in large numbers from disease. Having previously turned its back on the genocide, the international community began to send relief to the refugees.

In Rwanda—and more specifically in Zaire—great attention was paid to the plight of children, especially to the problem of unaccompanied children. "Unaccompanied children" was a phrase used to describe children who had been separated from their parents or caregivers during the violence and the refugee exodus. Though children who were genuinely unaccompanied comprised only the tiniest fraction of the refugee population, the international community came to the aid of many children by setting up orphanages or homes for them. These orphanage programs were usually in violation of aid agencies' own policies, and the homes usually proved to be, at best, unhelpful and, in many cases, bad for the children.

The dynamics of the failure were simple. After the genocide, a refugee exodus, and arrival in a camp filled with disease, people were in dire circumstances. They struggled to provide food, shelter, and love to their own children and were often called upon to care for the children of relatives, friends, and neighbors.

Instead of providing aid to those caregivers, agencies set up orphanages. I talked with several mothers who placed their children—temporarily they hoped—into these orphanages, because they thought that such placement was the only way to ensure the survival of their children.

A vicious cycle began. Money flowed into centers to care for the increased number of children, and the increased resources led even more people to place their children in the centers. Media flocked to stories of "desperate war orphans," and problems multiplied. In a situation with little supervision, children were abused. Other children were "fostered out" to "work" for unscrupulous people in the camp. Some of the managers of these centers cut back on services to children in order to turn a profit. Centers were moved—sometimes hundreds of miles—and

because of the move, the children became separated from their parents. In short, by neglecting the strength of the true caregivers, the aid agencies created a situation that was rife with opportunities for exploitation.

Imagine your own family surviving disaster. If someone came to aid you, would you rather that they take your children away from you or support you to take care of your own children? The answer is just as obvious in Rwanda.

People who suffer deserve and greatly appreciate our aid. For that aid to be effective, however, we must have the humility to recognize their strength.

The survivors I met possessed the strength to care for and love their own children. They possessed the strength to find happiness amid the most difficult of circumstances. They possessed the strength to know a terrible reality and to preserve faith in the future. And though they had suffered tremendously and had every justification for anger and bitterness, they possessed the strength to choose dignity, compassion, and hope.

In Rwanda, I found people who had suffered more than I could have ever imagined, yet they were willing to welcome me, to talk with me.

After all the betrayal they had lived through, all the hardship, they were still willing to trust a stranger.

Certainly, I thought, if they can do this, then we must, at the very least, look them in the eye and respect their strength. We must see them as our fellow human beings, as our brothers and sisters.

One of the great disadvantages of the orphanage approach to caring for children in emergencies is that it strips people of their strength. Because our own culture has confused itself about strength, this is sometimes more difficult to see than it should be. We are often implored to "look inside," to "recognize our own potential," to "find our inner strength." We are told to do these things as if doing so were a mere act of will: if we look, we will find strength.

Strength is not found. Strength is developed in action. We develop our strength most fully when we act to serve others.

In serving others, we find that we have a power to create hope and shape lives. One of the most compelling facts about refugee camps is that a tremendous number of people are actively involved in helping others. By caring for others, people develop their own true strength.

I remember talking with a young man in the refugee camp near Goma. He was sixteen years old and was the clear leader of a group of fifteen boys who protected each other in the camp. I asked him to tell me about the other boys. It may have been a quirk of the translation, but he described each boy as powerful: "He is very powerful with making fire and cooking. He is very powerful with the soldiers from Zaire—they like him. He is very powerful with singing." And it struck me that one of the habits of the truly powerful is that they have the humility to recognize the power in everyone.

Strength also comes from being around strong people. No one with whom I talked in Rwanda seemed to have survived for long on his or her own. They may have been the only one of their family to escape the Interahamwe, but soon they met up with other survivors in a field. They may have survived alone chained in a room where they were repeatedly raped, but eventually they escaped and stumbled upon a group of survivors, and together they made their way back to safety. This—the strength of teams and shared purpose and common fears and common obstacles—helped them to survive.

Another strength comes from being with others, even when others aren't right there next to us. The human mind is narrative; we tend to think in stories, and there is a strength in story and tradition. Rwanda had experienced extreme violence before. From 1959 to 1964, a campaign of ethnic cleansing drove many Tutsis from Rwanda into Uganda. One woman in Rwanda said that her grandfather had told her about those days. He told her that if anything like that ever happened again, she should hide during the day and go at night only to family or a neighbor that she could trust with her life. And that is what she did. One young man, who had studied English in Kigali and hid with his sister and two young neighbor girls during the violence, told me that during the violence he thought of Elie Wiesel—the Holocaust survivor—and he asked me if I'd read *Night*.

The world is full of stories of courage, too infrequently told.

I've read other accounts of courageous people who took risks to care, and they often drew upon stories from their faith and their family. These stories were enough to assure them that, though they may have felt alone at the time as the only person providing secret shelter, they were in fact standing in a deeper, wider stream of conscientious people throughout history who have stood against injustice.

I remember standing outside a healthcare clinic in Rwanda, and another volunteer pointed to a young girl with a deep machete scar that ran from behind her right ear across the back of her neck. We look at a scar like that—we reflect on the evil that was the human hand that created that scar— and we are tempted to walk away from humanity all together. But when that same child smiles at us, when that same child lets us know that she has survived and she has grown, then we have no choice. We have no choice but to go forward in the knowledge that it is within our power, and that the world requires of us—of every one of us—that we be both good and strong.

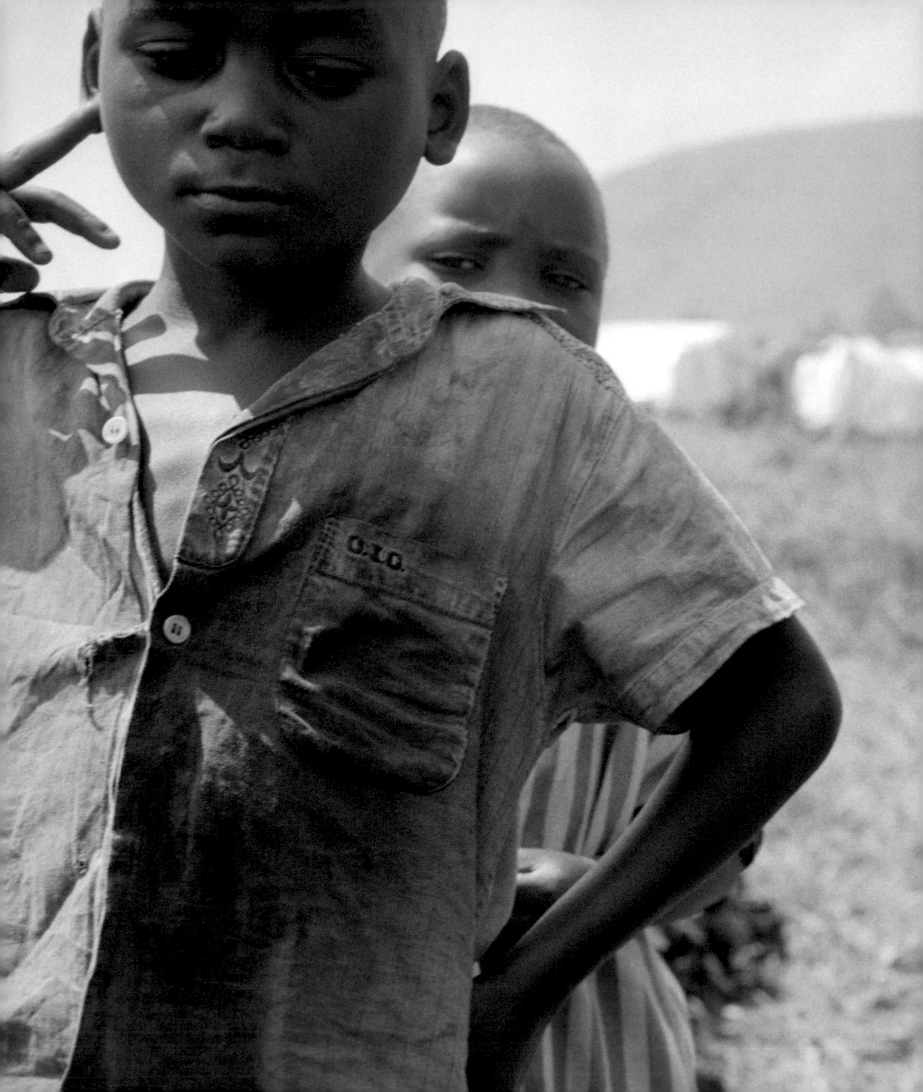

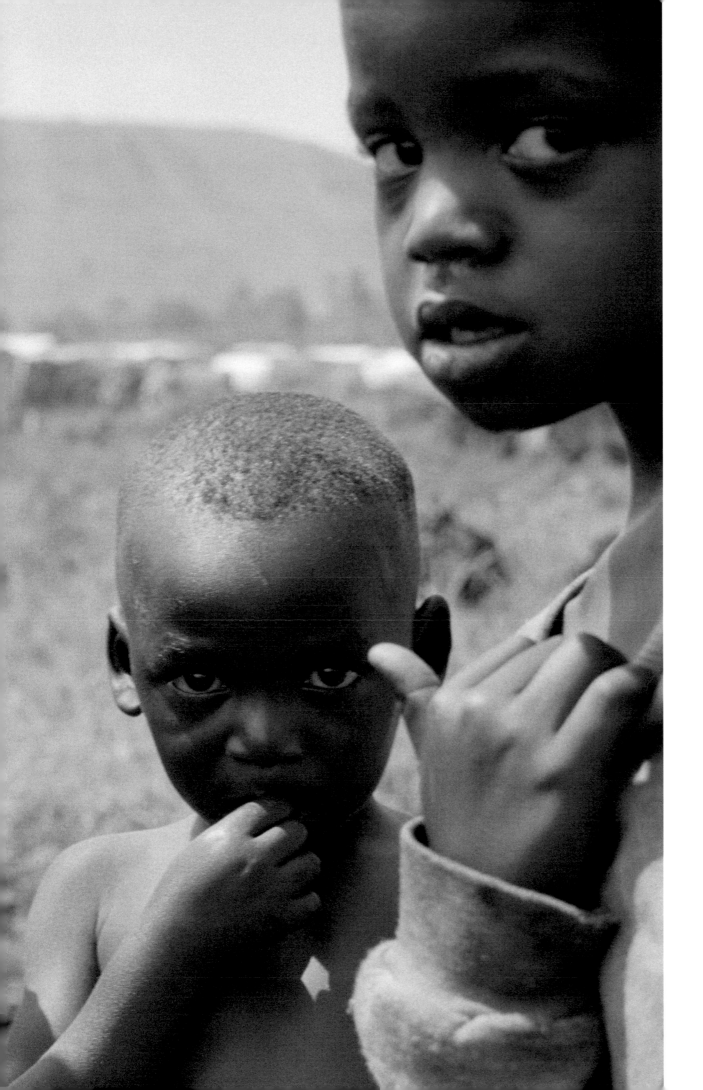

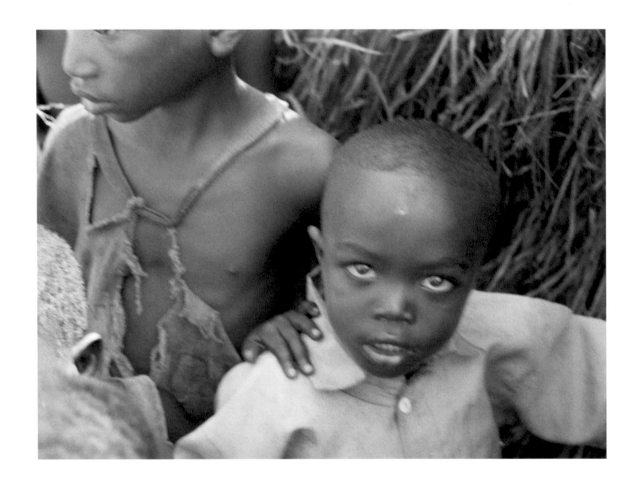

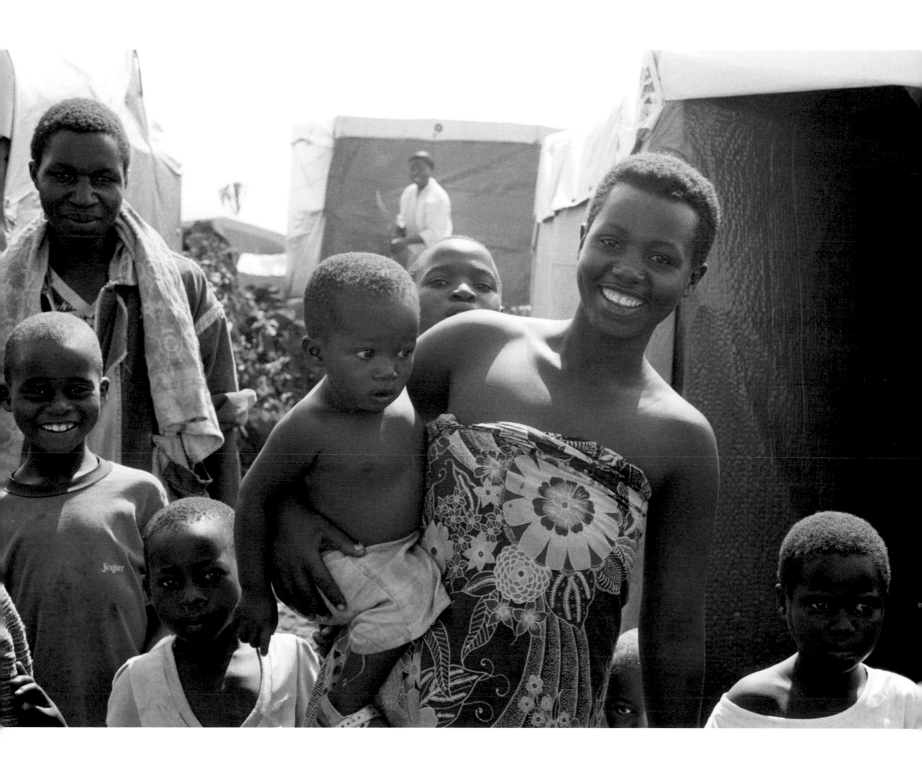

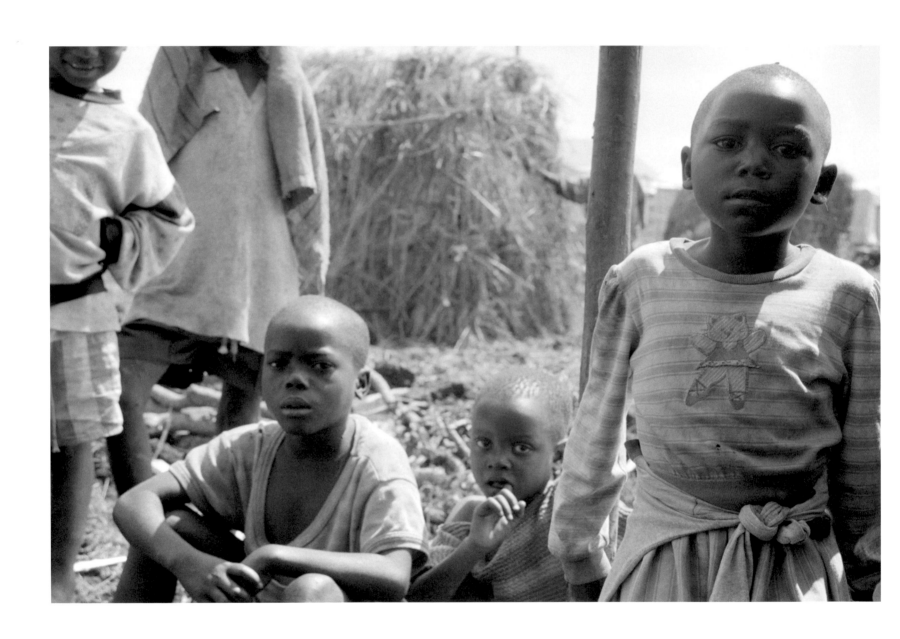

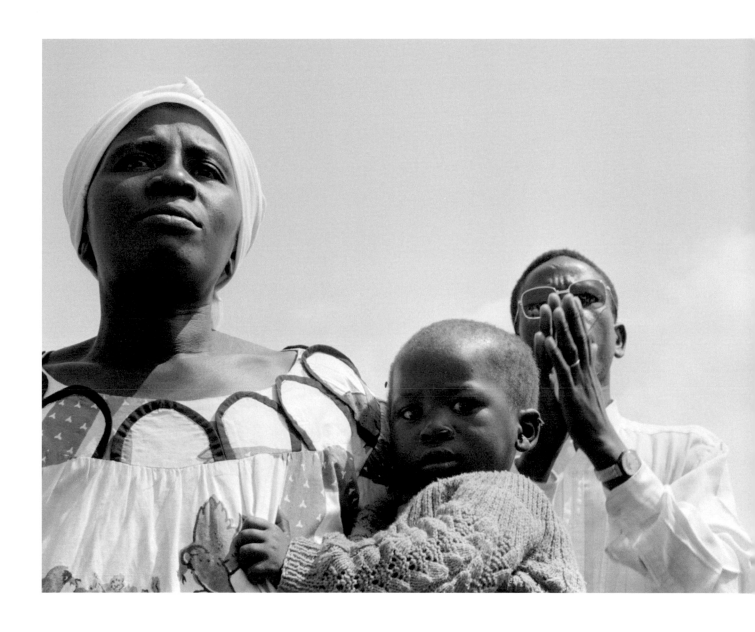

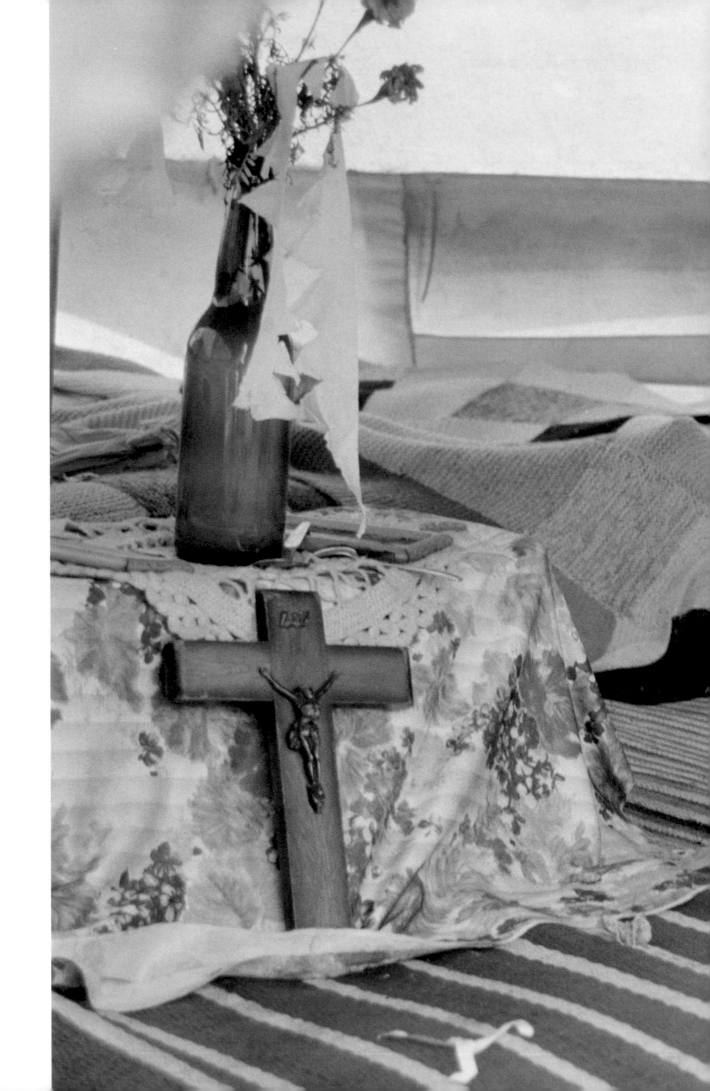

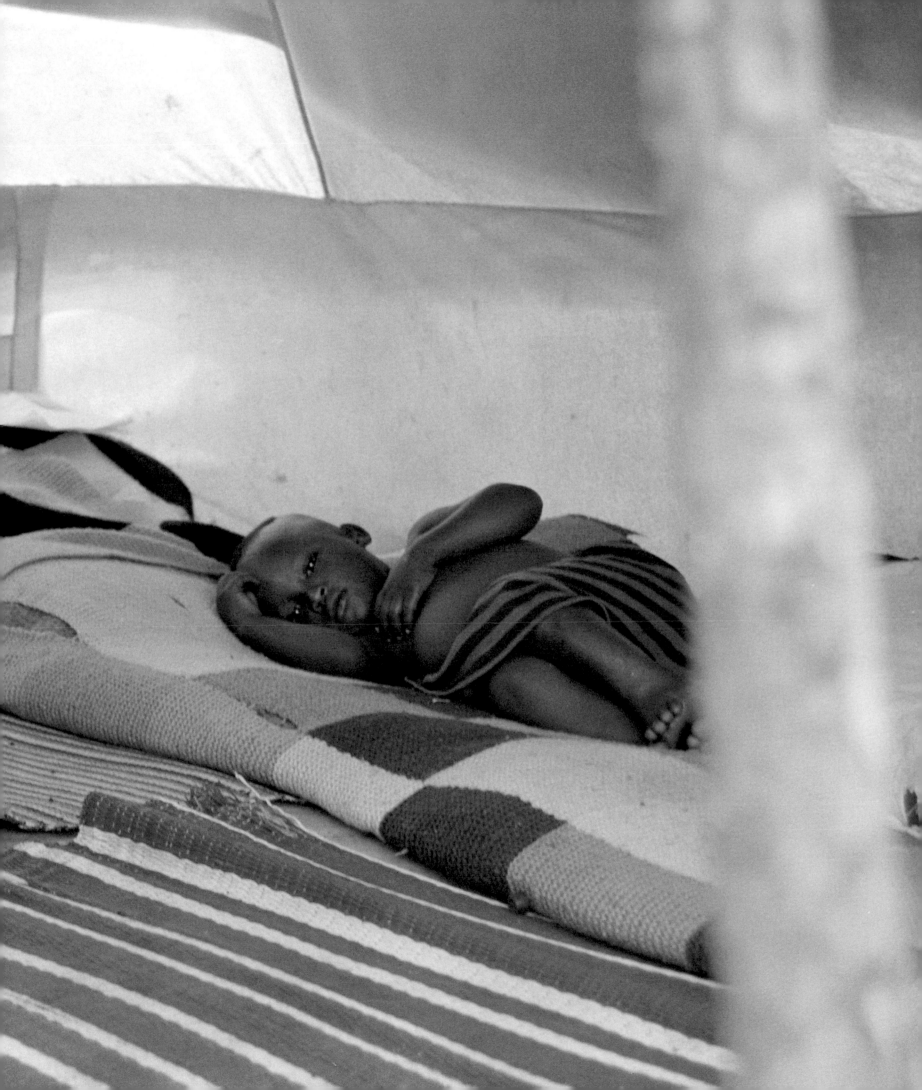

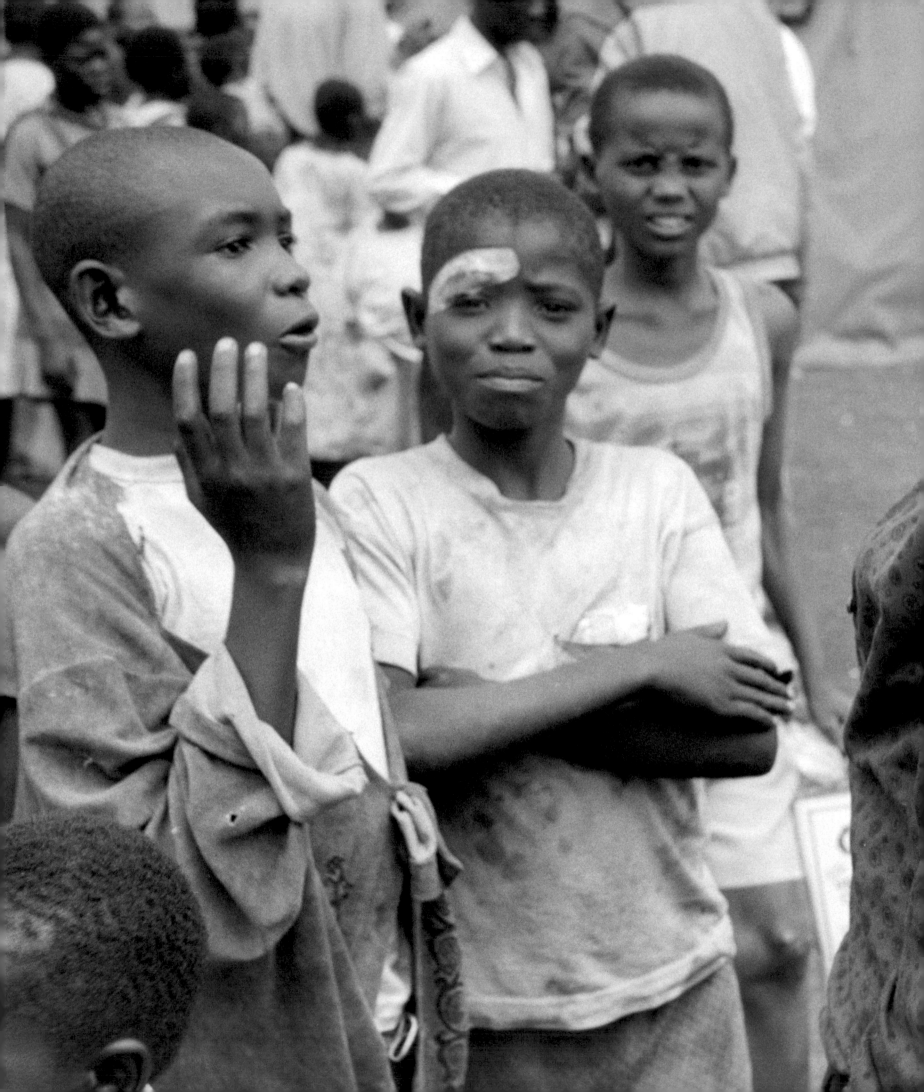

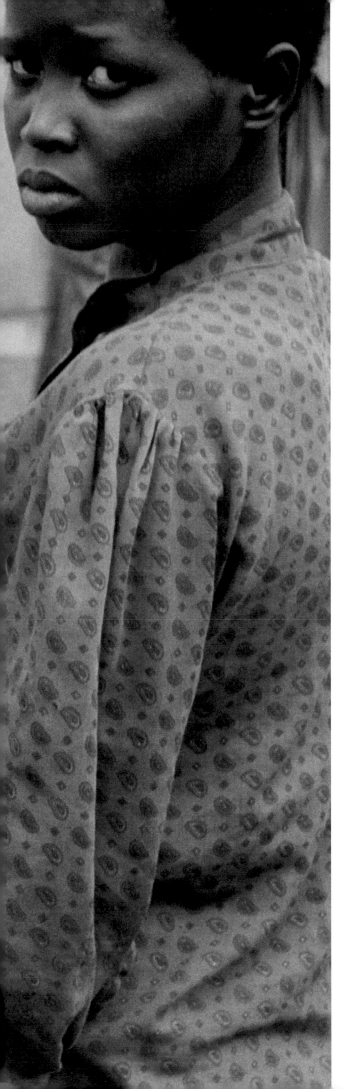

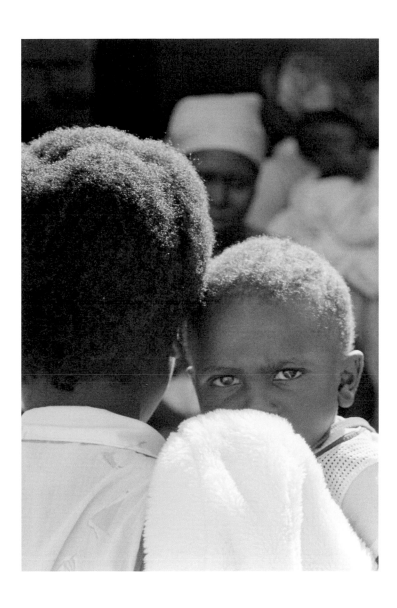

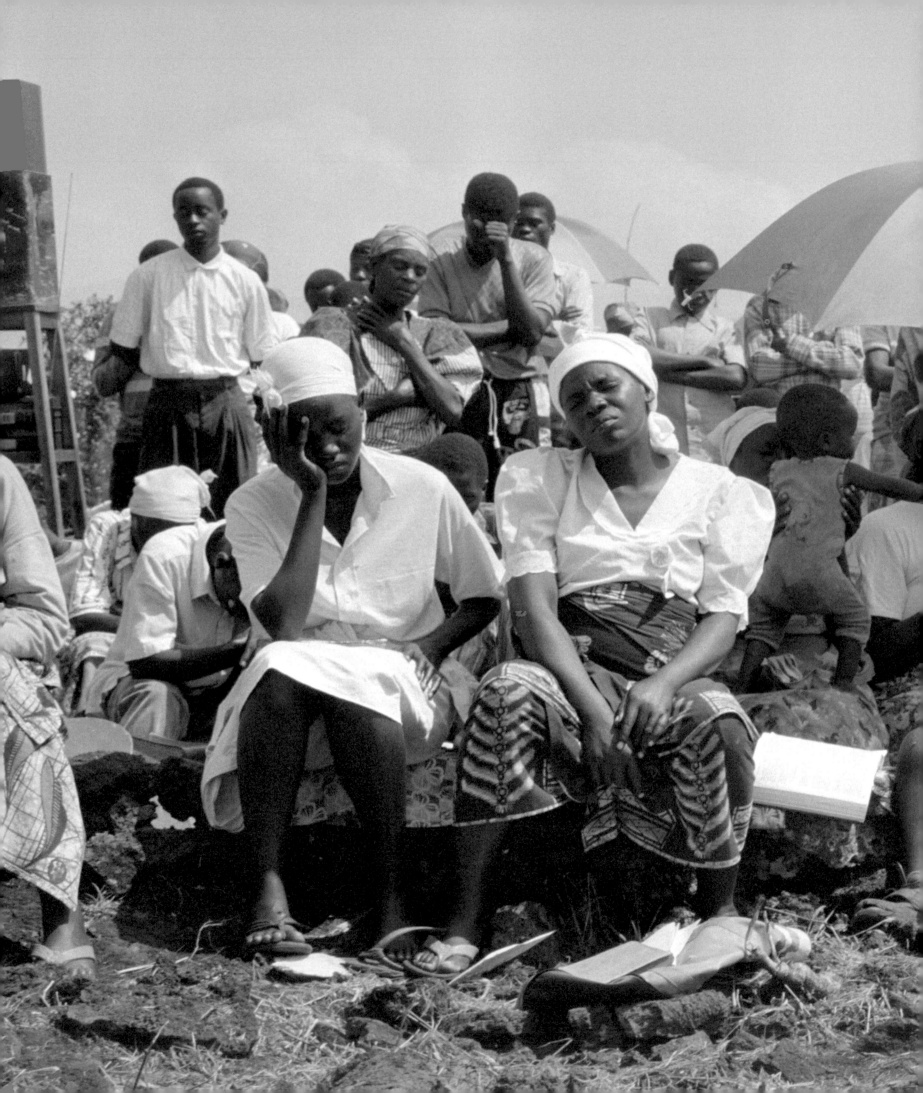

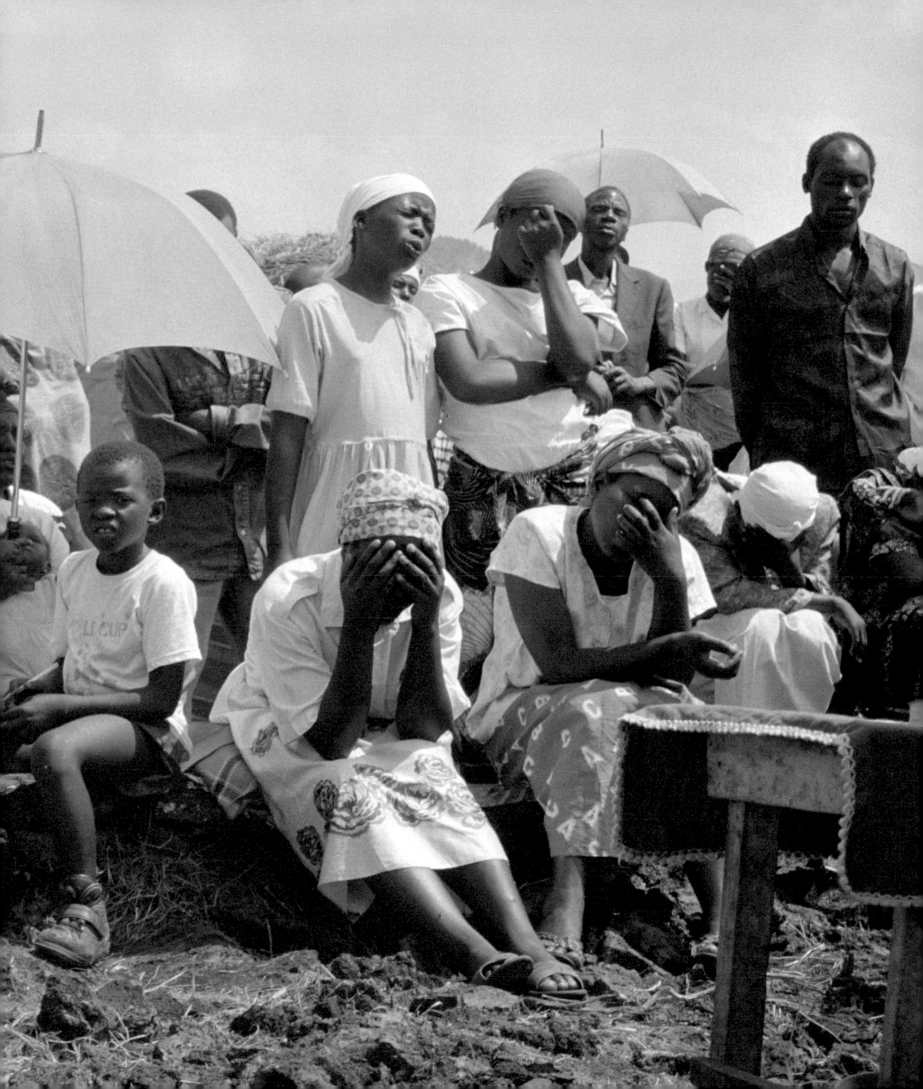

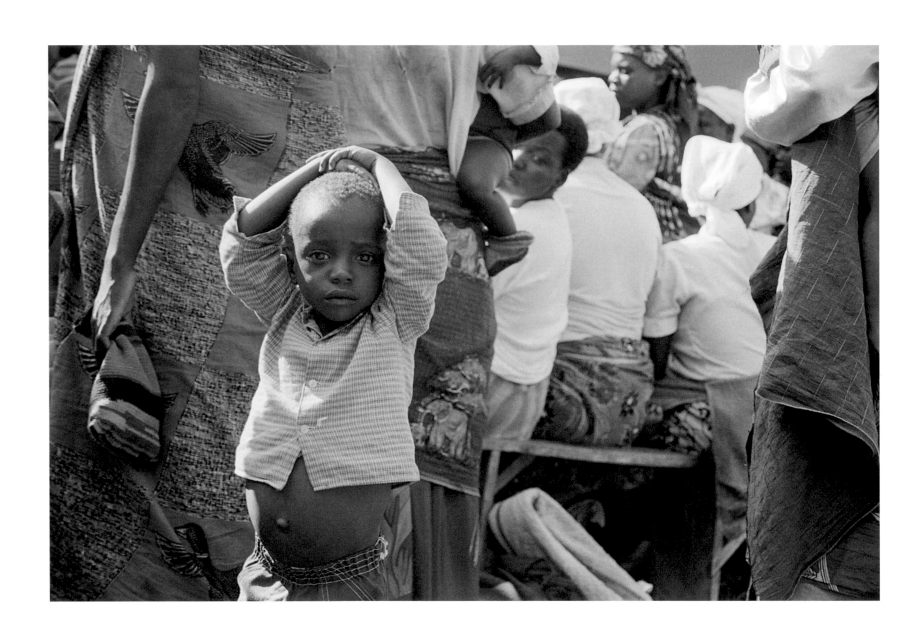

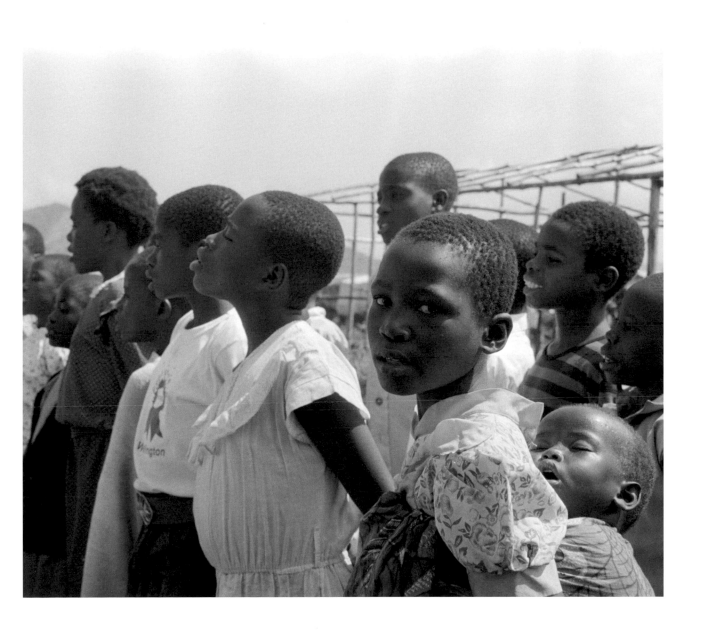

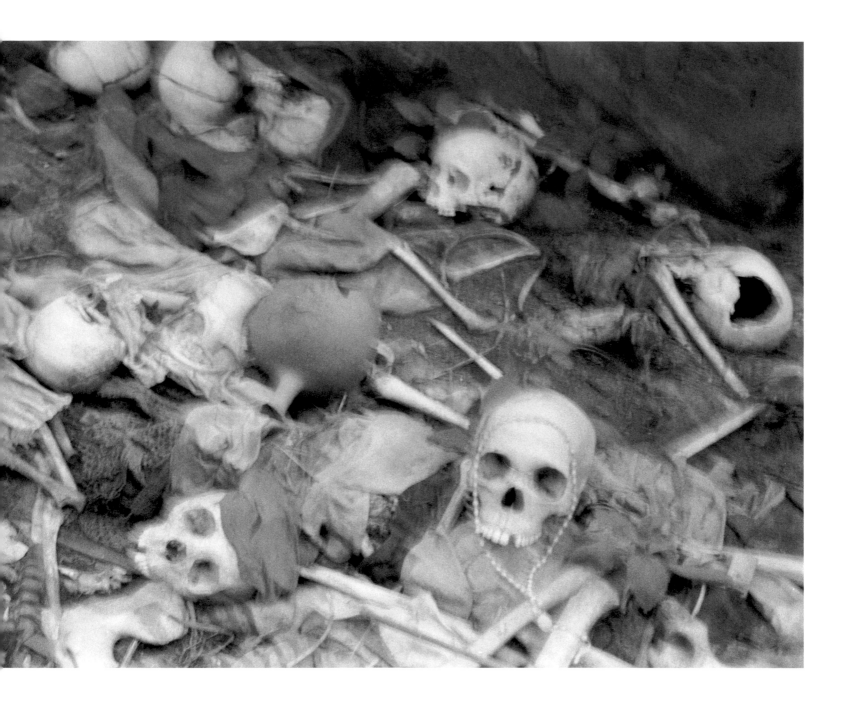

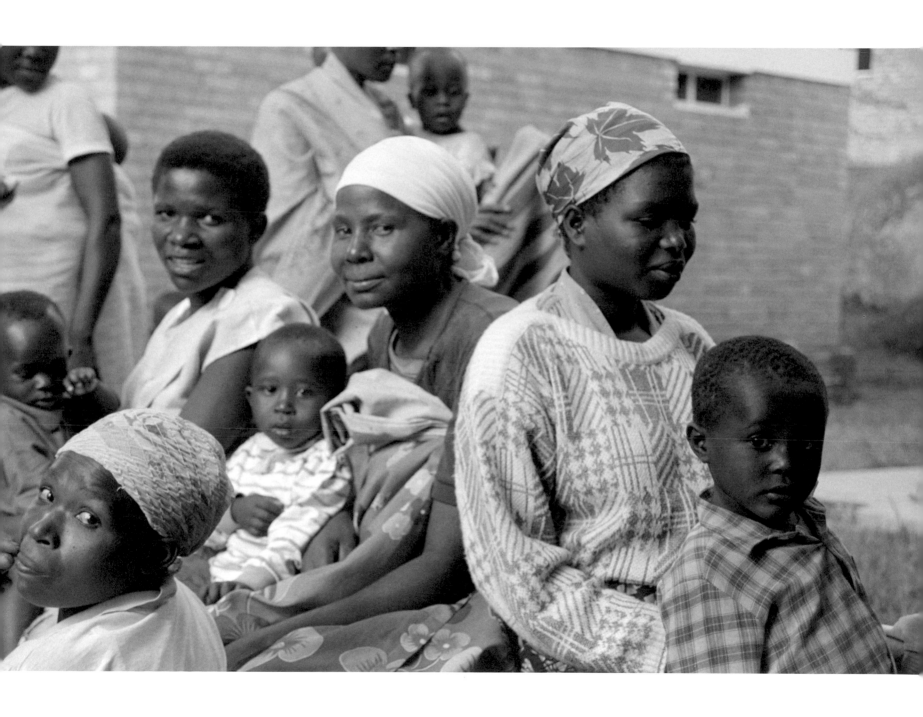

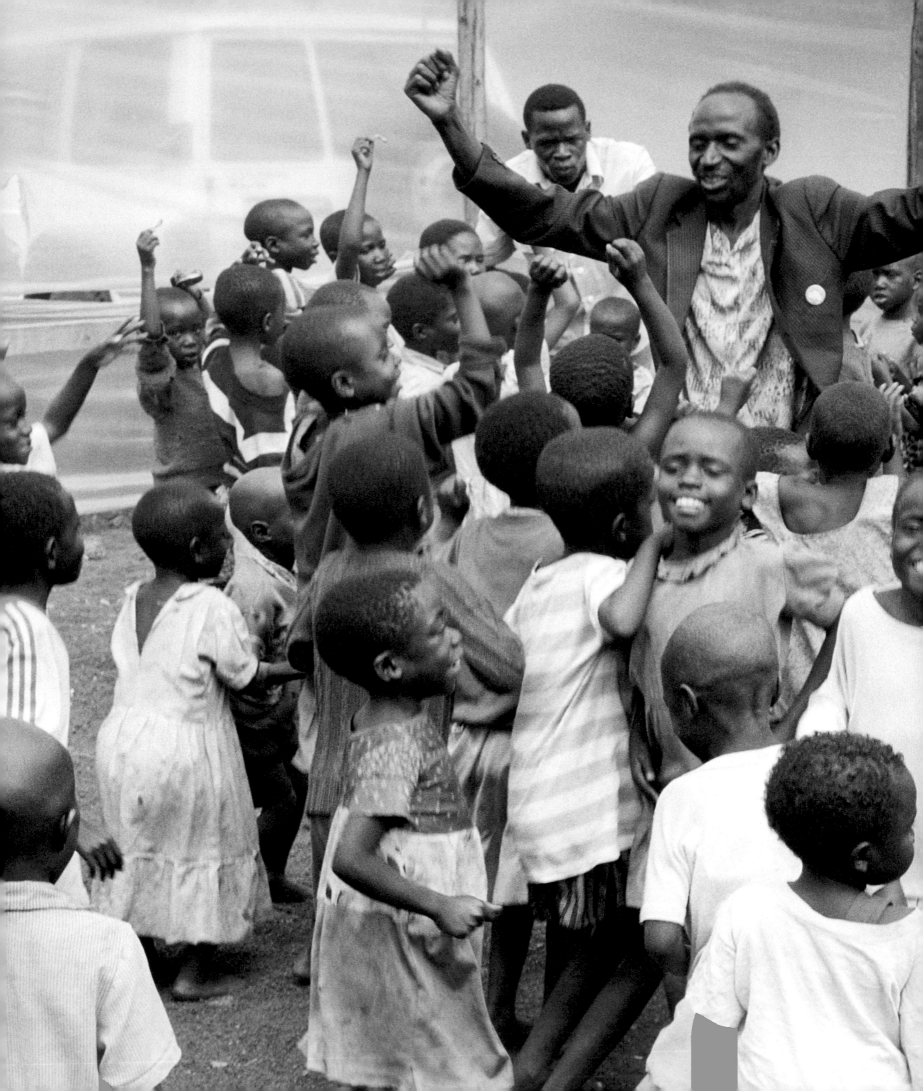

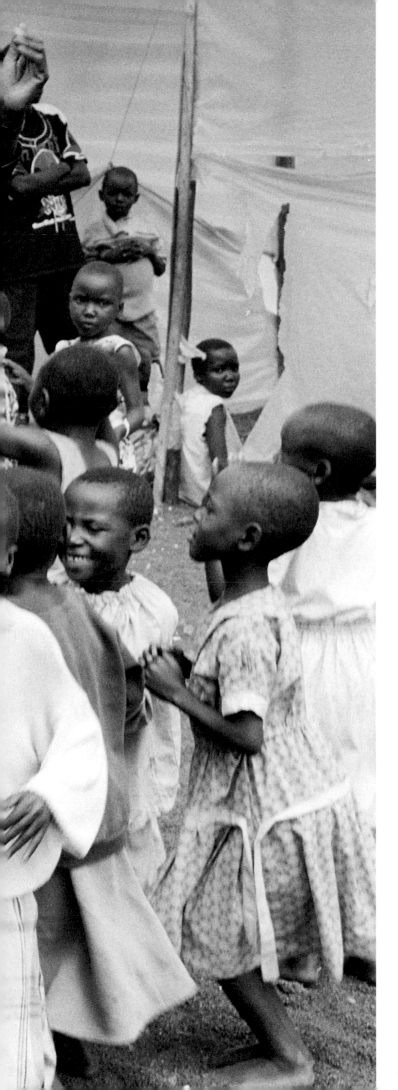

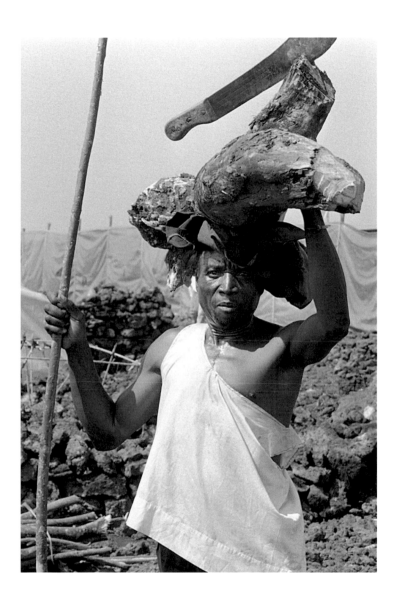

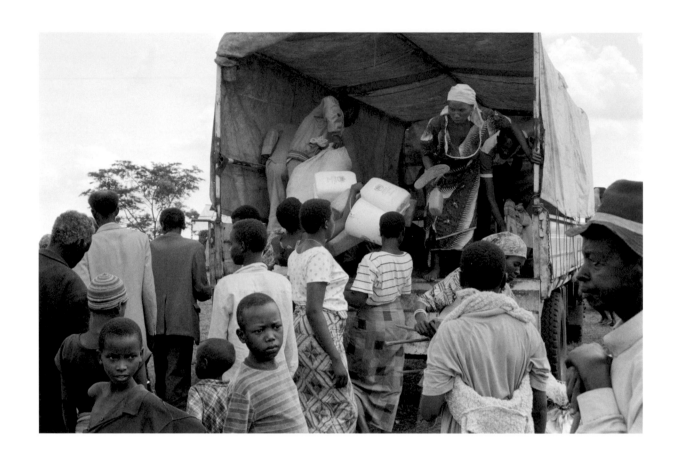

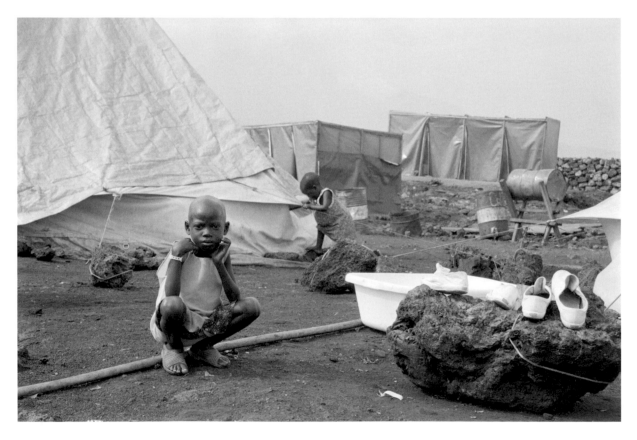

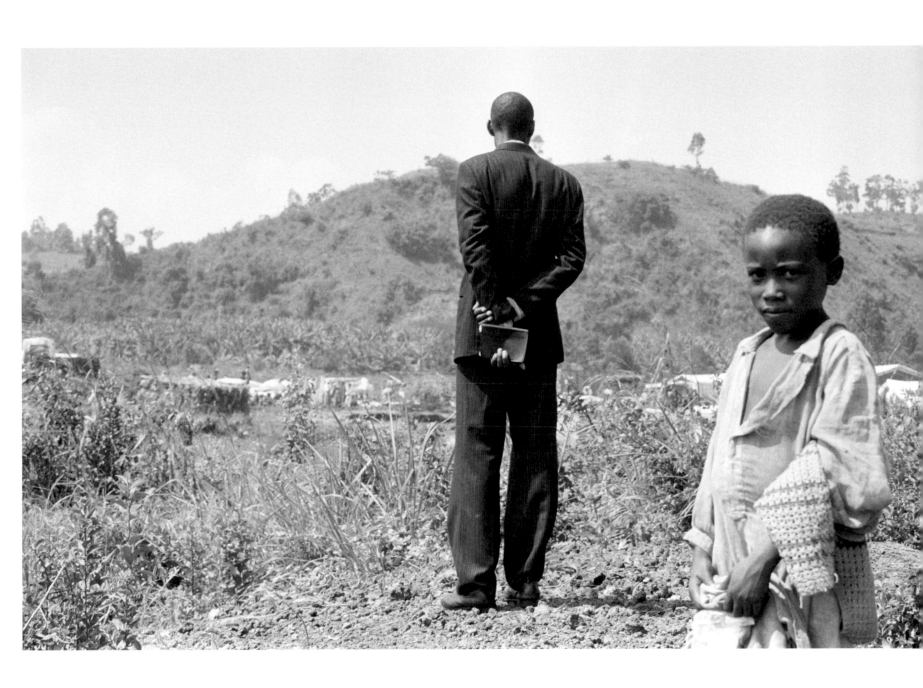

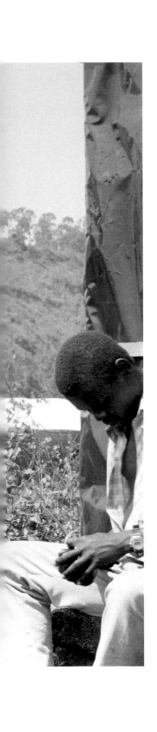

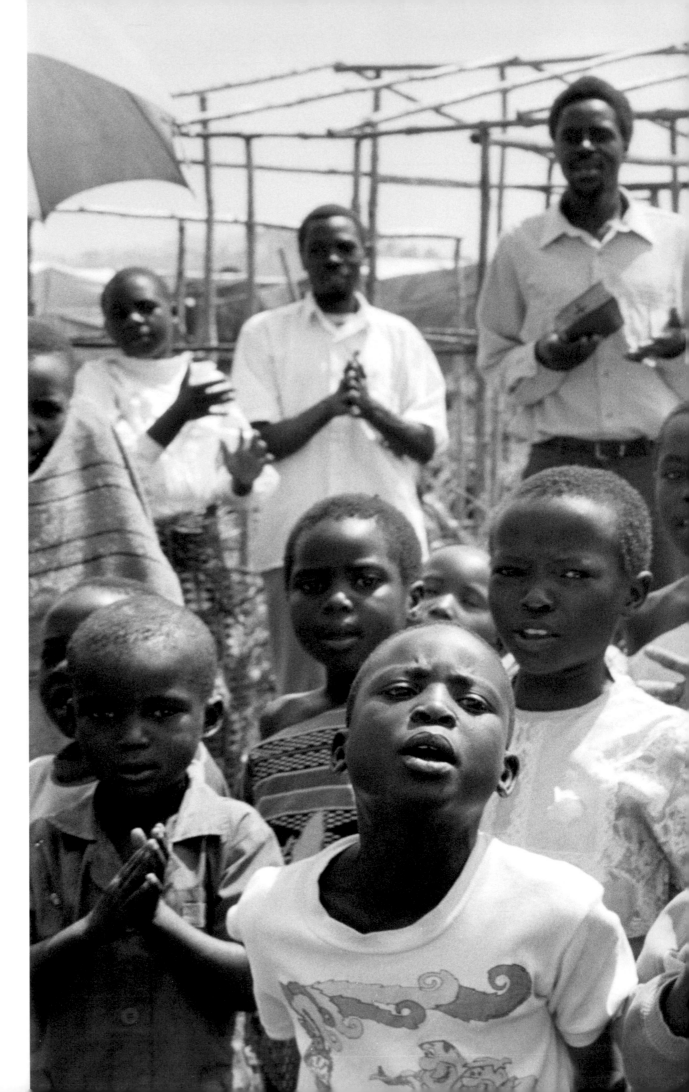

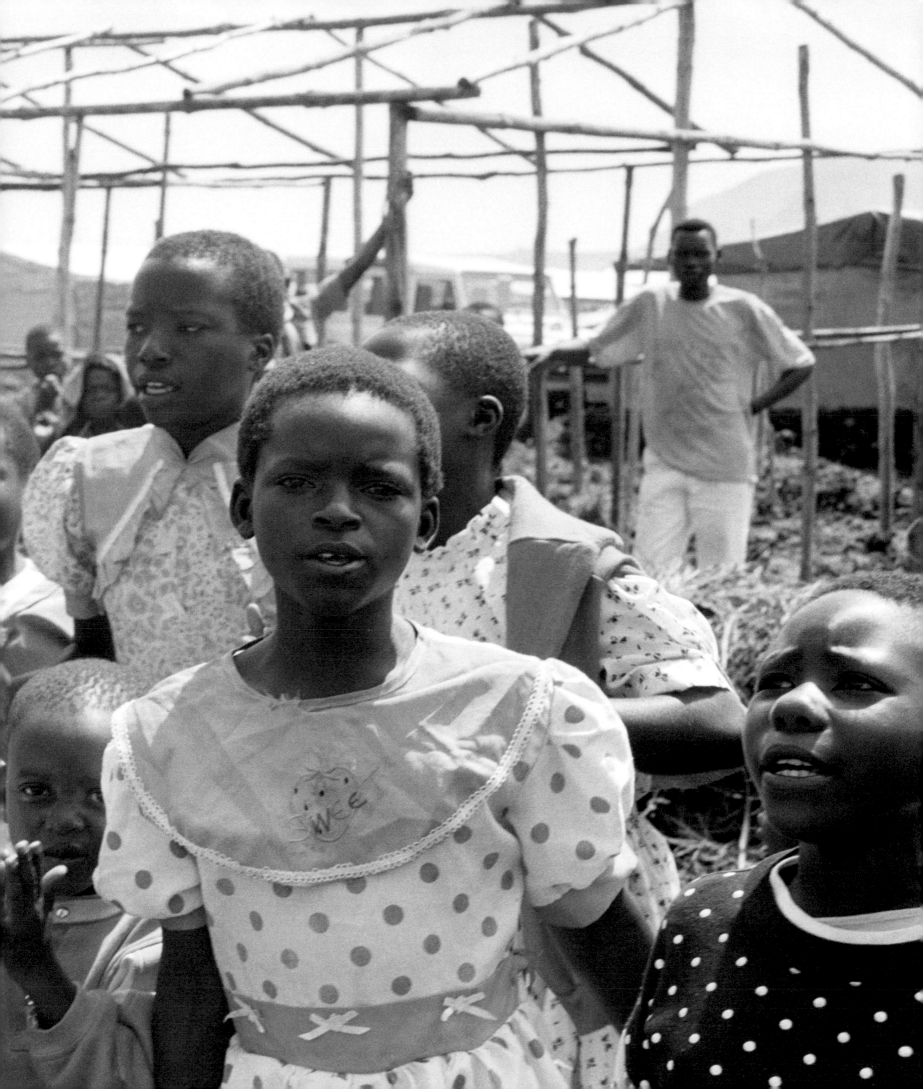

CAMBODIA

In Cambodia today there are more than 43,000 landmine survivors and 50,000 survivors of polio. The disabled are often viewed as useless, a burden, and are cut off from opportunities for education and employment. In a nation where the average income is less than a dollar per day, the disabled are often the poorest of the poor. When we see pictures of people with disabilities in Cambodia— and especially when we see pictures of children who have lost limbs to landmines, or have been disabled by polio—we often feel pity.

Pity is a natural emotion and is often misunderstood. Its etymological origins are shared with *piety* and *pious*. In its original sense, *pity* overlapped with qualities of compassion, faith, and duty.

Properly understood, pity is the emotion that comes when we see suffering and feel a duty to take action.

In its contemporary sense, *pity* has a negative patina of judgment. This sense has developed largely because in the seas of modern life, pity has torn loose from its original anchors in faith and duty. Lashed firmly to piety and the will to do good to others, the feeling of pity did not entitle someone to a sense of superiority, rather it required that action be taken to alleviate the suffering of another.

We should not be afraid to feel pity. It has its proper place in the modern world. When we first see a picture of a young boy who has lost a leg to a landmine, or when we first see a young girl disabled by polio, we probably respond first with a feeling of pity. Because of the modern negative connotation of the word *pity*, we might be inclined to say instead that we respond with *sympathy*, but sympathy implies a deeper level of understanding and familiarity.

Pity, like anger, has its proper place, though it is often misunderstood. Modern culture preaches that we should not feel anger, that we should not feel pity. This advice shows profound confusion about the human condition and human nature. Gandhi said—as did Saint Thomas Aquinas and Maimonides—that anger is a proper emotion. When we see an injustice, it should move us to anger. Our anger is the first flash of energy that we need to combat an injustice.

Gandhi said, "I have learned through bitter experience the one supreme lesson to conserve my anger, and as heat conserved is transmuted into energy, even so our anger controlled can be transmuted into a power which can move the world."

We should understand anger as we understand electricity: unregulated, it will kill us; channeled properly, it can help us to shape the world. The same is true of pity.

Often, we live focused on ourselves, lulled to sleep by the mundane details of everyday life.

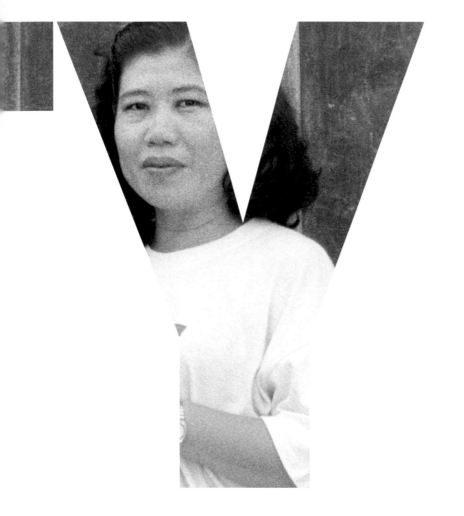

Pity, like anger, has the power to bring us to our feet. Pity can provoke us to take our first few tentative steps toward the light of duty that beckons beyond our own self-concern.

Pity, however, is still ultimately about how we feel. We see a poor family in Cambodia, and we question our use of wealth; we see a disabled child, and we question our use of time. For pity to serve us well, we must know how to see and how to act.

I remember listening to a Buddhist monk who explained a lesson he had learned. His teacher had once shown him a piece of paper with three small black dots in the middle. When his teacher asked him what he saw, the monk said, "Three black dots." His teacher asked him to look again. "I see three black dots, and they look like they are all about the same size," the monk said. His teacher told him to look again. "I see three black dots, all about the same size, and maybe they are the points of a triangle," the monk said. Finally his teacher said, "You focus on these three black dots; you tell me more and more about them, in greater and greater complexity; in comparison to the size of these dots, there is a virtual ocean of beautiful white space full of possibility and potential. You hold it in your hand, and still you did not see it."

The eyes of pity see a missing leg, but may not yet see the strength that comes from learning to overcome.

The eyes of pity may focus on polio, and thus be blind to a child's incredible possibility for growth and potential for courage.

The Cambodia Trust is a nonprofit organization that does inspiring, effective work on behalf of the disabled in Cambodia. The Trust trains Cambodians to fit prosthetic limbs and orthopedic braces. By training Cambodians, instead of relying on expatriate expertise, the Trust has created a sustainable service, and Trust staff are able to work not only to increase mobility, but also to engage in effective education, employment, and advocacy programs.

One of its most effective strategies is to employ the disabled, who then serve as role models in the community in a job that commands respect.

In this way, the Trust serves the whole person.

When I was in Cambodia in 1998, many of the victims of polio were still young. In the mid-1980s, Rotary International, UNICEF, the World Health Organization, and other concerned groups began a program to eradicate polio. The number of cases of polio dropped from hundreds, to dozens, and the last confirmed case of polio in Cambodia was in 1997.

The International Campaign to Ban Landmines, formalized in 1992, has also made significant progress. The campaign was awarded the Nobel Peace Prize in 1997, and 155 countries are now signatories to the Mine Ban Treaty.

We have clearly made progress, but much work still remains.

The Cambodia Trust still requires support, the children of Cambodia still require immunizations from polio, and hundreds of people still lose limbs to landmines and unexploded ordnance in Cambodia every year.

Progress has come as a result of concerted action, and pity played its role. Some of the first donations to the Cambodia Trust were given out of pity for the disabled of Cambodia. Some members of Rotary International, UNICEF, and the World Health Organization were inspired to act based on a feeling of pity for victims of polio. Some of the first supporters of the campaign to ban landmines were motivated by some combination of pity and anger over the reality that thousands of children the world over are missing limbs because they stepped on landmines that were not intended for them.

Pity has its place. Pity can prompt us to action. Instead of counseling, "don't take pity," the better counsel would be to let pity lead us to the dignity of action rooted in respect.

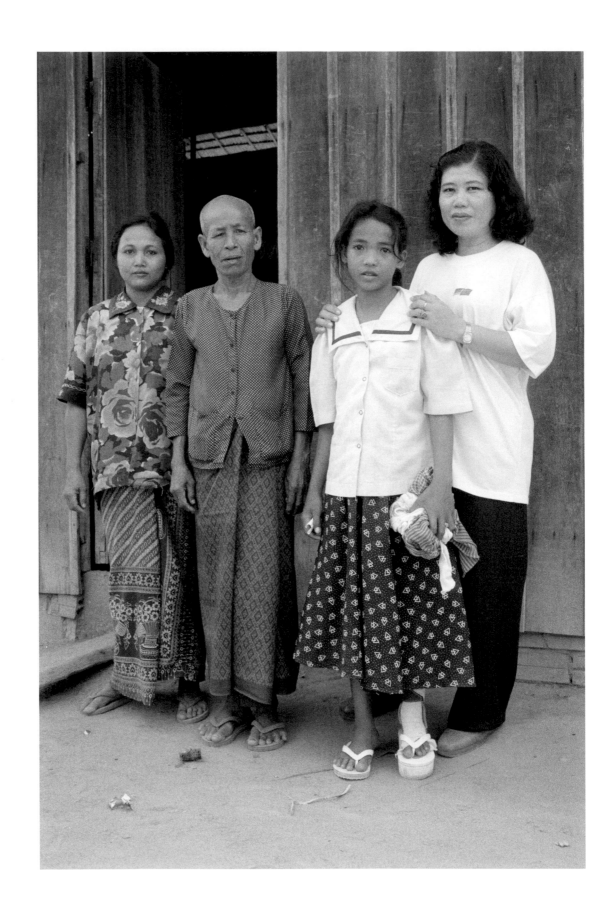

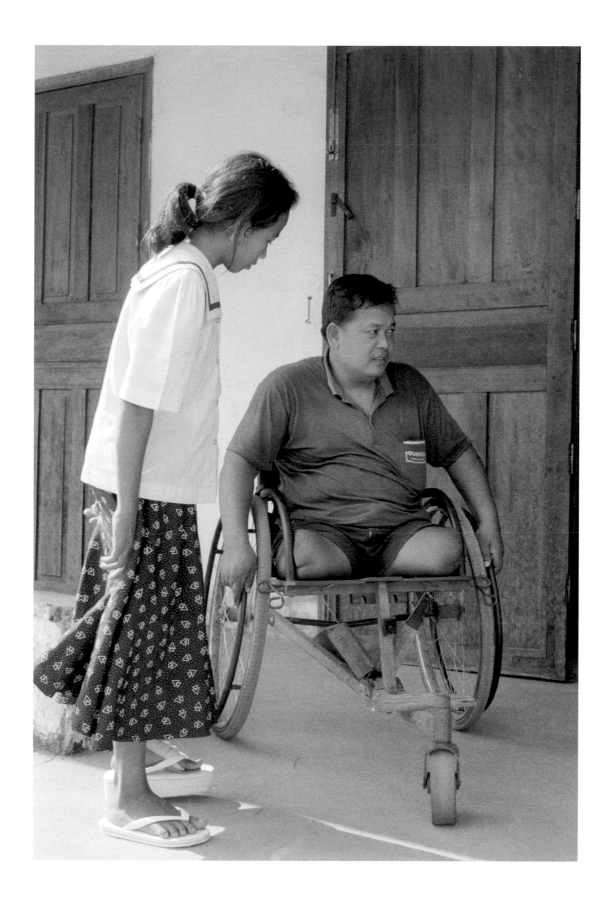

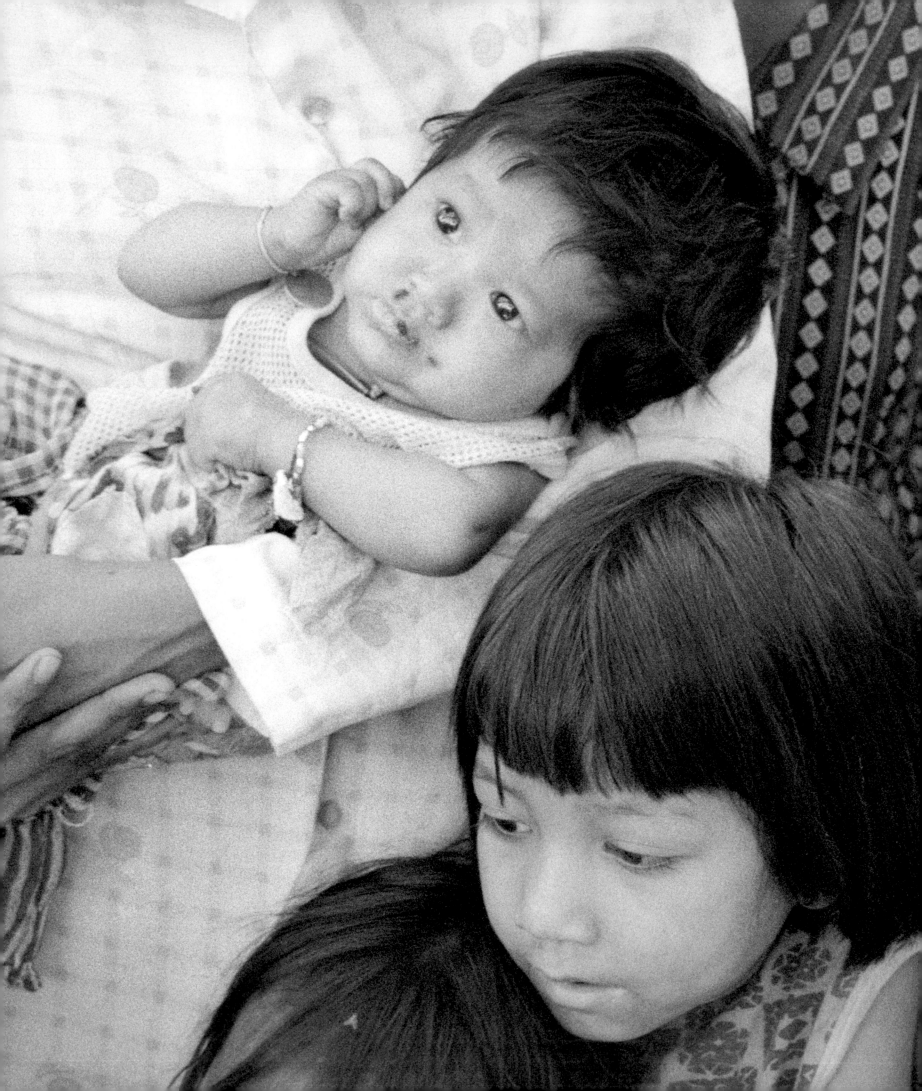

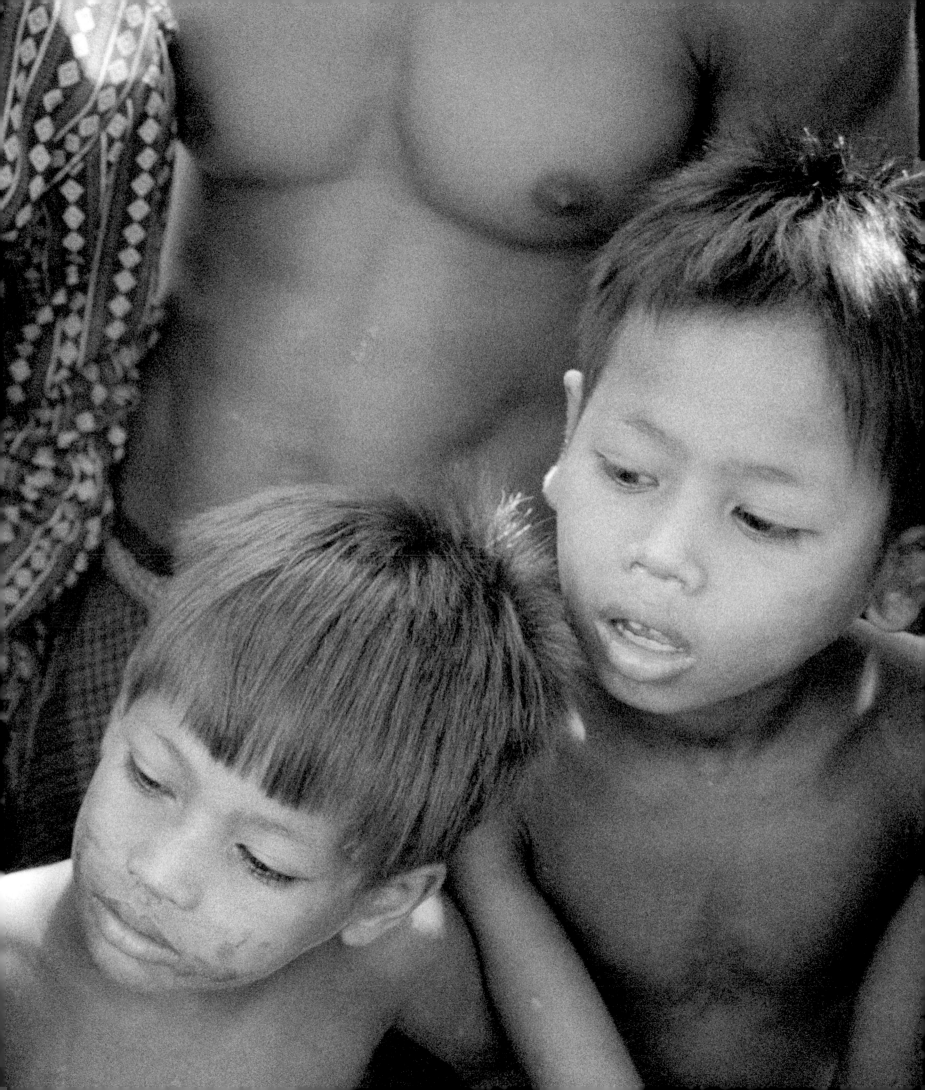

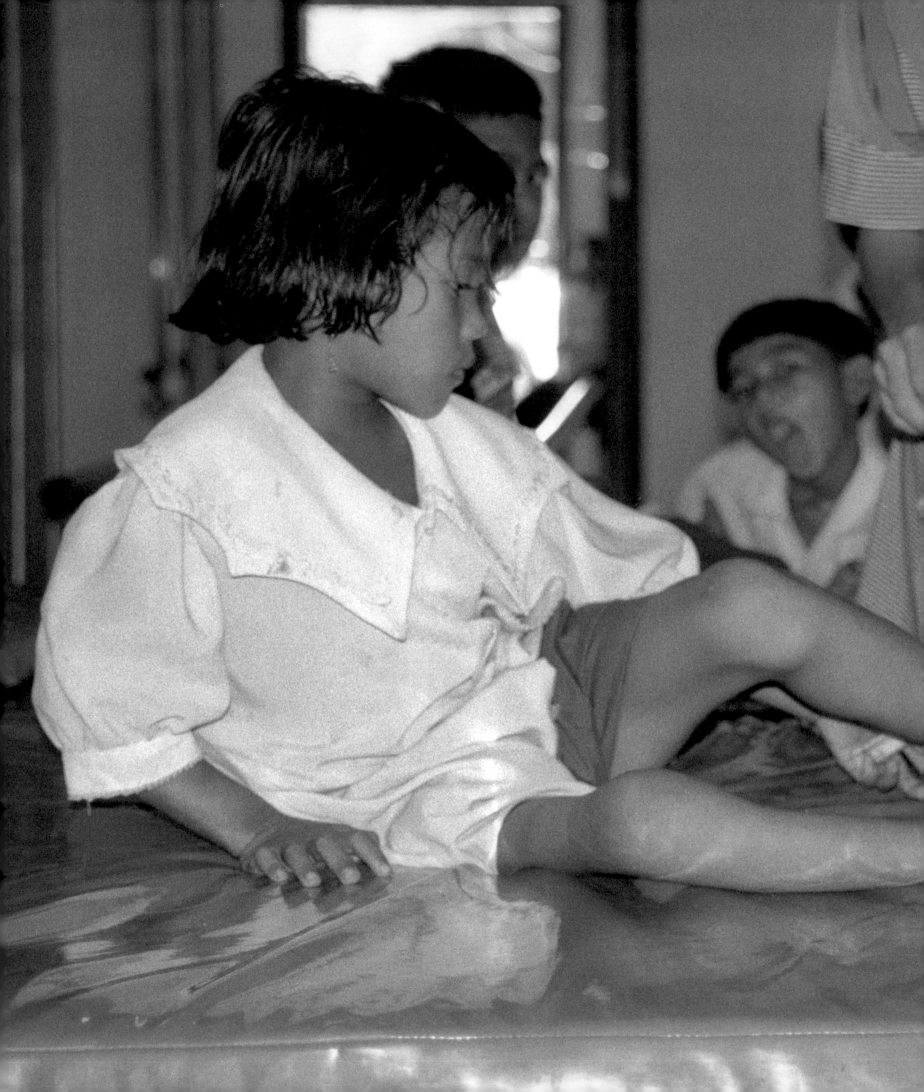

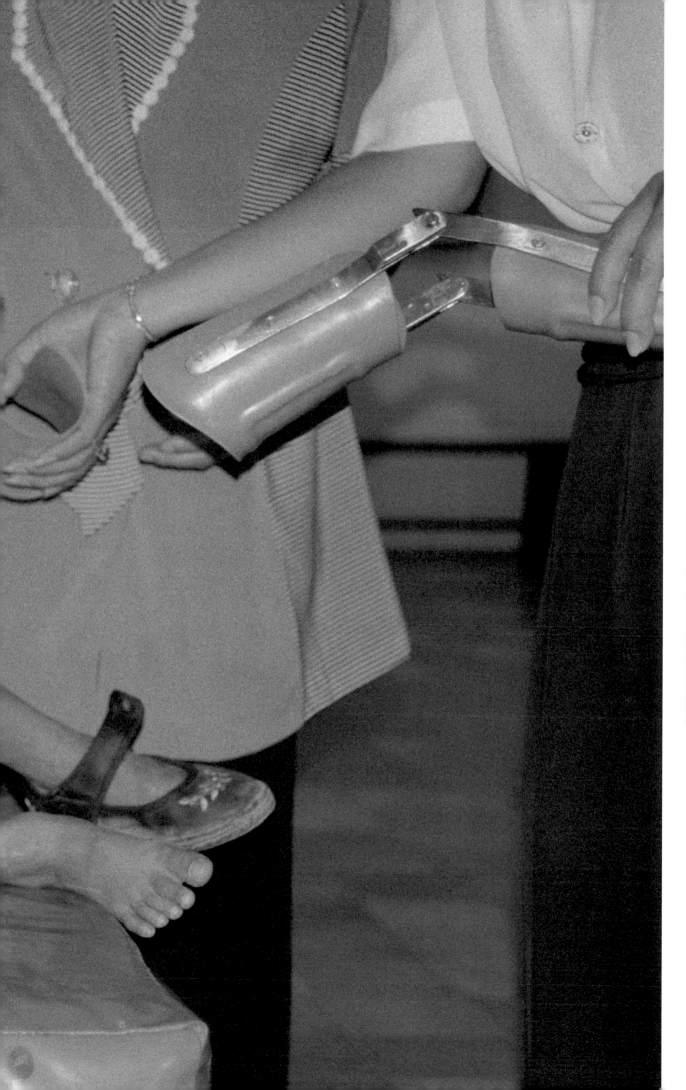

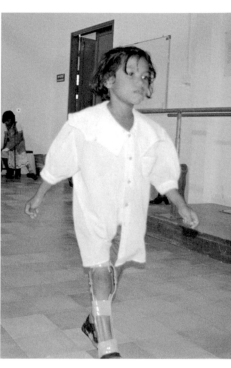

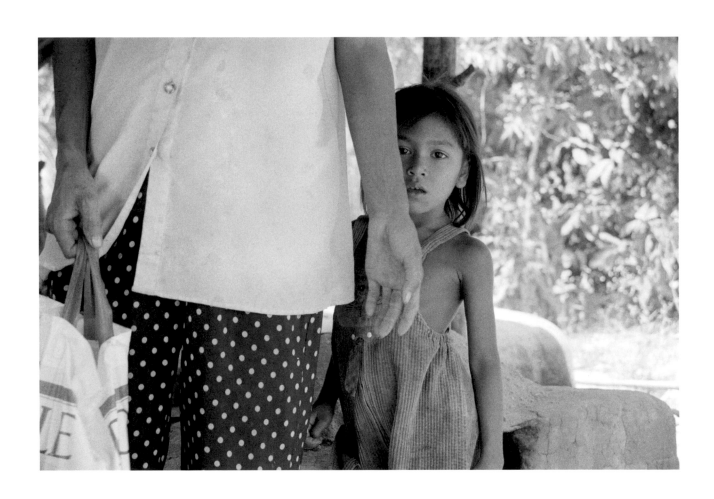

46 Pity

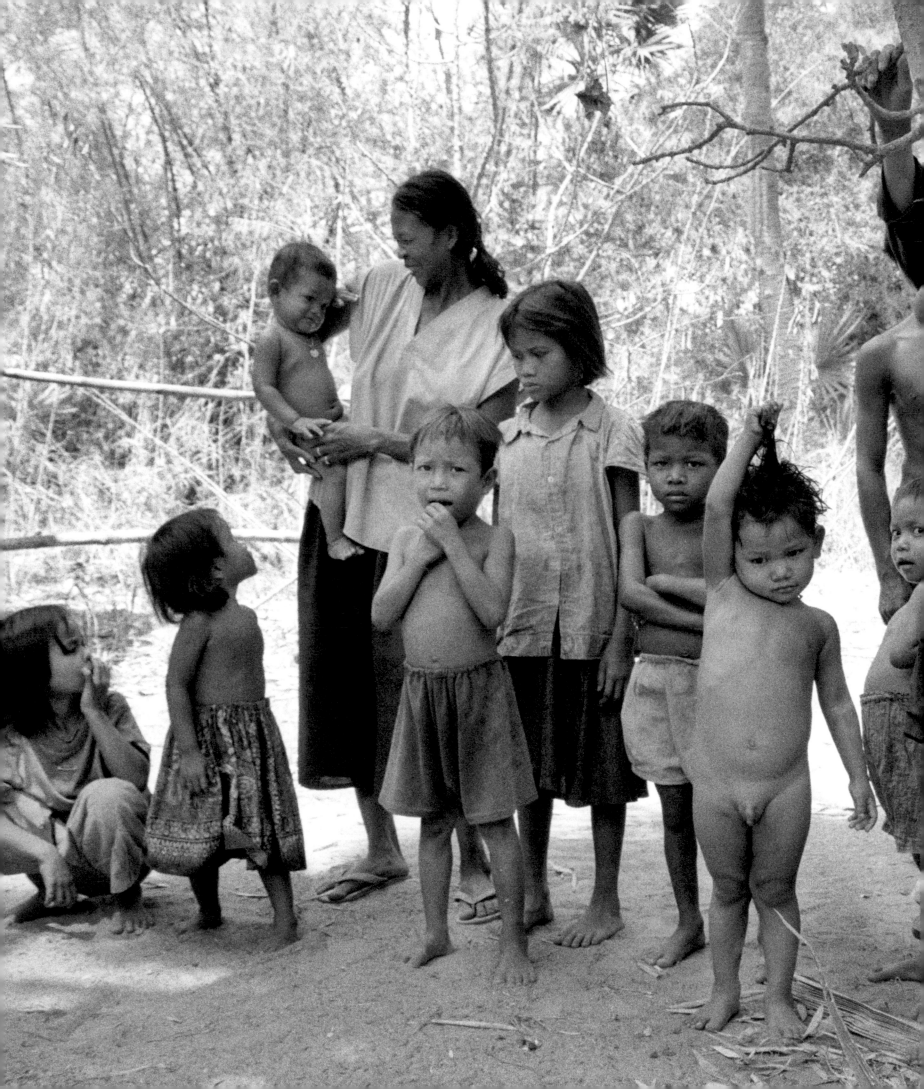

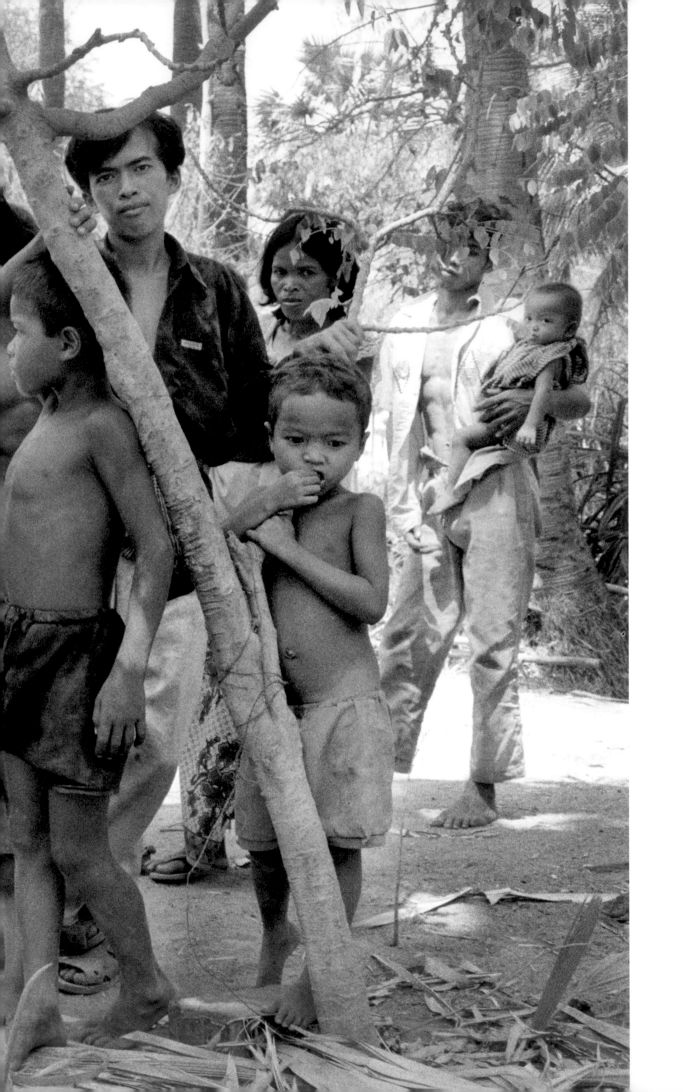

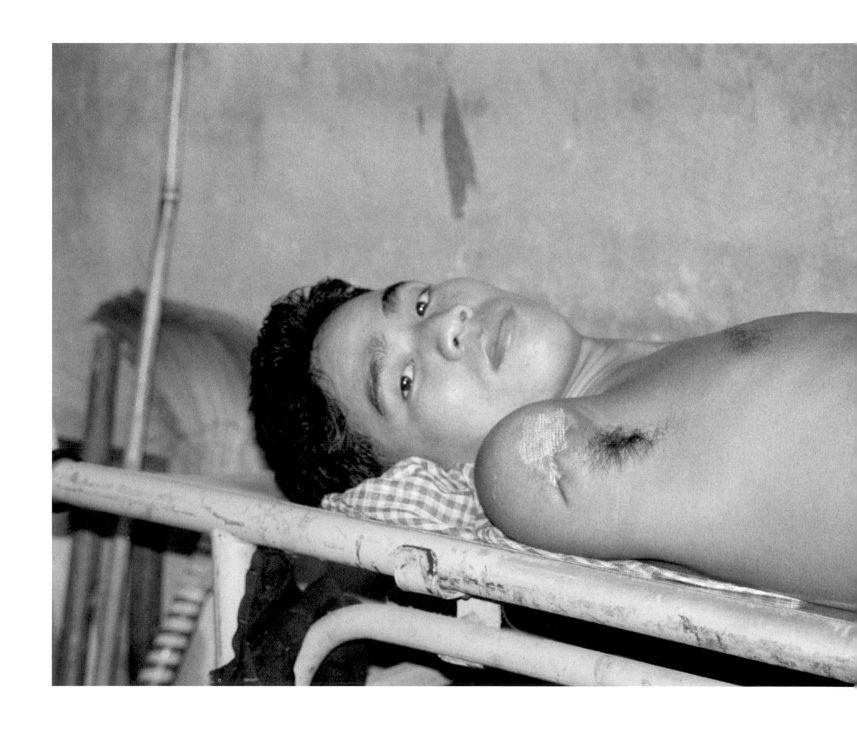

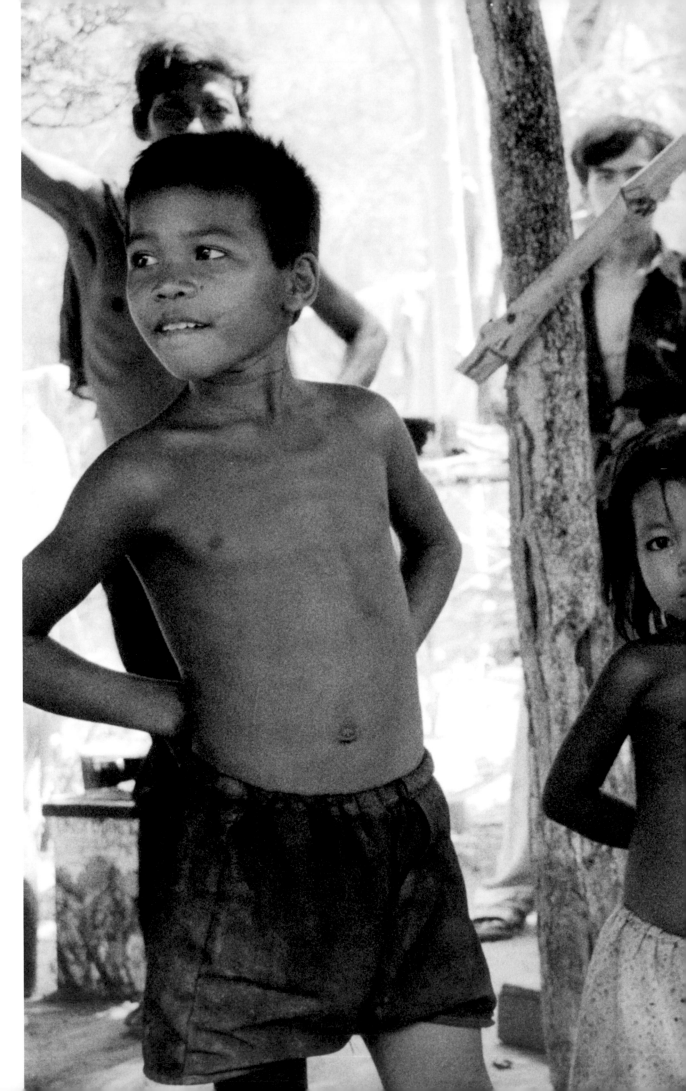

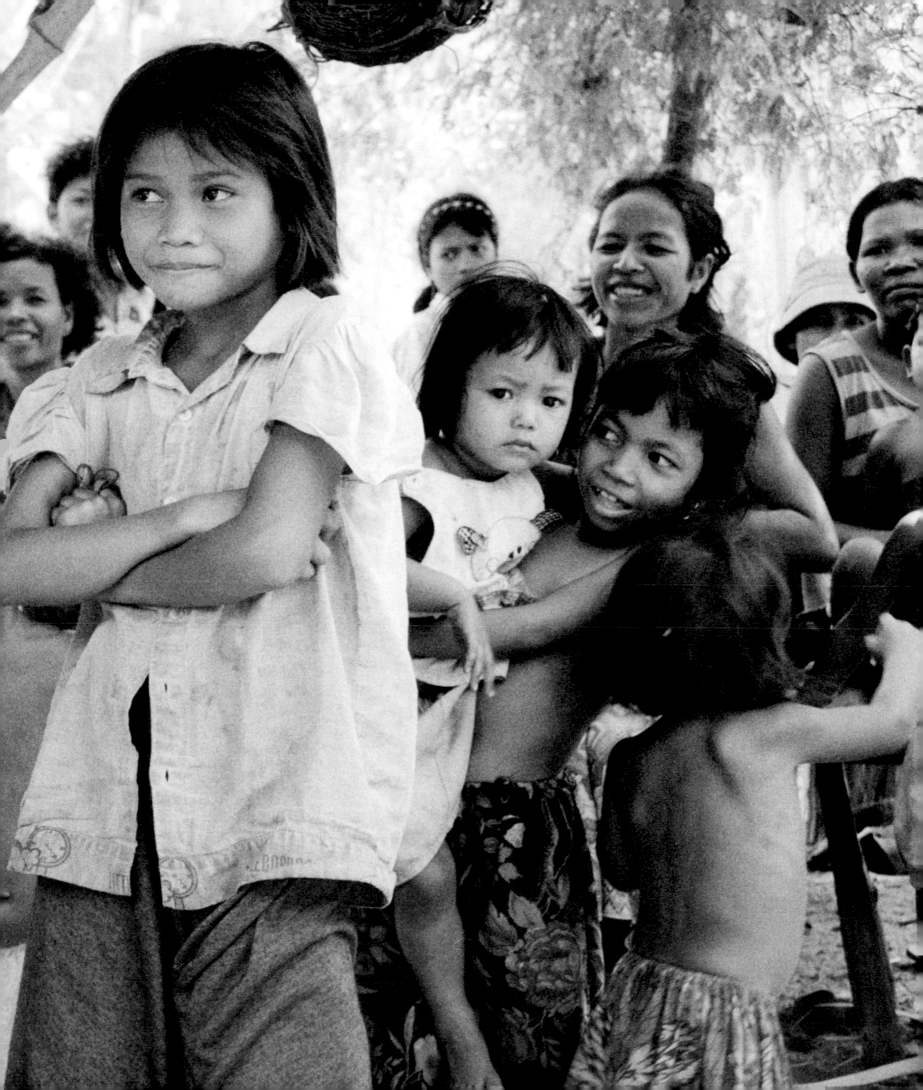

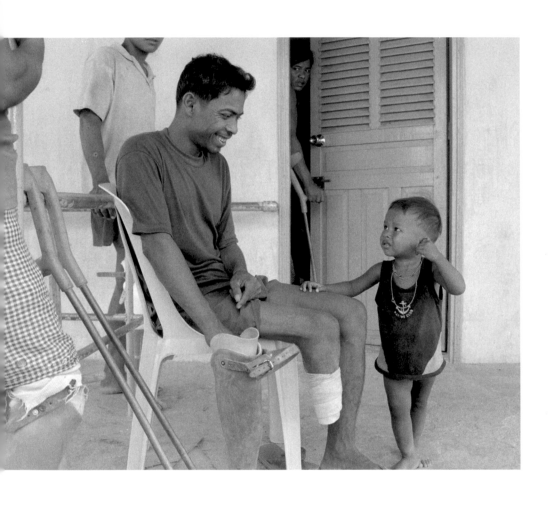

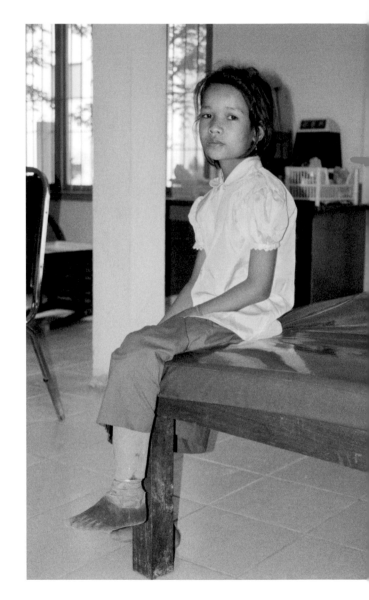

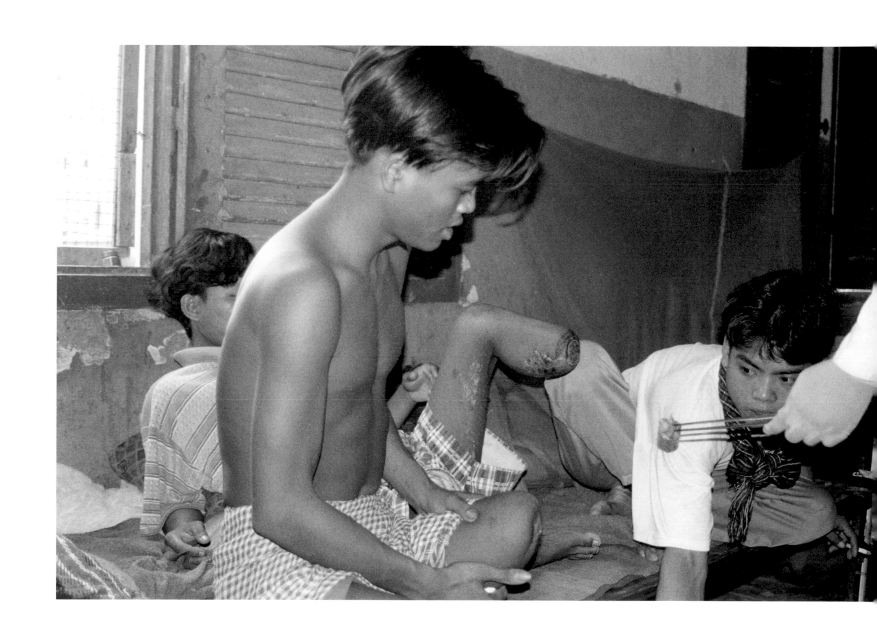

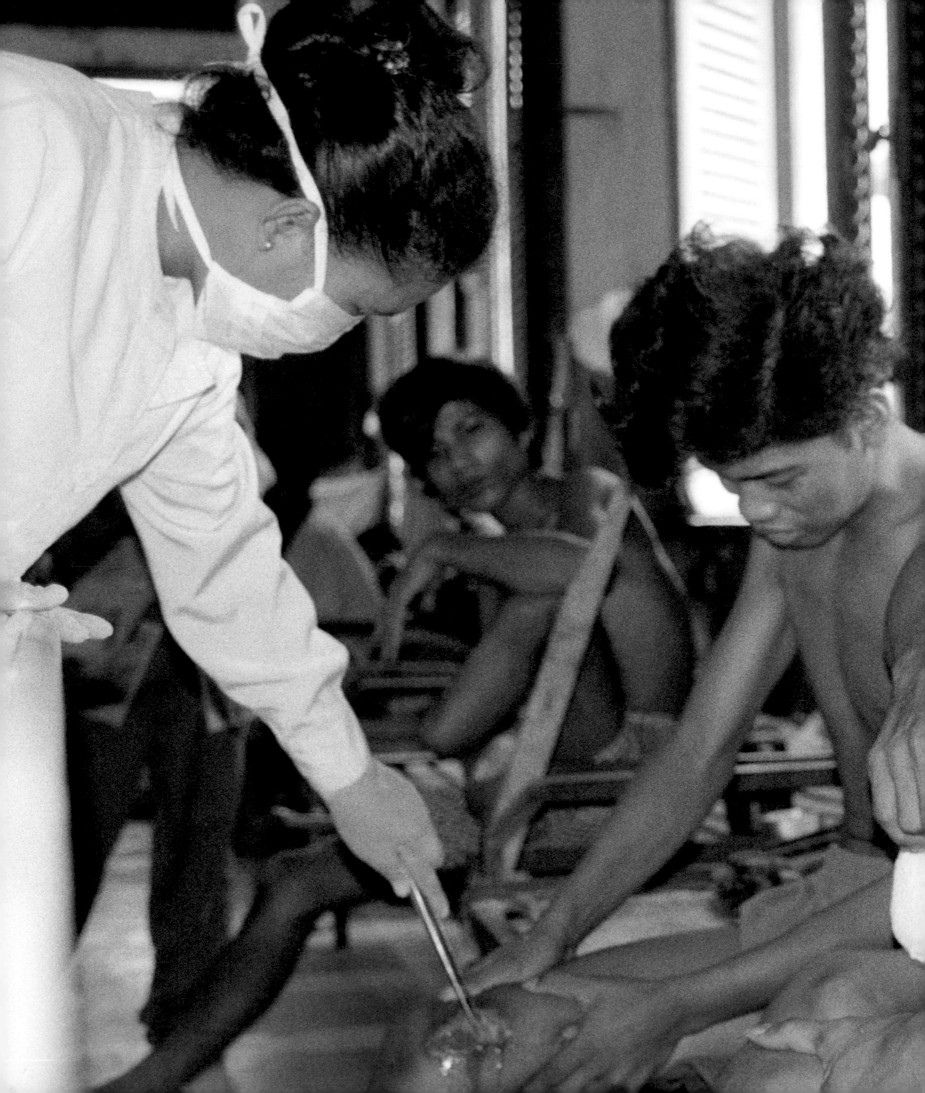

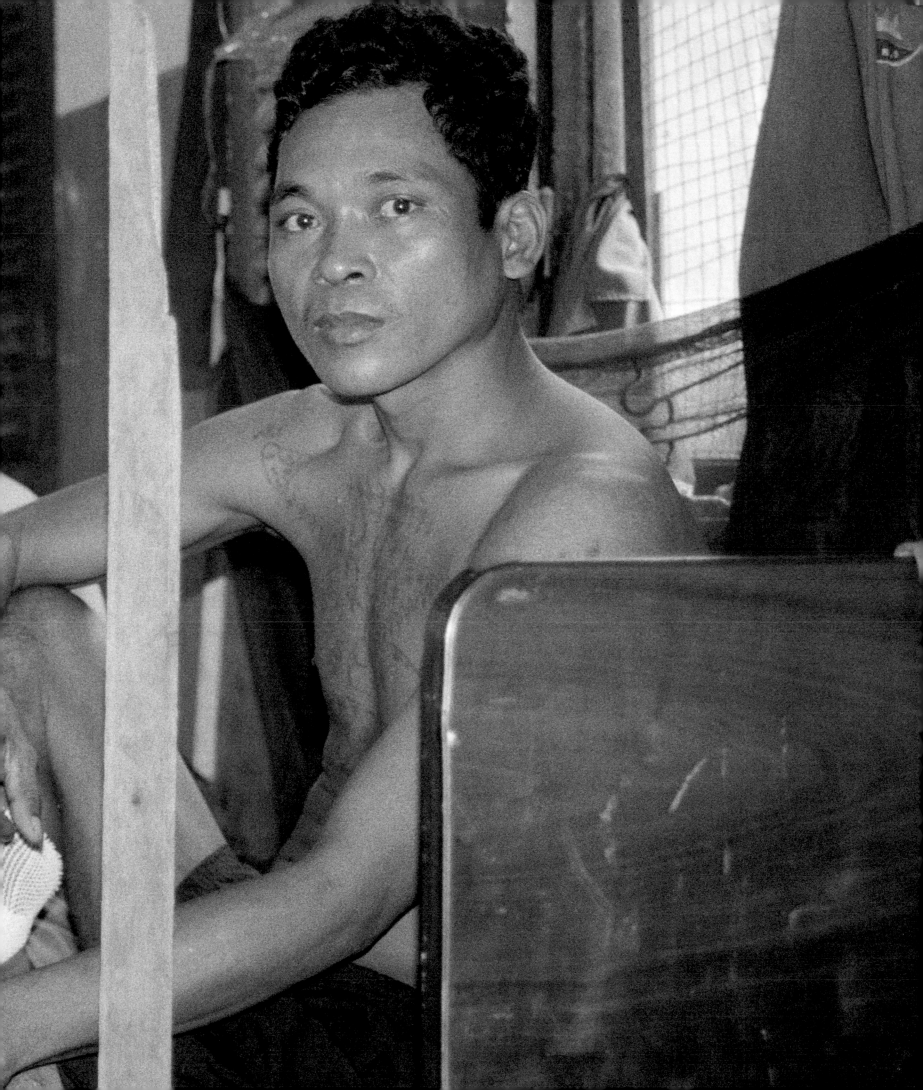

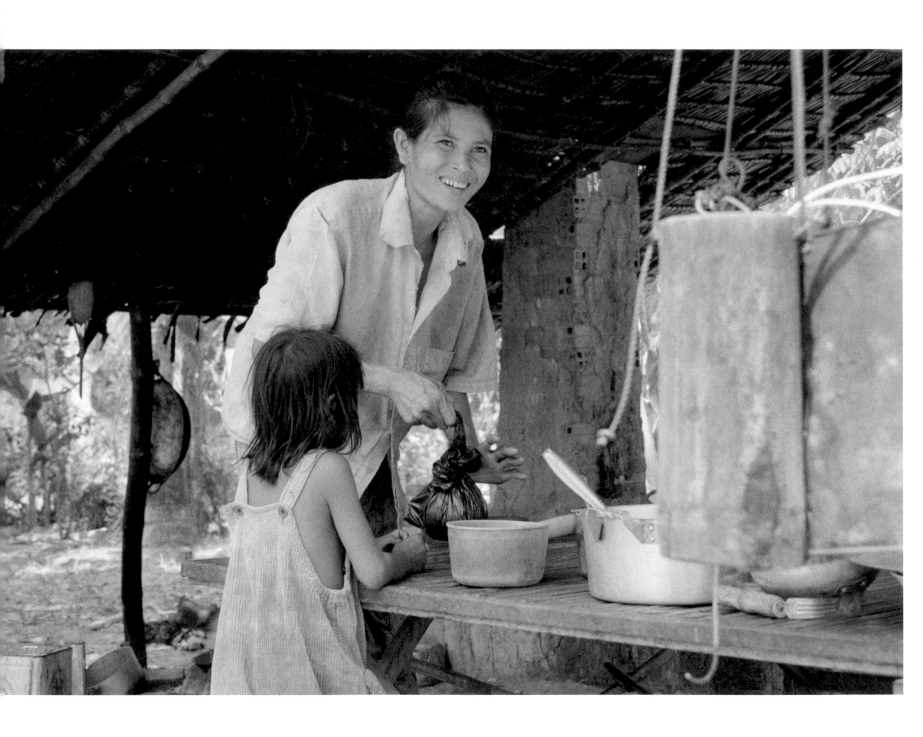

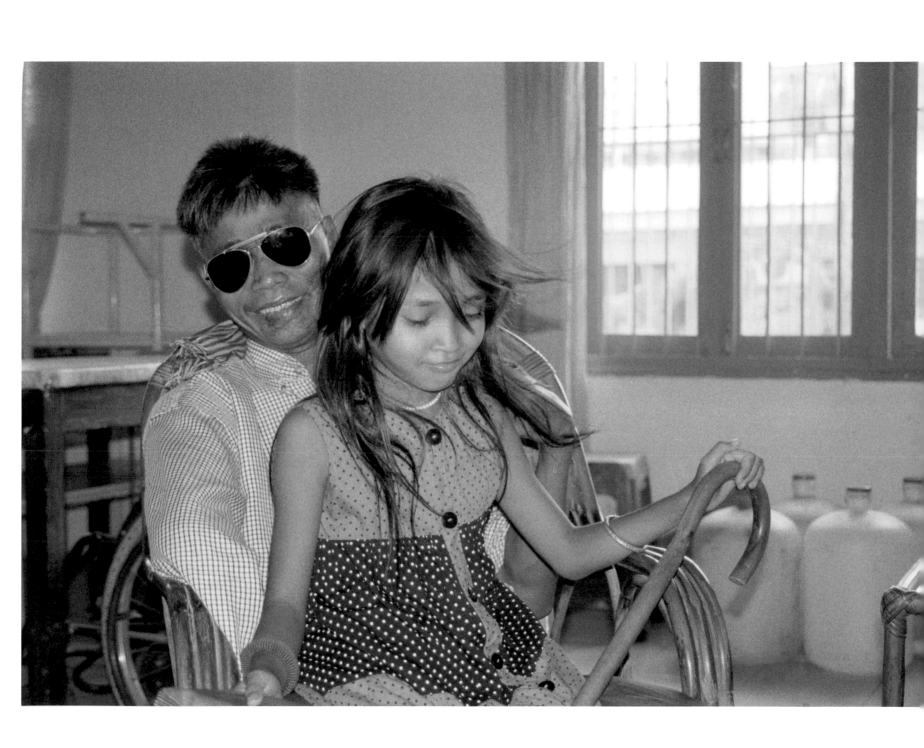

ALBANIA

Albania was governed for decades by a xenophobic, oppressive regime that imprisoned, executed, and exiled thousands of citizens. Anyone who was perceived to be disloyal to the utopian fantasy imagined by Enver Hoxha was in danger of imprisonment and death. As an enduring testament to Hoxha's paranoia, the landscape of Albania is still littered with hundreds of thousands of mushroom-shaped concrete bunkers. Ostensibly built to house one or two soldiers during an invasion, the bunkers serve as a visible reminder of the oppressive government that once held sway over every aspect of Albanian society.

After Hoxha's death, his dictatorship began to unravel; when I arrived in 1998, Albania was still struggling to become a modern democracy. In the poorest country in Europe, Albanians were living with a distressed economy, weak civic institutions, widespread corruption, dilapidated infrastructure, and powerful organized crime networks.

Early experiments with capitalism were poisoned by corruption, and in 1998, the country was still recovering from the collapse of pyramid schemes in which thousands of Albanians lost much of their life savings. At the same time, thousands of refugees poured into Albania from the north, fleeing ethnic cleansing in Kosovo.

In a situation of great poverty and great challenge, the population of orphans in Albania began to grow rapidly. Some of the children were orphans whose parents had died; others were children who had been abandoned. The first day I walked into the orphanage in Shkozet, I froze at the entrance.

The floor was covered with babies, yet the room was hushed. Many of the children had been ignored for so long that they rarely cried.

Outside in the street, older men gathered each day to play dominoes. These were men who remembered the King, endured Hoxha, and lived through the corruption of the early 1990s that plunged their country into riots as millions lost their money. These men did not hold any genuine hope for substantial political progress in the remainder of their lives. Many of the young people with whom I spoke had dreams of a prosperous, free, and modern Albania; for this older generation, it was enough to live in peace with dignity.

We can help to build peace, but it is not something that we can create alone. We might help to shape, but we can never master the political storms that will rage during our lifetimes. Our dignity, however, is something that we control as individuals.

Our dignity is our own. We can give it away if we choose, but no one can take it from us. In Albania, in 1998, I felt that the people had begun to emerge again—dignity intact—after waiting patiently for one of history's long storms to blow over.

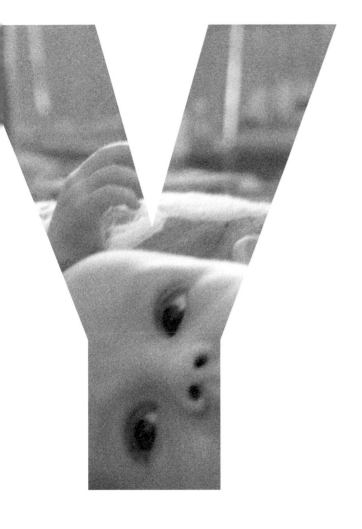

The orphans in Shkozet were born into a new and uncertain world. At the moment of their birth, they—like each of us—come into the world naked, but not unburdened. A great deal of all that they might know and experience and suffer and enjoy is set out for them from their first breath.

We rarely associate dignity with children, because dignity grows through a continuous process of trial. Tolstoy said that patience and time are the two most powerful warriors,[1] and we tend to associate dignity with age because our elders grow in dignity as they have wrestled with the trials of time. Men like Hoxha may assault dignity. Their regimes may mock dignity. But no matter how long their assault, they can never have our dignity unless we surrender it to them.[2] And just as others cannot take our dignity from us, others cannot grant our dignity to us. Dignity grows in time, from the seeds of dignity that are with us at birth.

No matter how difficult the trials of the present moment, every older generation has a charge to keep: to treat the young as worthy of dignity, to show the young that they deserve dignity, to live so that the young might see that every life has dignity.

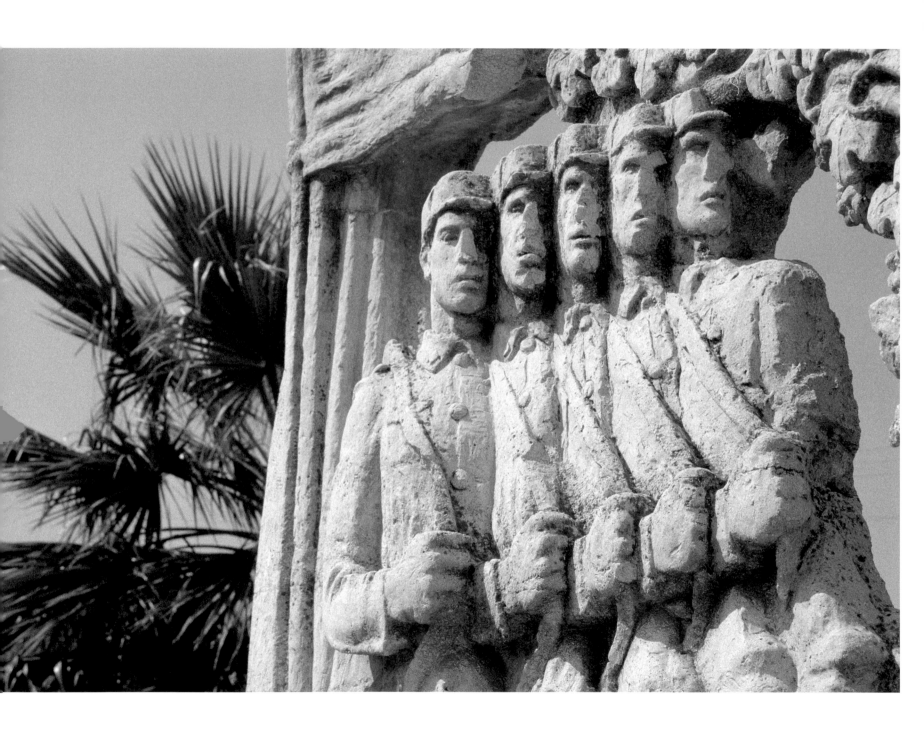

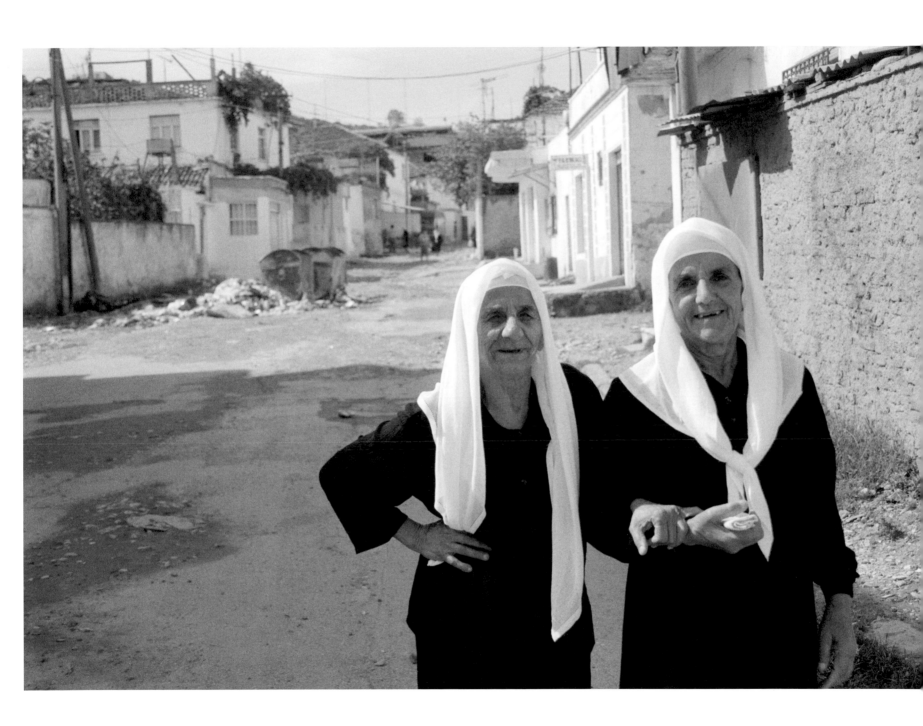

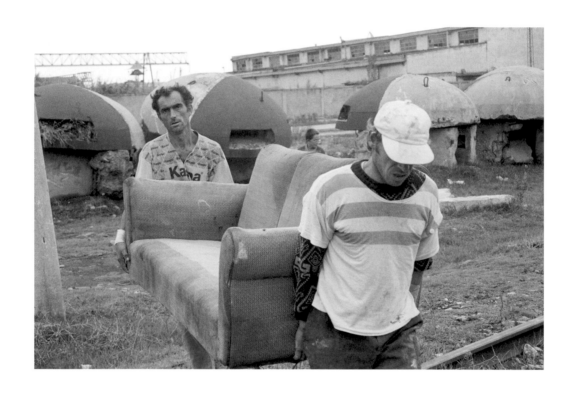

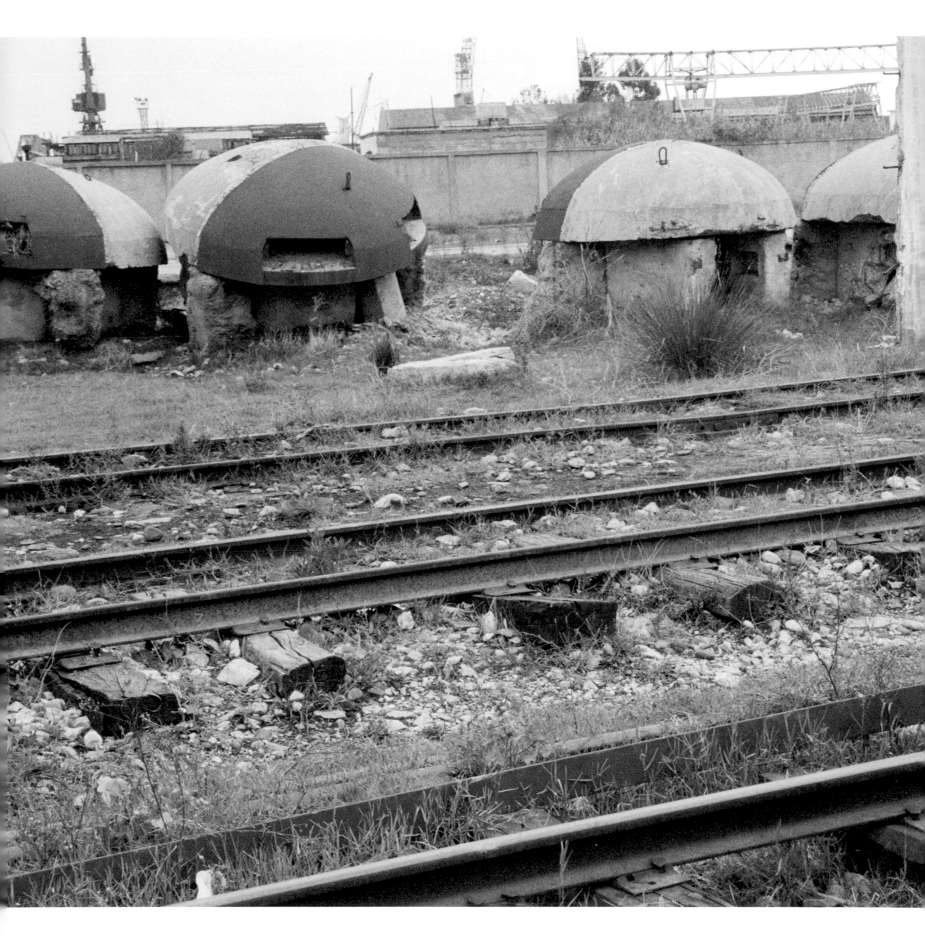

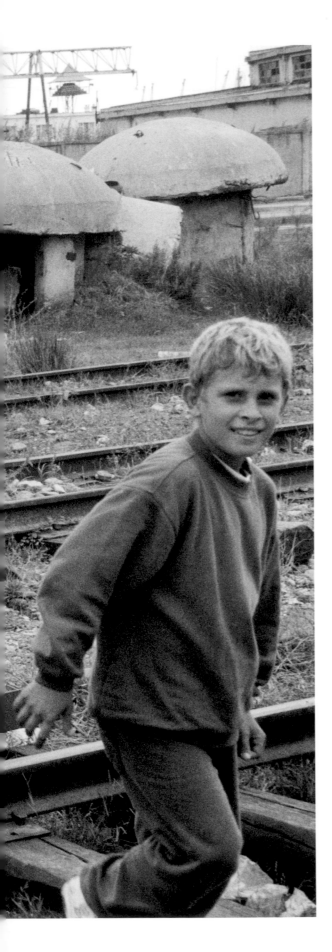

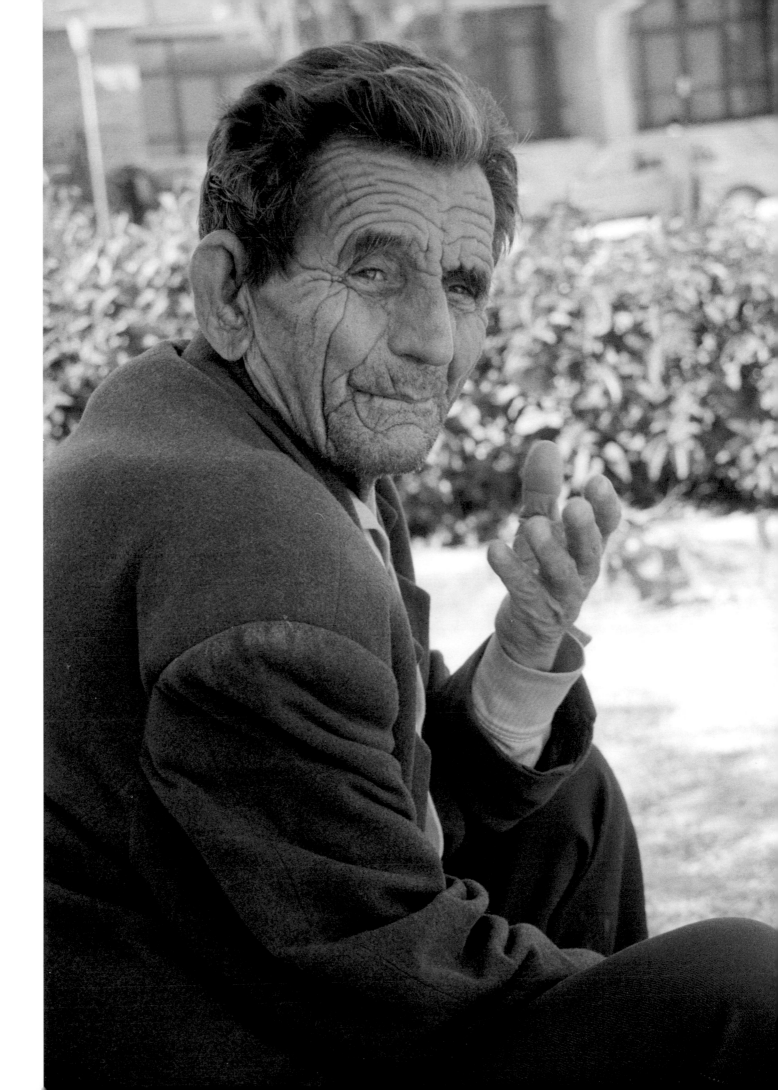

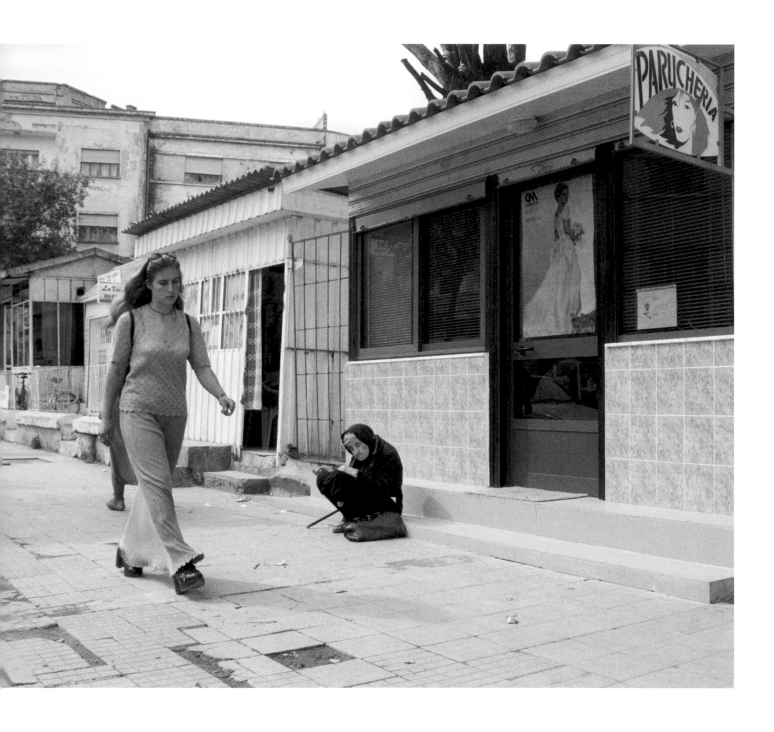

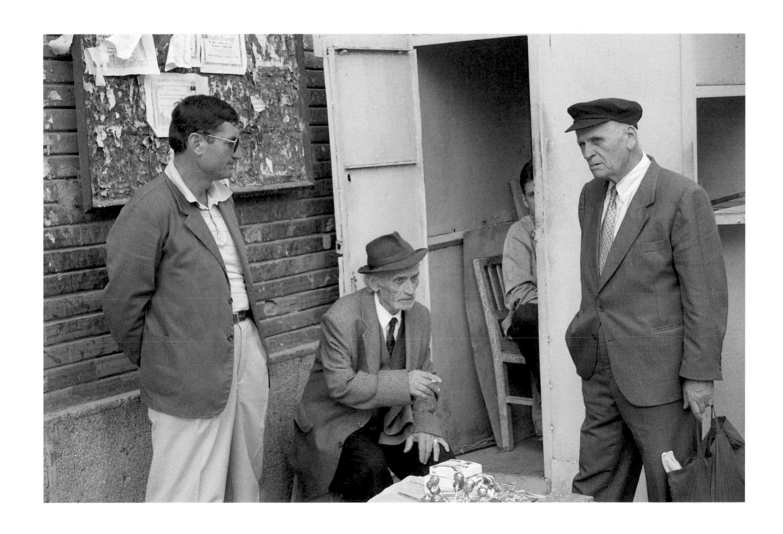

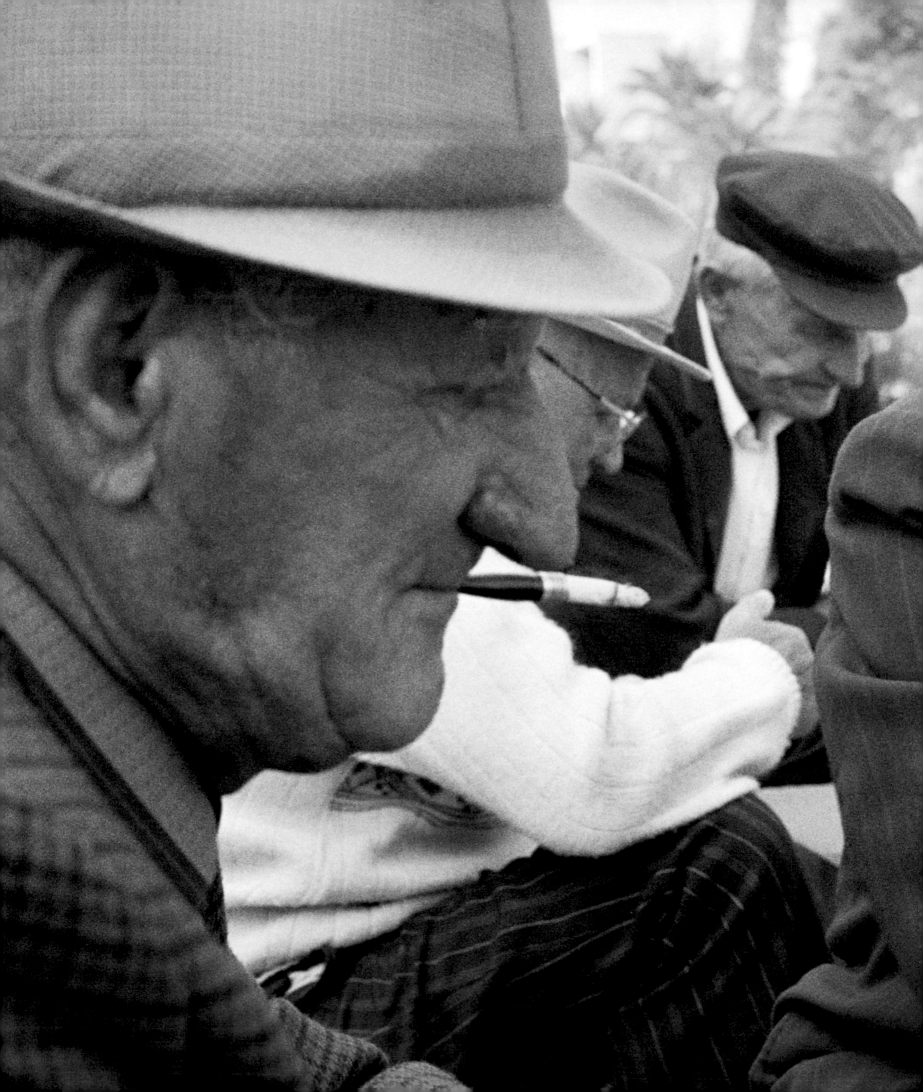

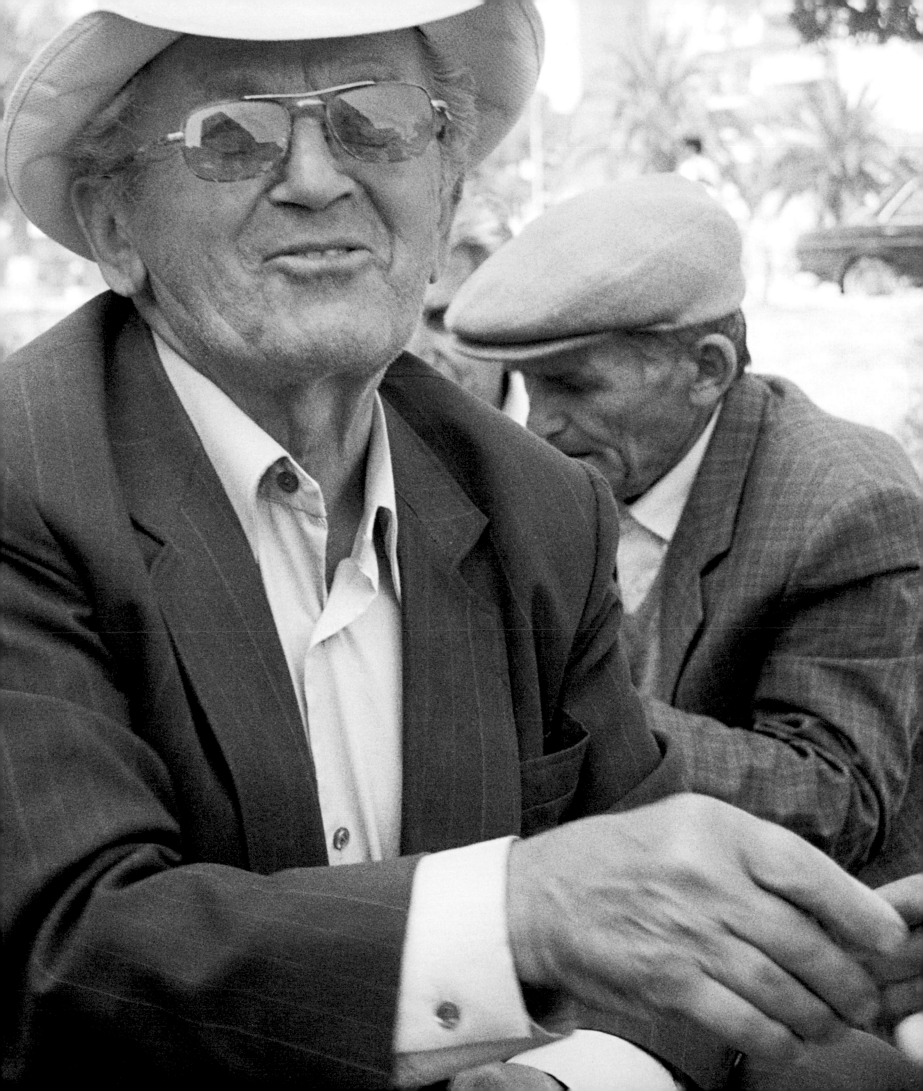

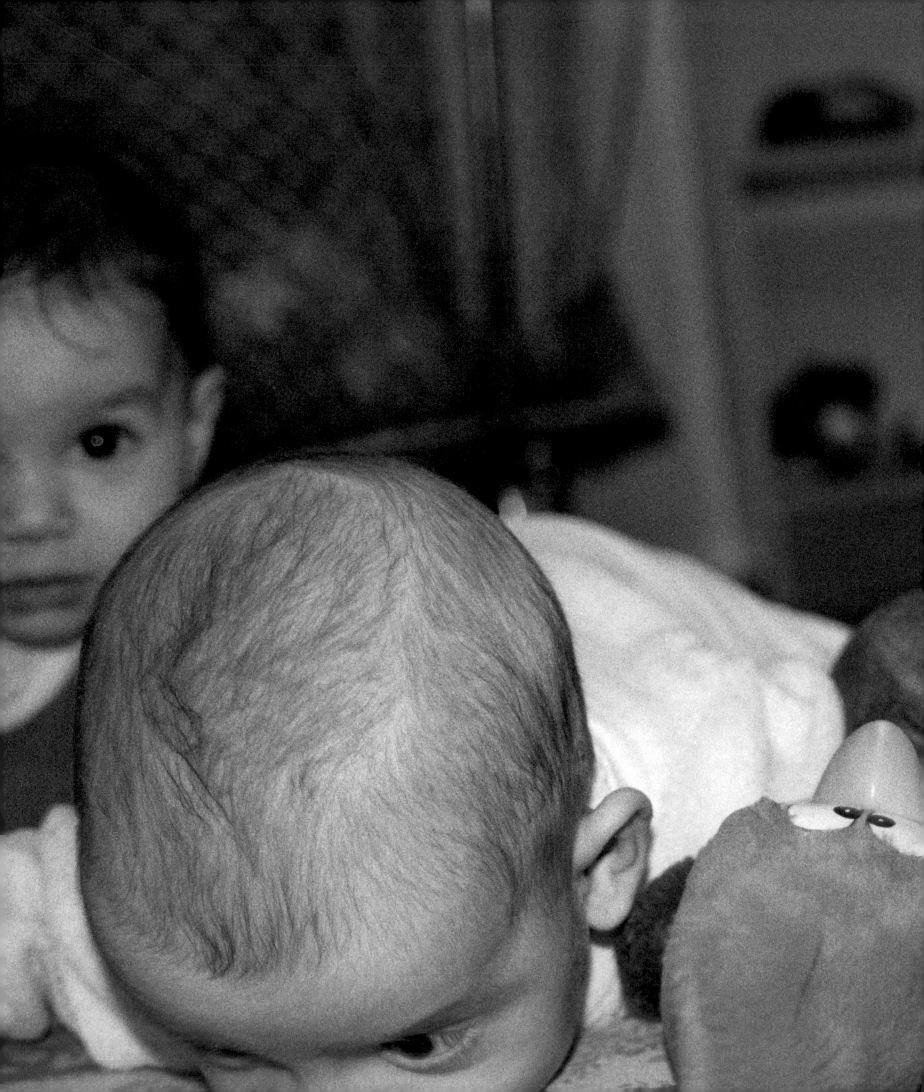

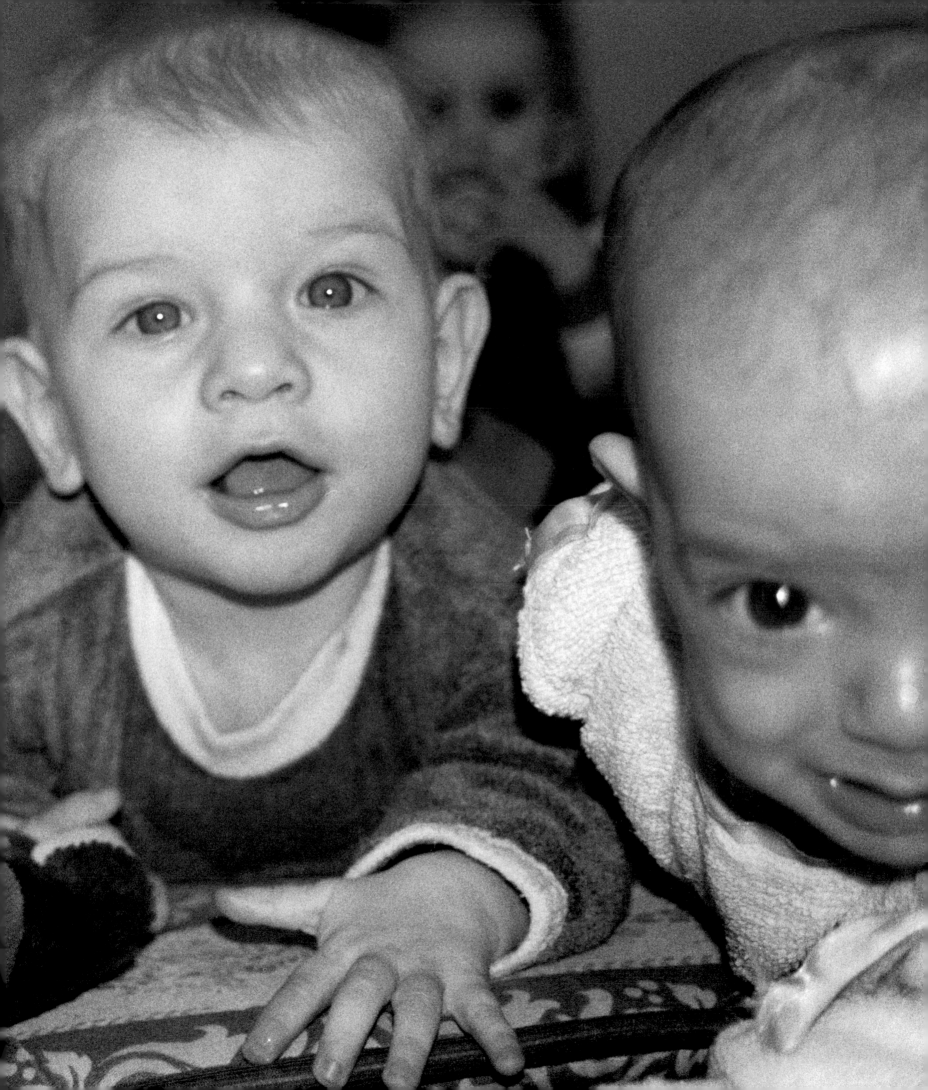

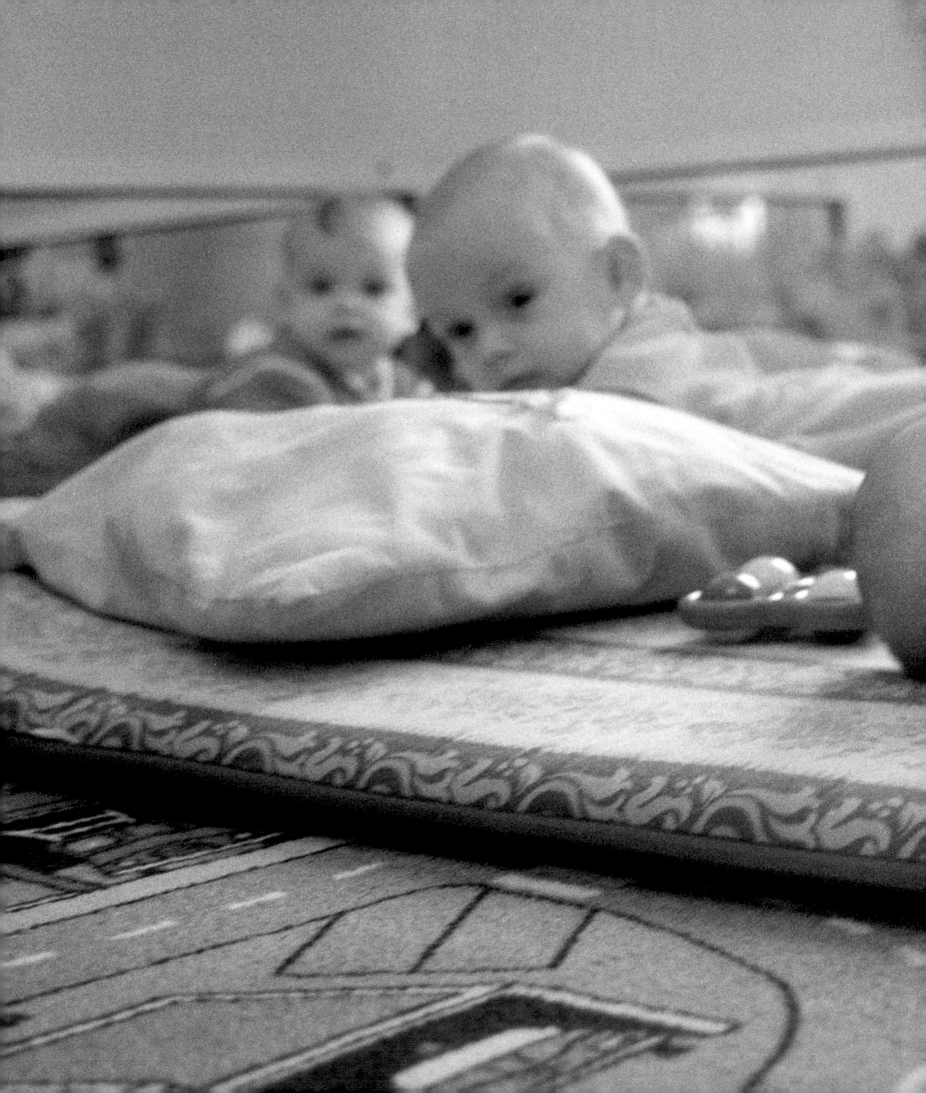

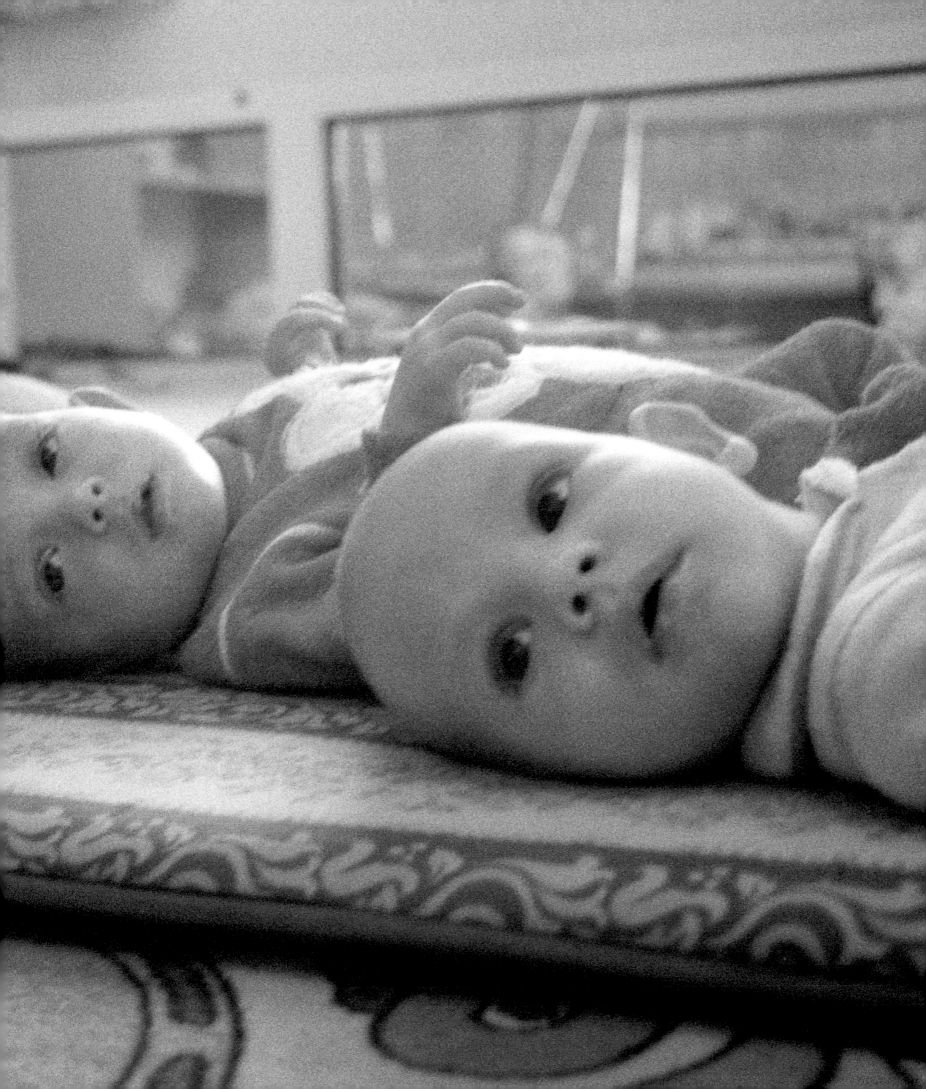

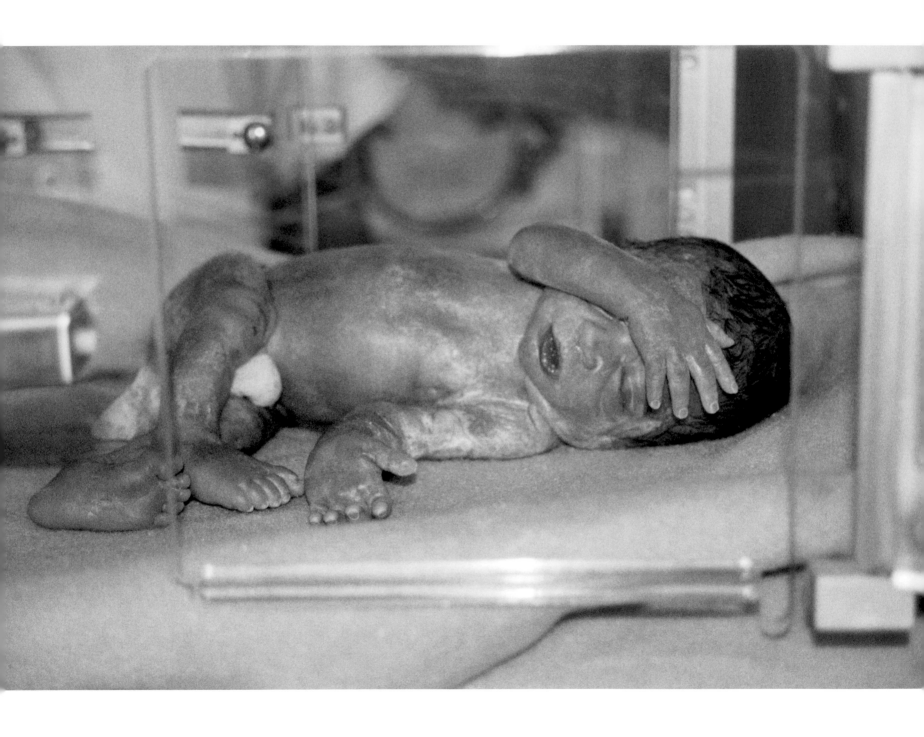

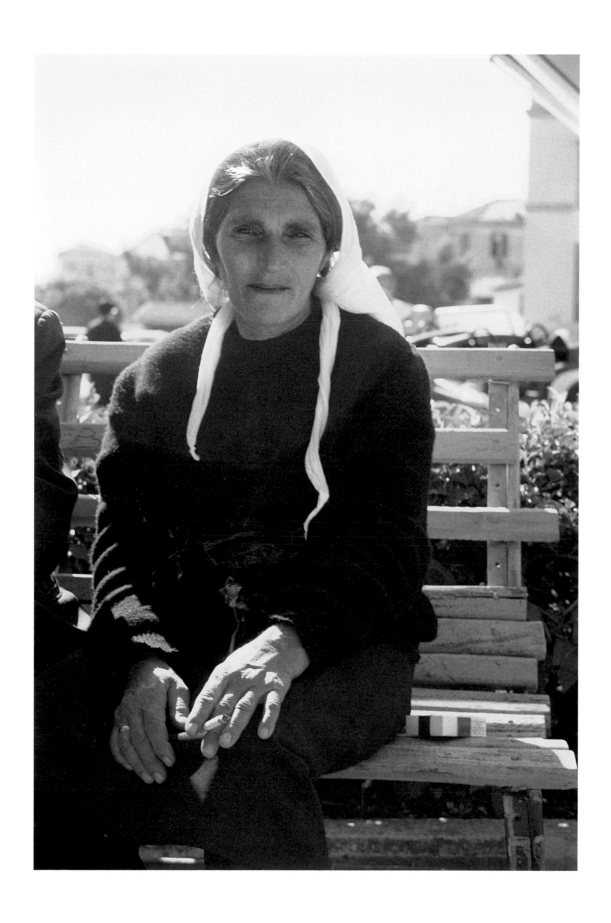

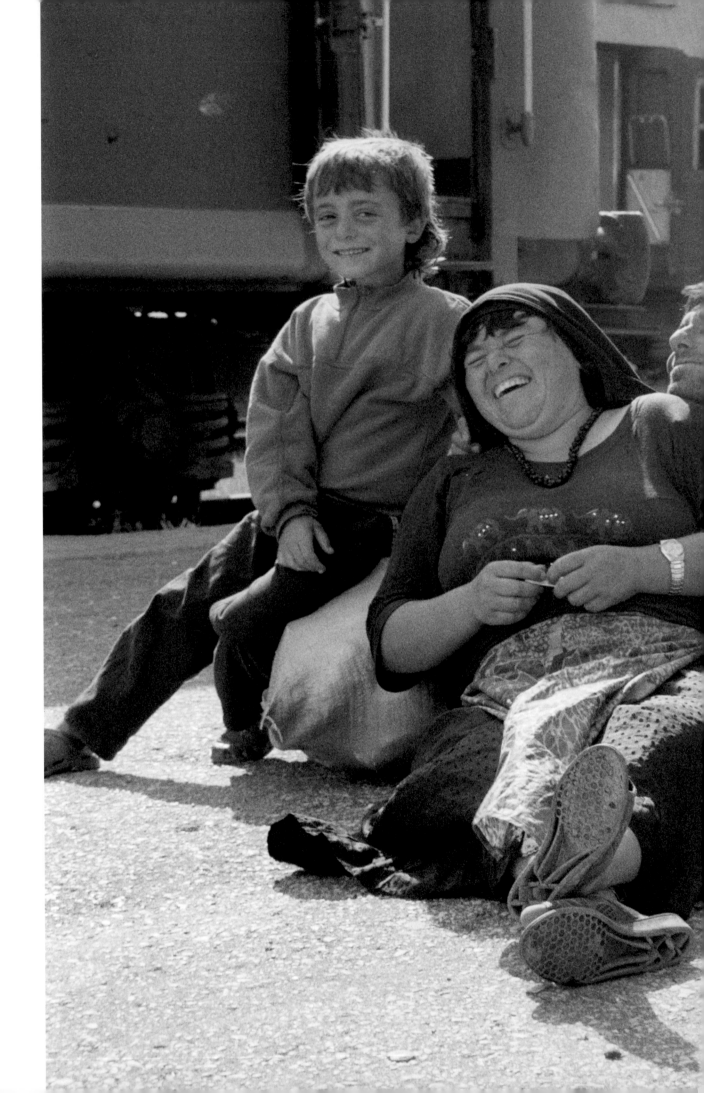

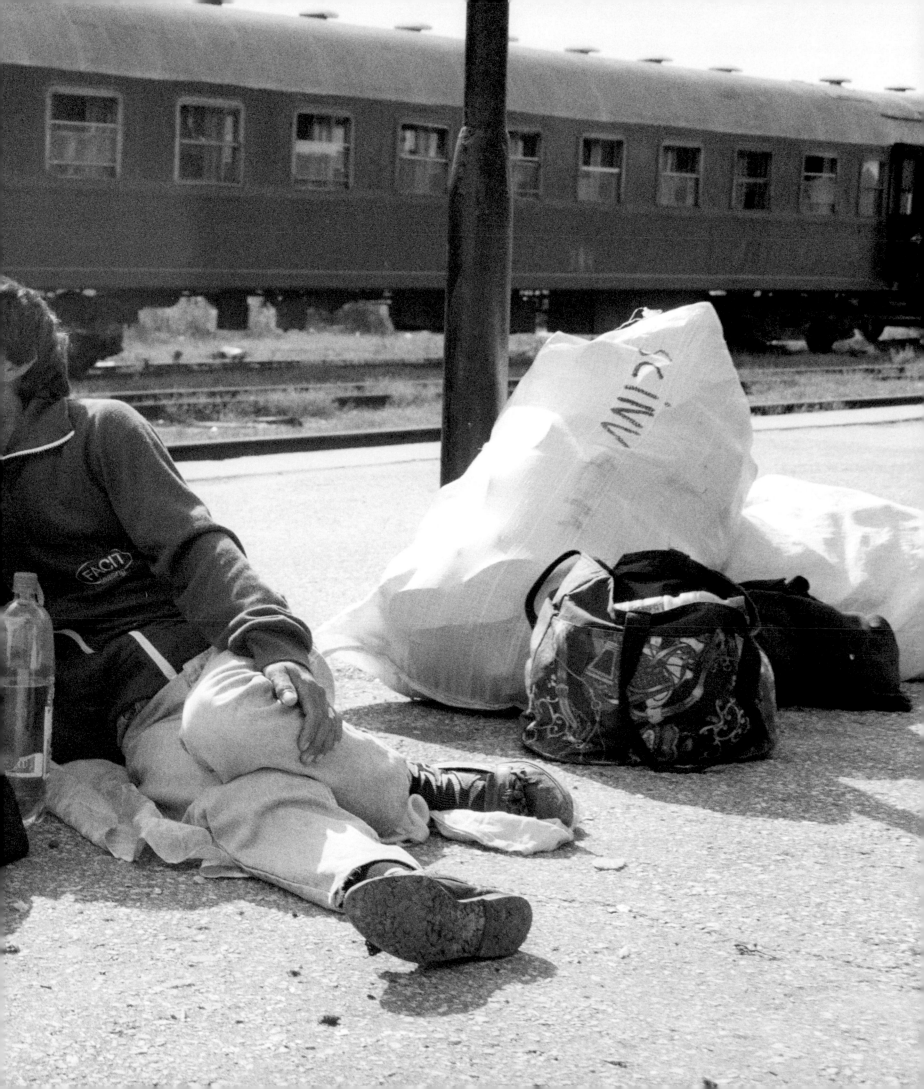

MEXICO

Chiapas is one of the poorest states in Mexico, and the indigenous population is among the poorest of the poor. The indigenous people of Chiapas earn less than a third of the income of other people in the state. And although Chiapas generates more hydro-electric energy than any other state in Mexico, a third of the homes of the indigenous population do not have running water or electricity. The literacy rate is the lowest in the country, and the state has high rates of malnutrition and infant mortality.

In 1997, I was a graduate student studying the politics and economics of the developing world. In the classroom we debated the benefits of free trade, the impact of international institutions on poverty, and the role of governments in shaping markets in the developing world. I found this study important. The issues seem abstract, but decisions on such matters impact people's paychecks and directly affect the ability of people to feed their families. But development—as was widely acknowledged in the classroom—has to do with far more than lifting people up from poverty. Real development does not simply increase wages—real development expands people's freedom to shape their lives and to pursue happiness. And for this freedom to be realized, we cannot simply measure income; we need justice, safety, health, dignity, education, and liberty. And history confirms, repeatedly, that these goods are not granted—they must be won.

The soldiers of the American Revolution, the patriots who won the struggle for women's suffrage, the Freedom Riders who awakened the conscience of a nation, the activists who brought down an apartheid regime in South Africa— all of these victories were made with courage.

In my life, I watched on television as Chinese students protested in Tiananmen Square, and later I traveled to China and came to know those students. I watched the Berlin Wall fall, and later came to study with people who had lived behind that wall. I believed that bravery was essential to freedom. I also believed that the role of courage in history can never be fully understood in the classroom alone.

I came to Chiapas intending to learn. Mexico was a neighbor about which I knew little, and I was studying at a time when Chiapas was still often in the news. In January 1994, the rebel group Ejército Zapatista de Liberación Nacional (EZLN) had briefly taken control of several towns in the State of Chiapas in protest of the North American Free Trade Agreement and in protest of the treatment of the indigenous population in Chiapas.

COU

The military campaign was short-lived; the Mexican army quickly defeated the rebels. While their military impact had been slight, the EZLN was effective in drawing international attention to the situation in Chiapas. The awareness that they generated inspired other social movements throughout Mexico. In Chiapas, many of the issues of the moment were alive: indigenous rights in a post-Cold War world, the effect of international agreements on domestic economies, and the impact of a global information infrastructure on local struggles.

Within only a few days on the ground, I saw the situation as far more complex than had been portrayed in the media and far more complex than I can do justice to here. A wide and diverse group of peoples all had a variety of claims and interests and issues, each of which affected the events that eventually made the news.

In Chiapas, I discovered the depths of my own ignorance about many issues despite months of study. What I did learn clearly, however, was that courage is a virtue with many hues. Bravery is a bright hue, and as a student of positive change, I was naturally attracted to the bravery of Tiananmen and the Berlin Wall; I was attracted to the bright, shining possibility that, in a particular moment in time, bravery could shape the course of history and improve the lot of others. In Chiapas, I came to see more.

Courage has a hue even deeper than bravery, however, and that is perseverance. It is perseverance that builds. Great things are won and lasting things are built not in a flash of action but in a long, slow, quiet series of everyday acts performed over a lifetime of steady effort.

If we compare the simple act of raising a spoonful of food to the mouth of a hungry child with the final result of having raised a healthy adult, we are overwhelmed by their sense of disproportion. If we compare a single swing of a hammer or a single stroke of chalk on a chalkboard with the final result of having built a school where dreams are realized, we are overwhelmed by the magnitude of what has been accomplished.[3]

It is, in fact, the courage to do the thing that we must do, day after day, that enables us to meet the greatest challenges. Lives flourish and justice is done by the steady force of human beings who proceed with a quiet, persistent courage.

In our most remembered moments of bravery, the struggle is all. Fueled by passion, people do make great and worthy and necessary sacrifices for others. In moments of crisis, we must count on bravery. In perseverance, we press forward not to achieve a single objective, but to build a worthy life and a healthy community.

In Chiapas, the festivals are simple and beautiful. These celebrations affirm the beauty of living and the health of the community. In Chiapas, I came to see how celebration is central to perseverance. In Camus' *The Plague*, Tarrou says, "Of course, a man should fight for the victims, but if he ceases caring for anything outside that, what's the use of his fighting?"[4] It is not enough to fight for a better world; one must also live a life that is worth fighting for.

We do not rest simply so that we can work harder. We rest because we are fortunate to be living, and life is to be enjoyed. While bravery can often flourish when we have to fight against something, the long, steady campaigns of perseverance are best sustained when we are working toward something. We celebrate so that we might know why we struggle.

Chiapas was a natural place to come to learn for a student of history, interested in change with justice and attracted to bravery. I learned less about international economics and indigenous rights than I had planned and far more about courage than I had intended.

I left with a richer view of courage. Bravery is essential. In certain times and at critical moments, the fate of entire peoples is settled by the bravery of a few. But those moments are developed over time, and justice is not won in a flash. It is perseverance that builds, perseverance that creates. Bravery rides into history on the steady horse of perseverance.

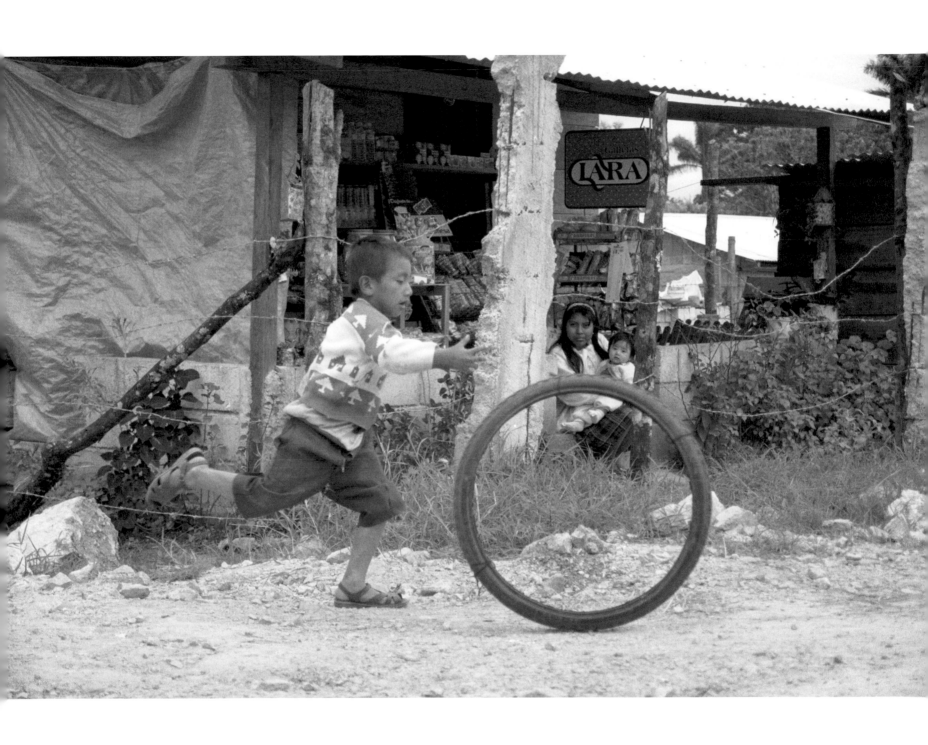

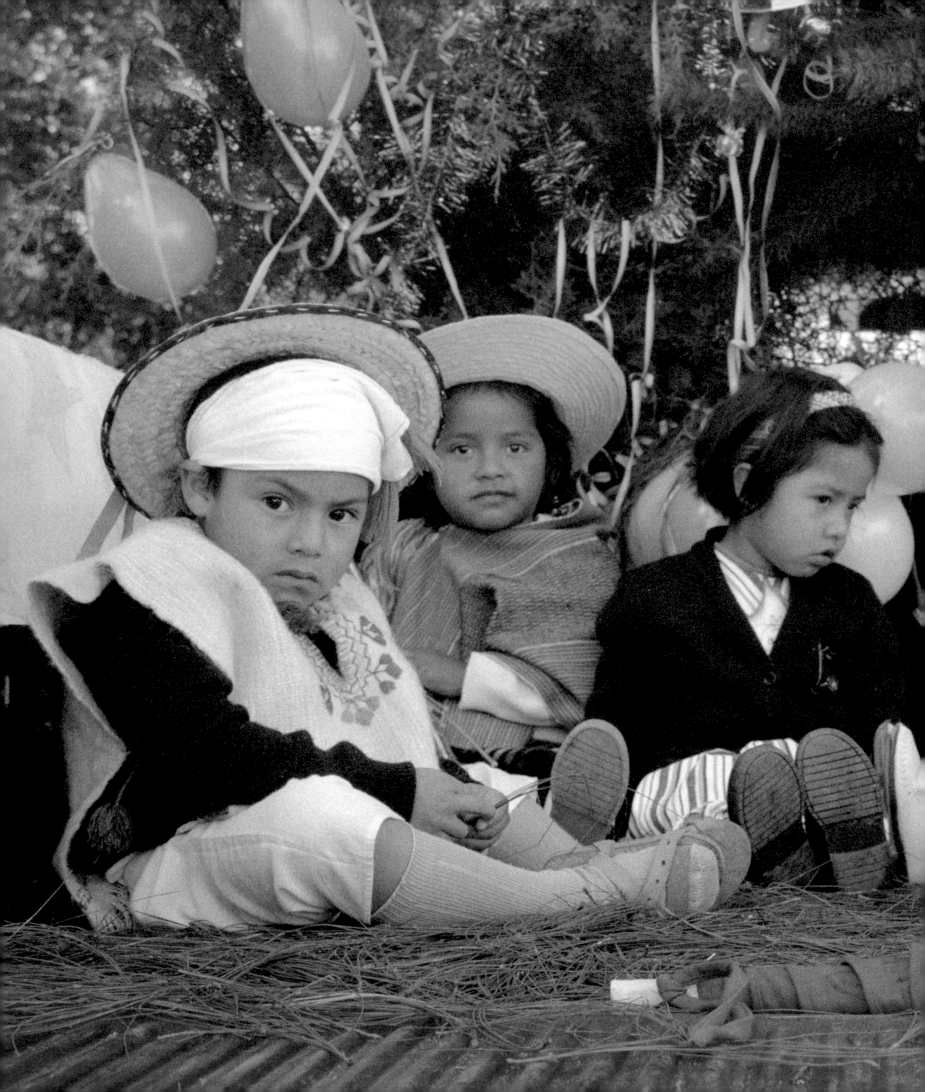

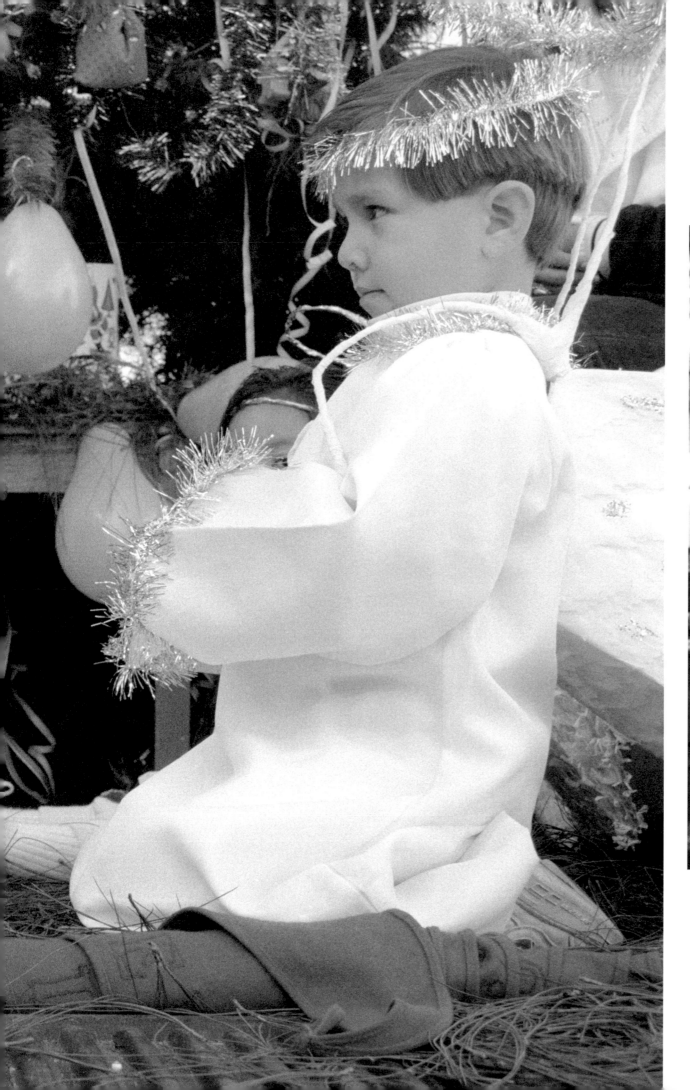

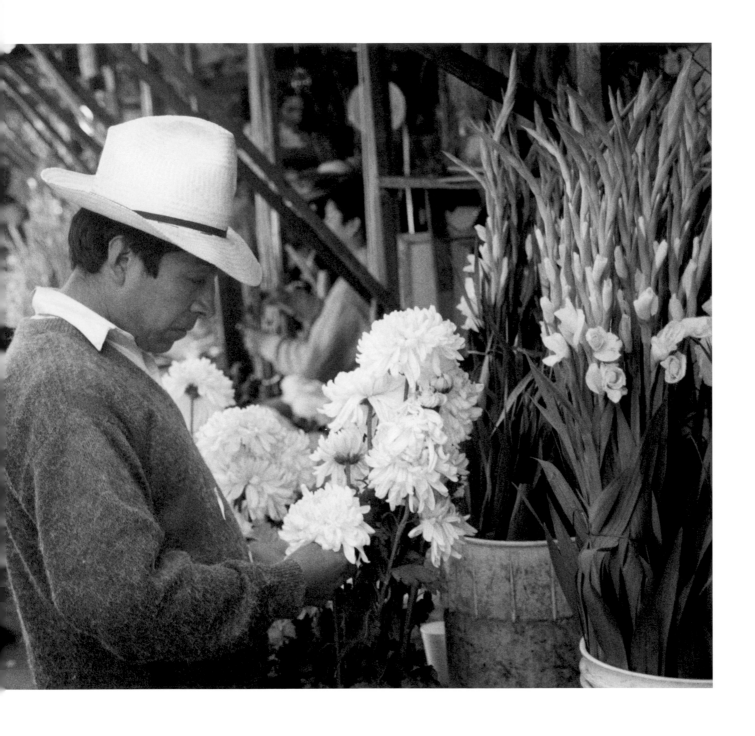

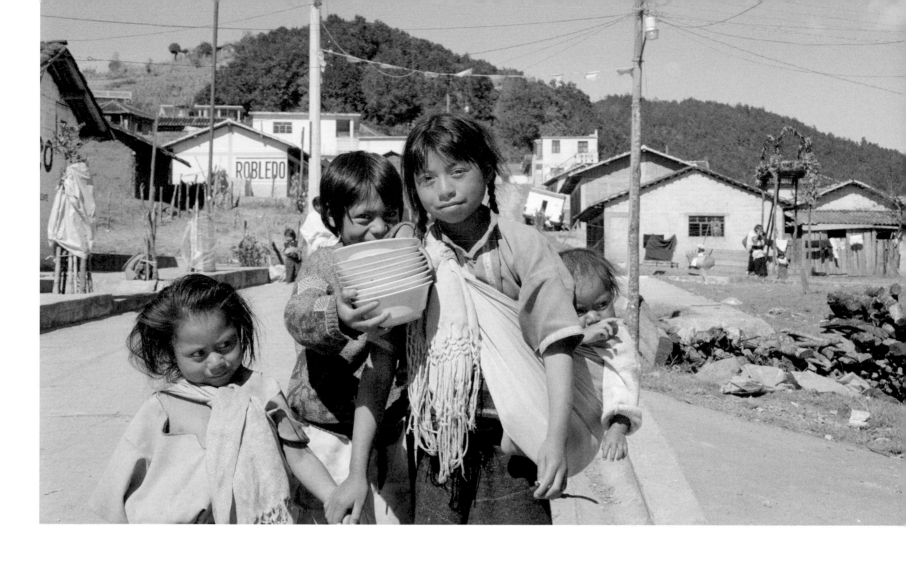

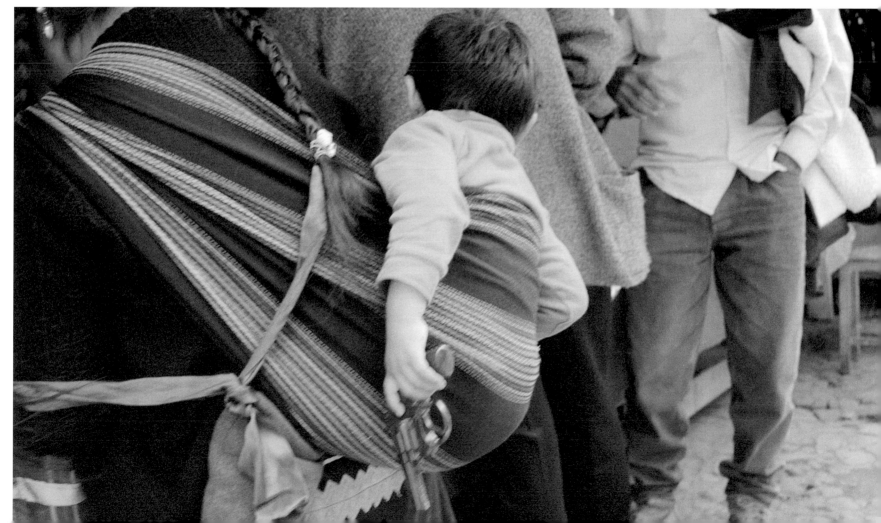

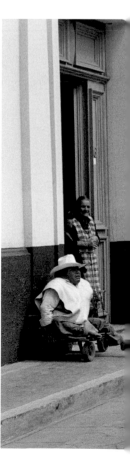

Mexico 91

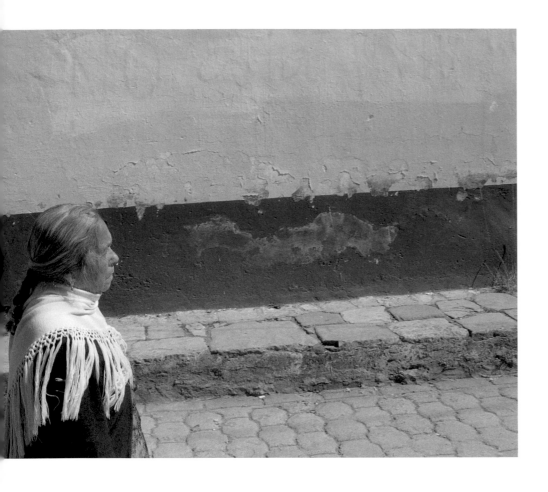

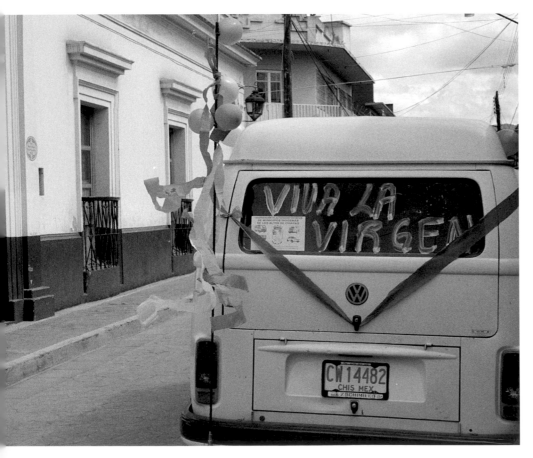

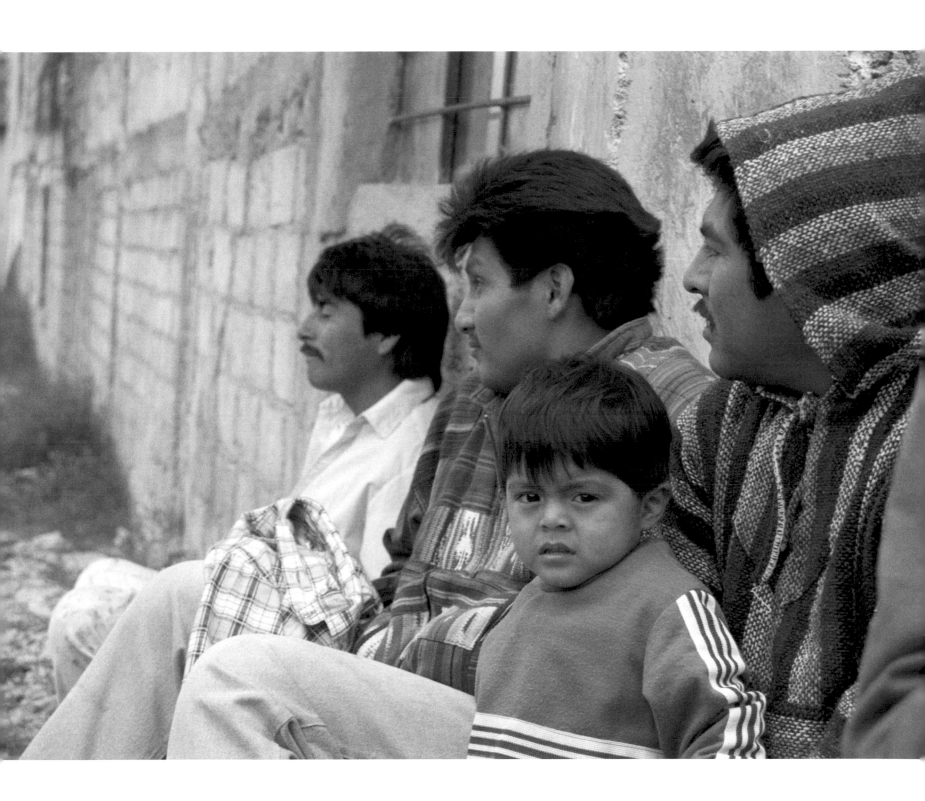

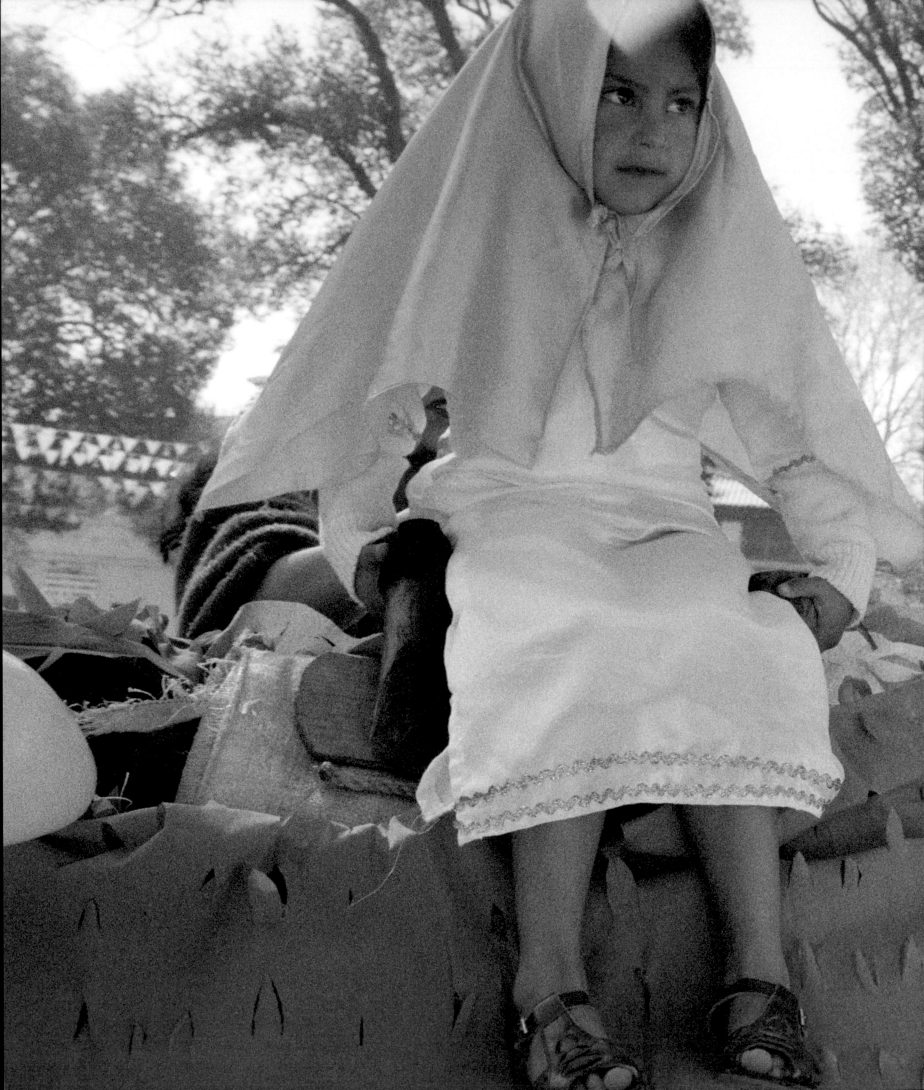

INDIA

The river Ganges is considered a holy river by Hindus, and it flows through the heart of the city of Varanasi.

Hindus believe that if they die in Varanasi, they will be released from the eternal cycle of birth and rebirth.

In a humble building not far from the water's edge, Mother Teresa's Missionaries of Charity run a home for the destitute and dying. There, the poorest of the poor can die with dignity. Many of the patients are seriously physically ill; some are severely mentally ill.

A few boys lived in the home.

One boy—mentally and physically disabled—had been abandoned and for years had begged on the street before being brought to the home. He smiled often, but the only word he could say was namaste.

Each time he said it, he would offer the traditional Hindu greeting and bring his hands together in front of his chest and lower his head. The *namaste* greeting has a spiritual origin that is usually understood to mean, "I salute the divinity within you."

The Missionaries of Charity are Catholic, but they serve everyone, and they welcome everyone to serve. Jews, Muslims, Protestants, Buddhists, Hindus, agnostics, atheists, Zoroastrians, and others work with them around the world. The missionaries live the lesson, "Because you did it to the least of these my brothers, you did it to me," and believe that when they take someone off the street to die with dignity, welcome an orphan, care for the mentally ill, tend to a leper or the abandoned, they are serving God directly. To be a "volunteer" in the home is simply to join—however briefly—a community of people living and working together. The sisters see that the volunteers who come to them are sometimes afflicted with Western diseases—such as loneliness or materialism—that are every bit as apparent and destructive as tuberculosis.

Whatever inner doubts they may harbor, the sisters express their faith by living a life of absolute poverty and extraordinary hardship, all while doing the world's most needed and difficult work. What I found incredible, and what was truly inspiring, is that they do all of this work with great happiness. The sisters skip and run through the home. They share jokes with the patients, and they laugh out loud. They do work that most of us would consider heavy and onerous—like feeding a dying person—and they do it with a sense of great joy and light.

Being with the sisters and being with the dying and the mentally ill put faith in a new perspective. So often, when questions of faith emerge in the public square we all share, these questions are talked about and soon shouted about; faith becomes a source of argument and conflict.

Yet, just as the Ganges flows through Varanasi, a powerful river of real experience, real action, and real human connection runs through the home, washing away all potential for conflict.

When Catholics and Jews, Hindus and Muslims tend to the ill and the dying, what are the differences that matter? Then, what differences can make people shout or fight or kill over faith?

Mother Teresa treasured silence. Why silence? Mother Teresa said that God is the friend of silence, that silence is required to touch souls. Silence is the home of prayer.

Silence is also the home of example. If you are whole, you do not need to proclaim your wholeness. When you are a person of deep belief and love, your faith shows in the way that you live.

Living a life dedicated to mysteries that they acknowledge to be beyond full human comprehension, the Missionaries of Charity have mastered the ability to accept people without having to understand them fully. This ability to accept is a key to faith, but it is also the key to love.

If we want to change something, we must begin with understanding, but if we want to love something, we must begin with acceptance.

Because the sisters live this acceptance, they are able to embrace people—complete with all sorts of weaknesses, failures, foibles, and strengths and faiths—and work with them wholeheartedly.

The sisters live their entire lives in faith, but to me, it seemed that they needed to whisper barely a word about their theology because the integrity of their work says everything.

I came to understand after some time in a place of such care and love, that when we see self-righteousness it is in fact an expression of self-doubt and self-hatred. In a place where people are able to accept themselves, love themselves, and know that they are loved, no one needs to criticize, or compare, or cajole, or convince; in fact, no one needed to do anything, other than simply be true: to love one's neighbor.

The sisters and the patients at the home did not have to proclaim anything. They did not have to impress or admonish or pressure. They simply were. They were poor. The patients were physically ill, and many were mentally ill. Still they were—all of the sisters and all of the patients—people living a life together that was rich with dignity and healthy with meaning, and they possessed the immense power that comes from living with integrity.

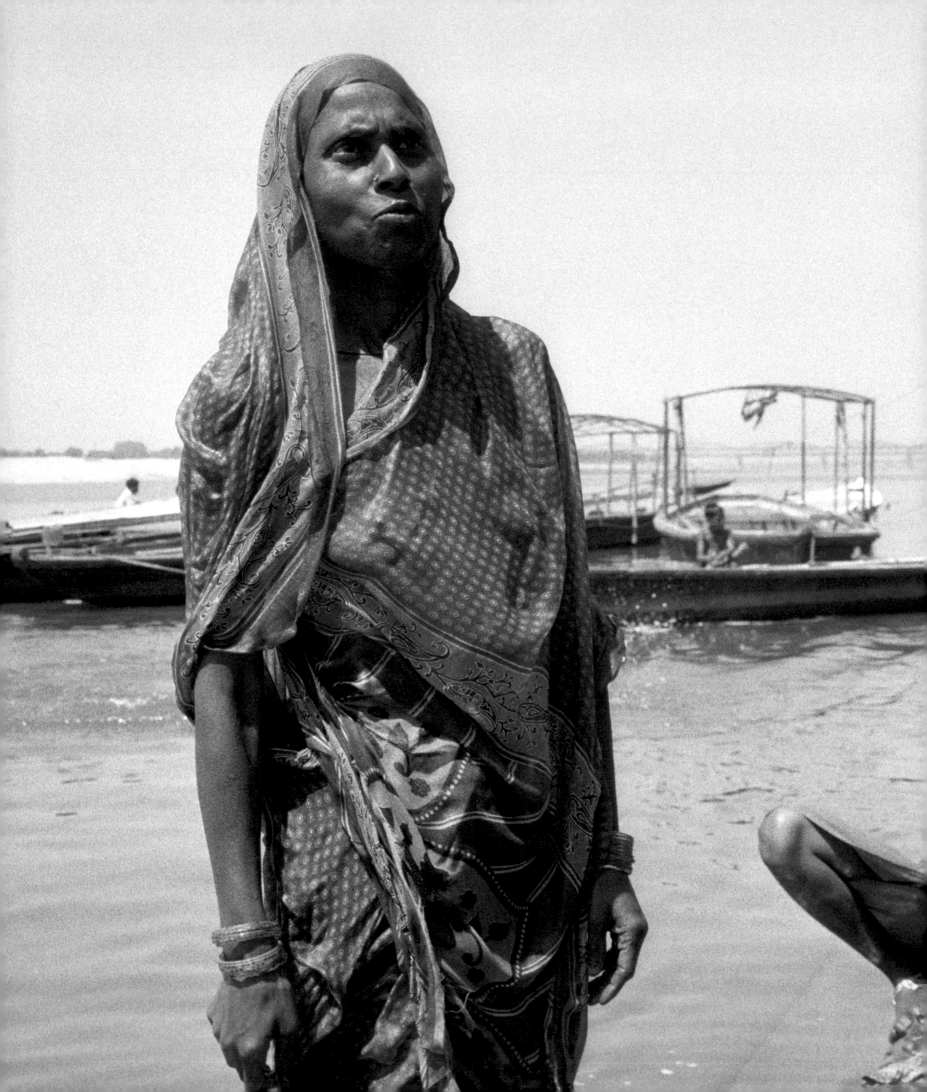

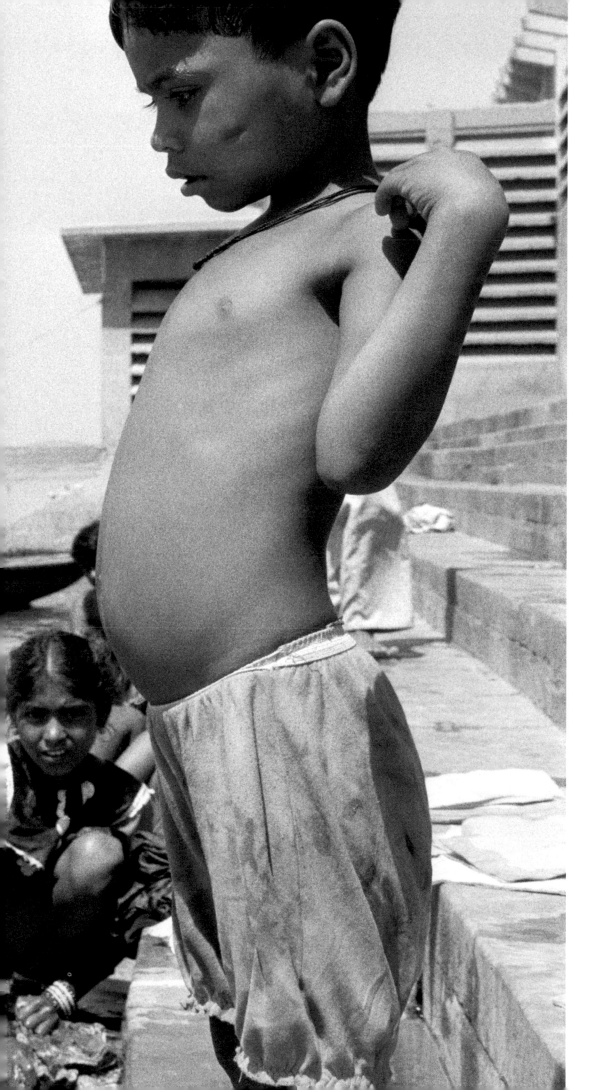
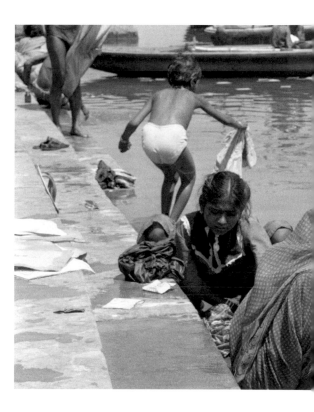

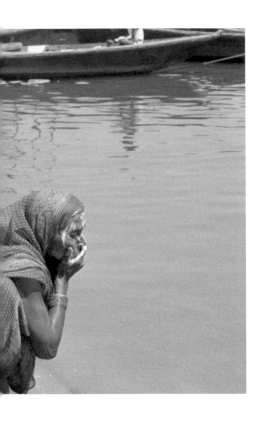

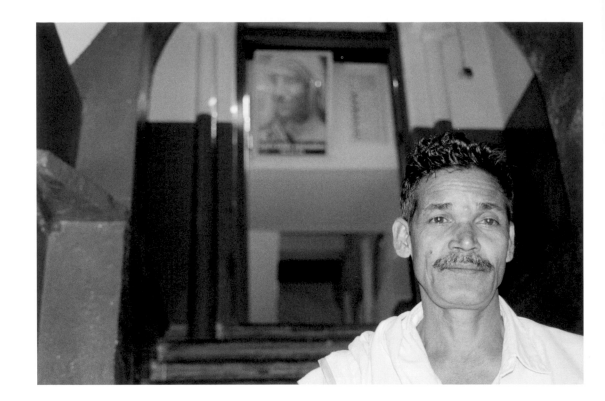

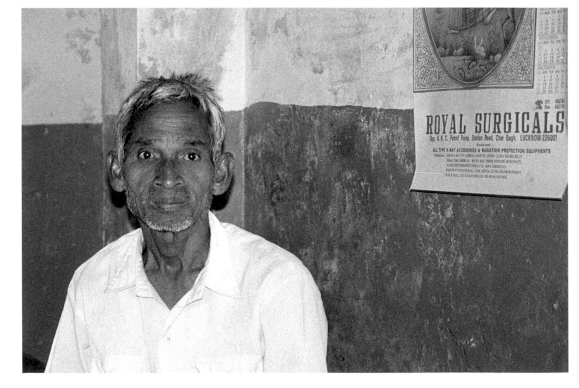

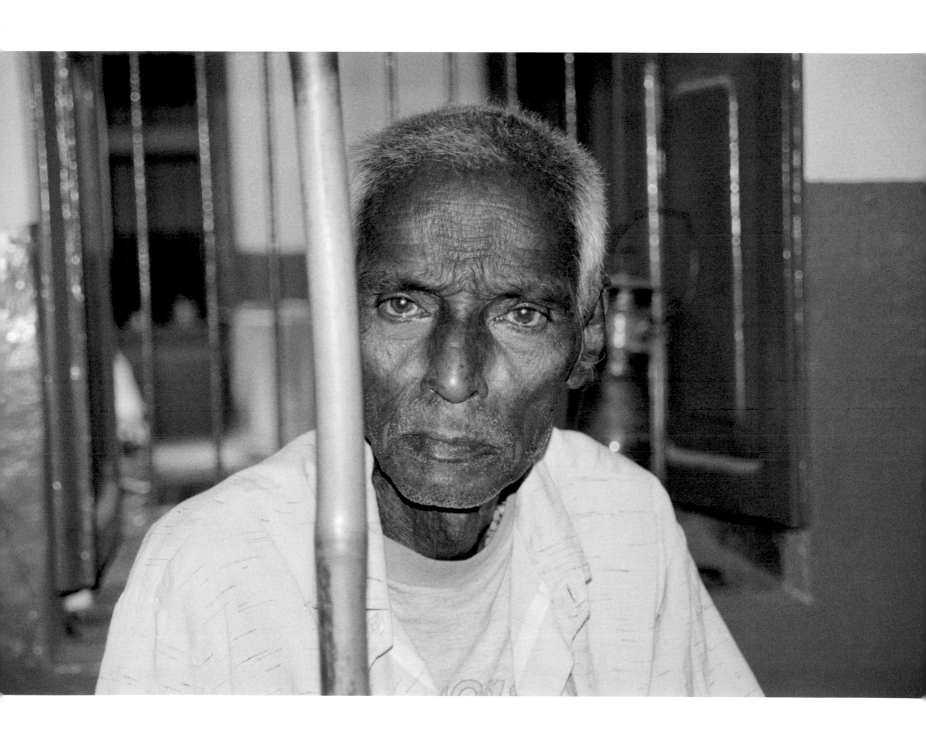

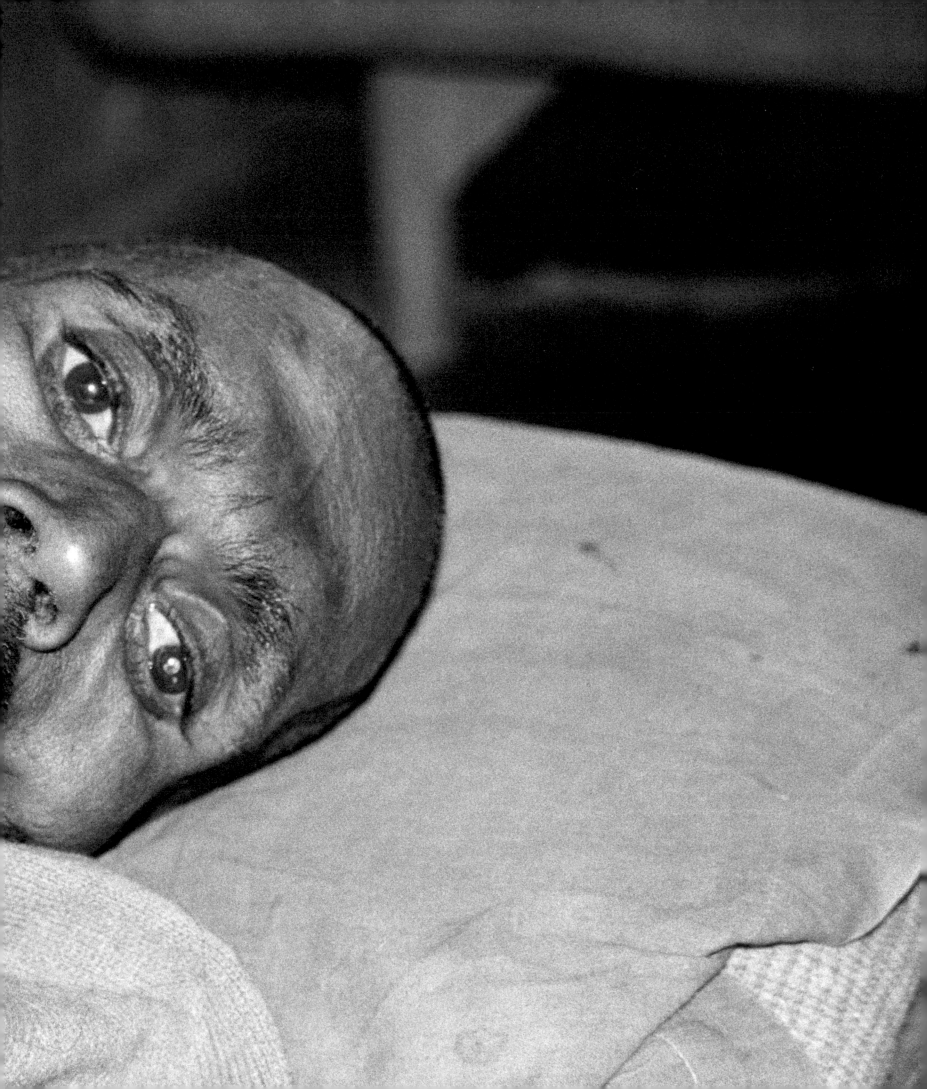

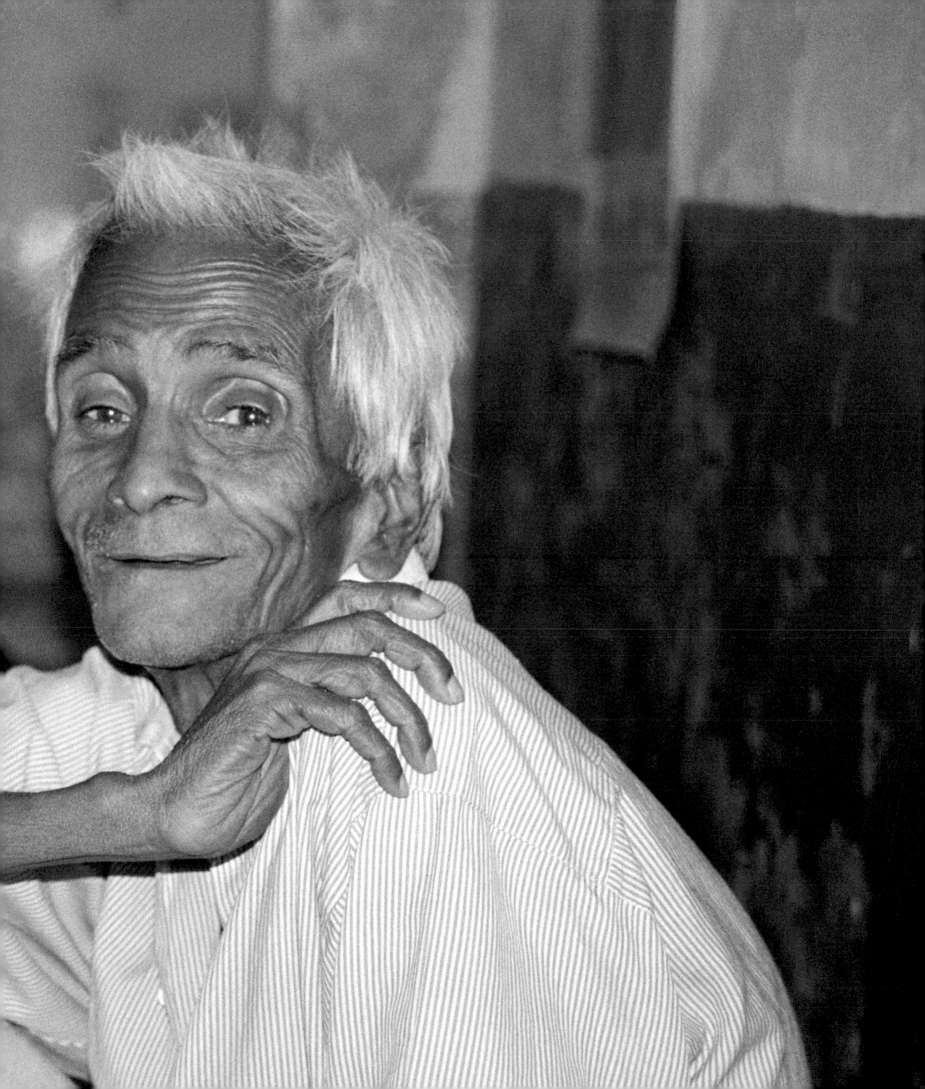

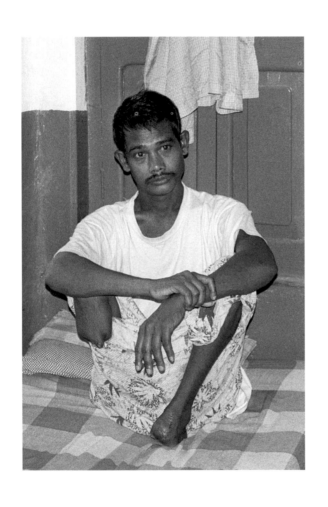 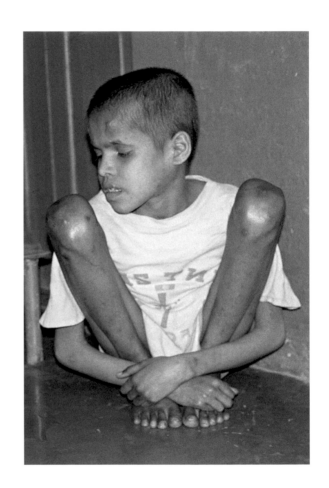

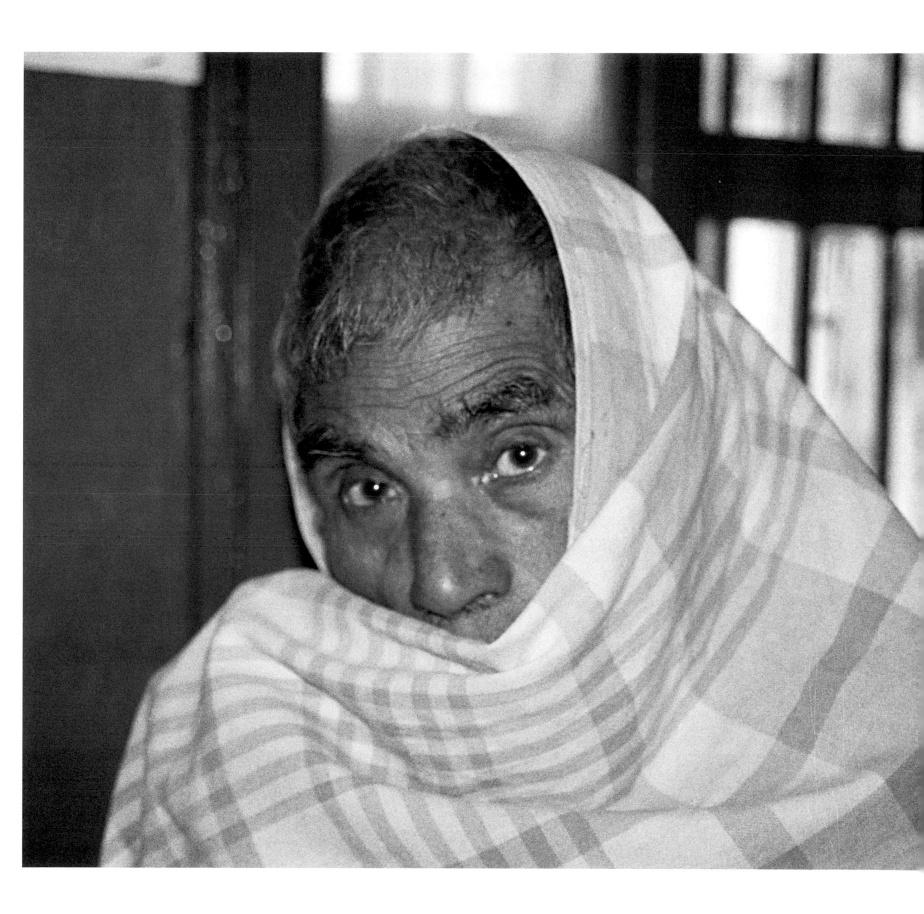

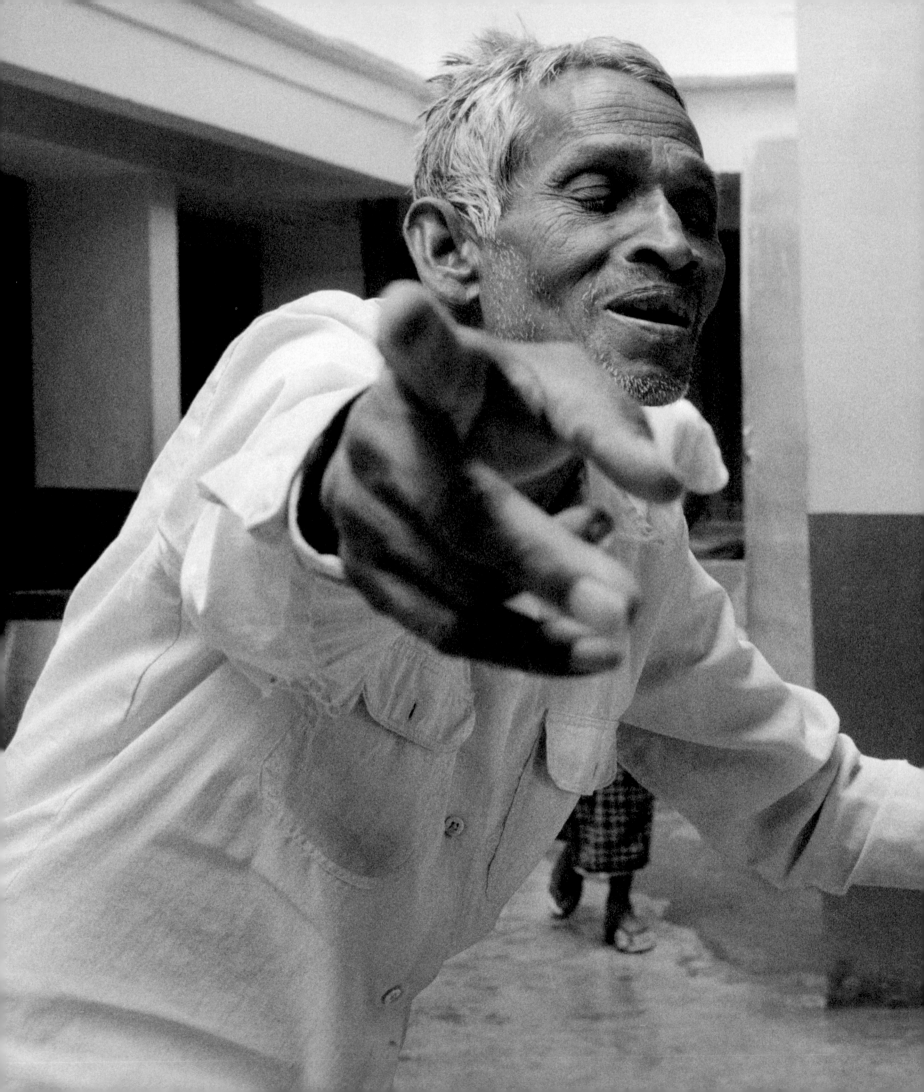

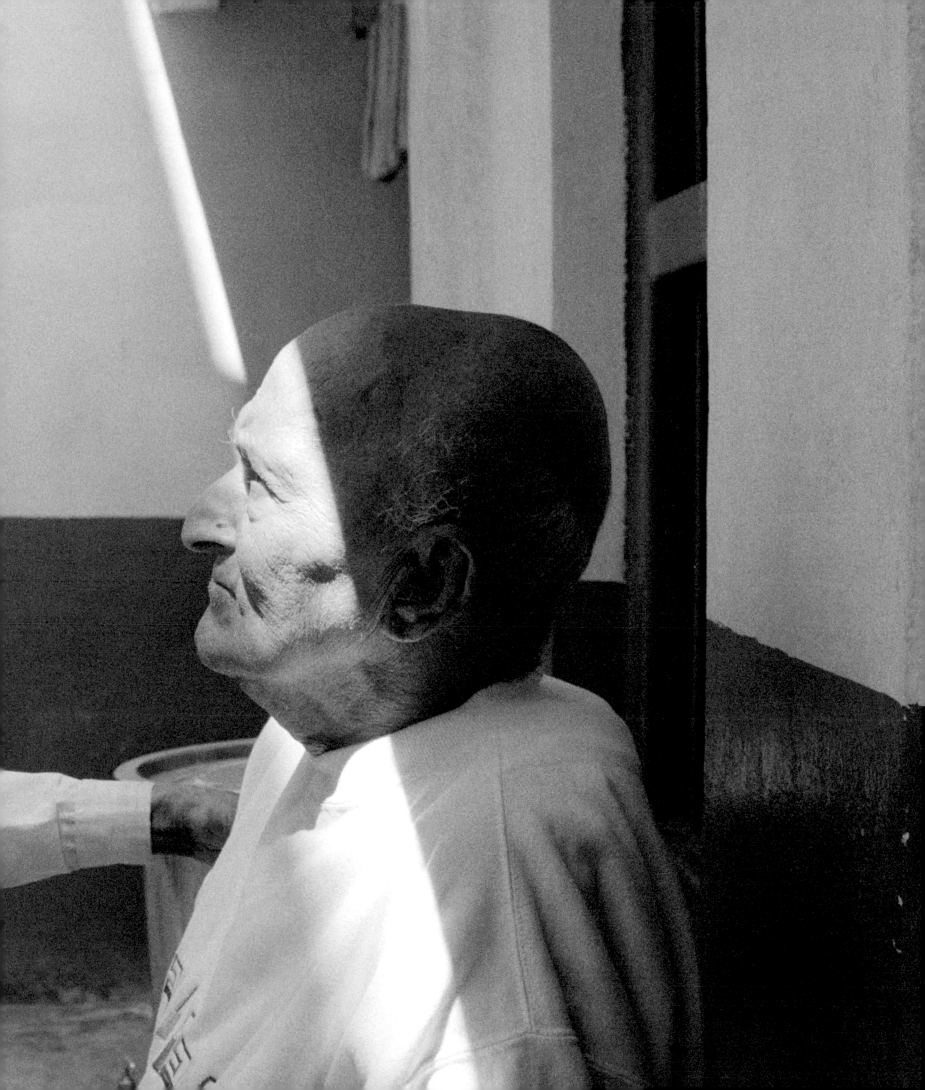

GAZA

Certainly, I was a tourist, but a tourist much concerned with questions about humanity.[5]

—Henri Dunant, founder of the Red Cross, describing his early experience in a war zone

Henri Dunant was an unsuccessful businessman on an errand of personal profit when he woke one morning to find himself near a battlefield littered with the dead and choking with the wounded. Troops of both the Franco-Sardinian and Austrian armies were lying desperate in the fields of Solferino. Dunant later wrote,

> The poor wounded men…were ghostly pale and exhausted. Some, who had been the most badly hurt, had a stupefied look… [others] had gaping wounds already beginning to show infection, [and] were almost crazed with suffering.[6]

Dunant stopped for two days and did what he could to help. Given the enormity of the suffering, his efforts were tragically inadequate. He had no knowledge, few supplies, and little support. He gathered together a group of local women and organized them to take food and water to the wounded, to collect fresh linen, and to wash wounds. Dunant pressed passers-by into service and wrote letters to the families of the wounded men.[7]

Later he wrote about his experiences, and inspired by the reception his book received, he decided to promote a simple idea: soldiers should not die and suffer alone, volunteers should help, and the wounded and those who aid them should be exempt from attack. From this idea, the International Red Cross was born.

Our vivid experiences light our life in flashes. A few moments, a few days, can shape our lives—if we let them. But, of course, this only happens if we're willing to try. Dunant was on a battlefield for two days. He was a businessman with no knowledge of medicine or war. Yet, on the basis of his experience of two days, he felt that he should form an organization (the Red Cross) and embed a set of principles in the conscience of humanity (the Geneva Conventions) that would be relevant to all people, everywhere, then, now, and forever.

Experience can inspire us, but it can also crush us. Dunant walked away from the battlefield inspired to change the way that the world took care of those who suffered in war. He could have just as easily walked away disgusted by men's wastefulness of other men's lives, and he could have left

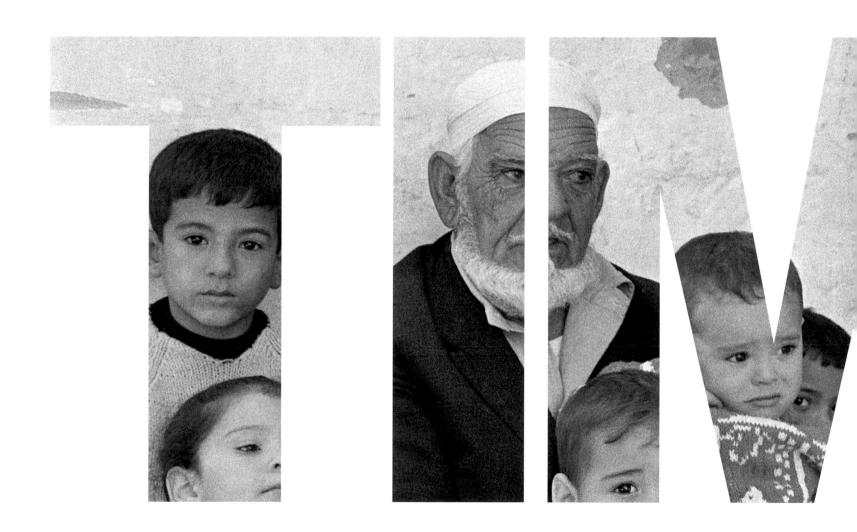

dismayed at the very, very small amount of service that a single pair of hands could provide amid so much suffering.

Dunant had been preceded by tens of thousands of military men and professionals in various medical corps before him: yet none of them, with all of the time they had passed with the wounded, were possessed with Dunant's vision.

Time and experience and suffering can bring wisdom, but they can also shackle us to the tragic acceptance of things, "the way they've always been."

In the Gaza Strip, if you ask a child where she is from, she will likely tell you Haifa or Tel Aviv or Jerusalem, even though neither she nor her parents have ever even seen these cities. Gaza is one of the most densely populated areas in the world, and the majority of the people are registered with the United Nations as refugees from the 1948 Israeli-Arab War.

I was in Gaza in 1996—a period of relative calm—when I could walk the streets and people waved me over to sit with them for tea and falafel. They referred to Gaza—the place where they had lived every day of their lives—with a wave of the hand as "this place." I had to rethink the word refugee. In Gaza, families did not live in temporary shelters, but in permanent buildings.

Families had lived on the same block for fifty years, yet they still had dreams of another "home."

Walking the streets bred a particular humility. In 1996, Gaza had been controlled by Israel for nearly thirty years, by Egypt for twenty years before that, by the British for thirty years before that, by the Ottomans for four hundred years before that, and—over the course of the three thousand previous years—by others, including the Crusaders, the Caliphate, the Byzantines, the Romans, the Macedonians, the Persians, the Babylonians, the Assyrians, and the Israelites. My shoes carried only a few days of dust. How much time would it take even to begin to understand such a place?

There was little work to be had in Gaza, and groups of men would sit outside and talk. An American walking the streets was a novelty. I was stopped everywhere. When I sat down, tea would come, and children would be sent running for the nearest man who spoke English. Minutes later the children would come flying back, a dutiful translator in their wake. We would exchange greetings, touch our hands to our hearts, and sit again.

I felt that in Gaza—perhaps more than anywhere else I've ever been—young people grow up conscious of their history. Not only did they tell me about homes they had only imagined, but even children—nine, ten years old—recounted their version of the Israeli-Arab conflict. Prominent graffiti portraits testified to the most recent clashes, with particular attention to the young, now dead. Older people in Gaza often quoted Arafat to me—his lines about the womb as a weapon—and I thought then of the tremendous burden that the next generation of leadership must carry, even if only to help these people begin to think of themselves as a generation that was born, not to fulfill a history of revenge, but to create a future based on hope.

No American can ever understand Gaza fully, but we do know of Gandhi in India, Dr. Martin Luther King Jr. in America, Václav Havel in the Czech Republic, Nelson Mandela and Desmond Tutu in South Africa. We can know that not only is it possible to end cycles of violence, but that it is also possible to build a foundation of compassion on a history of bloodshed. No victory over a history of bloodshed has ever been perfect; no victory has ever been complete, but we know for certain that there have been victories.

Even to suggest this possibility, however, invites others to point out all of the blind spots in our understanding of the past, all the things we have forgotten or never learned, all of the past injustices still to be righted, all of the wounds of past wrongs still left wide open.

The past is real. History matters. The world cannot be started anew. Our past is rich with great possibility, yet time can also sully the landscape of our minds with the wreckage of past failures, old feuds, and false promises.

To believe that fighting people might come to the table of peace, and not overturn it, requires an almost absurd faith in the capacity of human beings.

To believe that after hundreds of years of conflict among peoples, a small group of individuals might still establish a new direction that leads to lasting change? Surely such change is impossible: except, of course, for the fact that is has been done many times before.

In Gaza, I took a photograph of a young man standing in front of a graffiti mural that displayed a portrait of another young man who had recently died in political violence. The two of them looked as though they could have been brothers: one of them dead, a reminder of the world as it is and has been; the other living, a testament to the world as it might yet be.

As "tourists"—to use Dunant's term— we cannot in our brief time ever fully understand the past. We can, however, follow Dunant's example. We can accept the necessity of the possible and the weight of the past, the deals and compromises, the calculations and intrigues, the insults, the injuries, the injustices. Yet we can make it our legacy to reach for the impossible and use our time to improve ourselves and the world.[8]

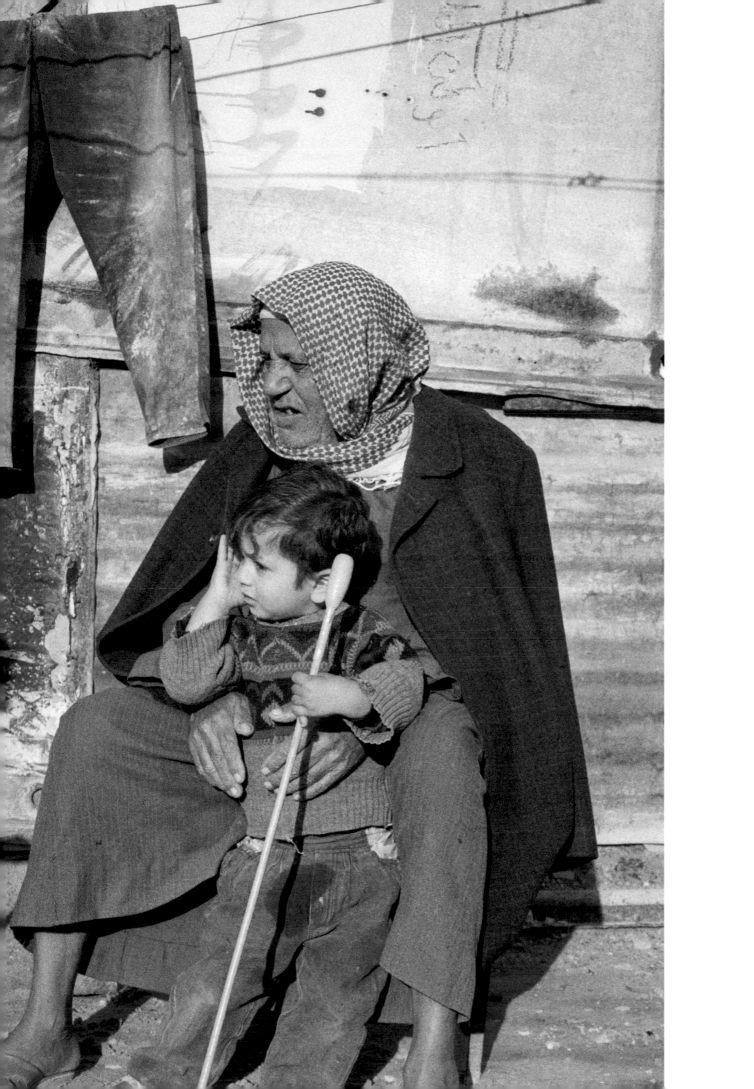
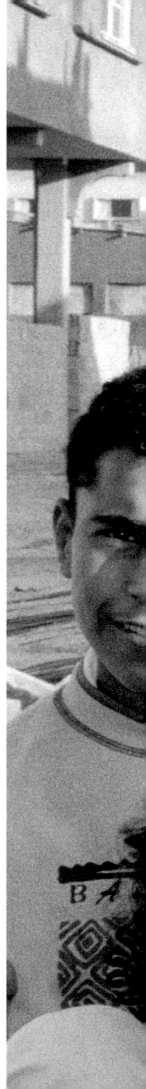

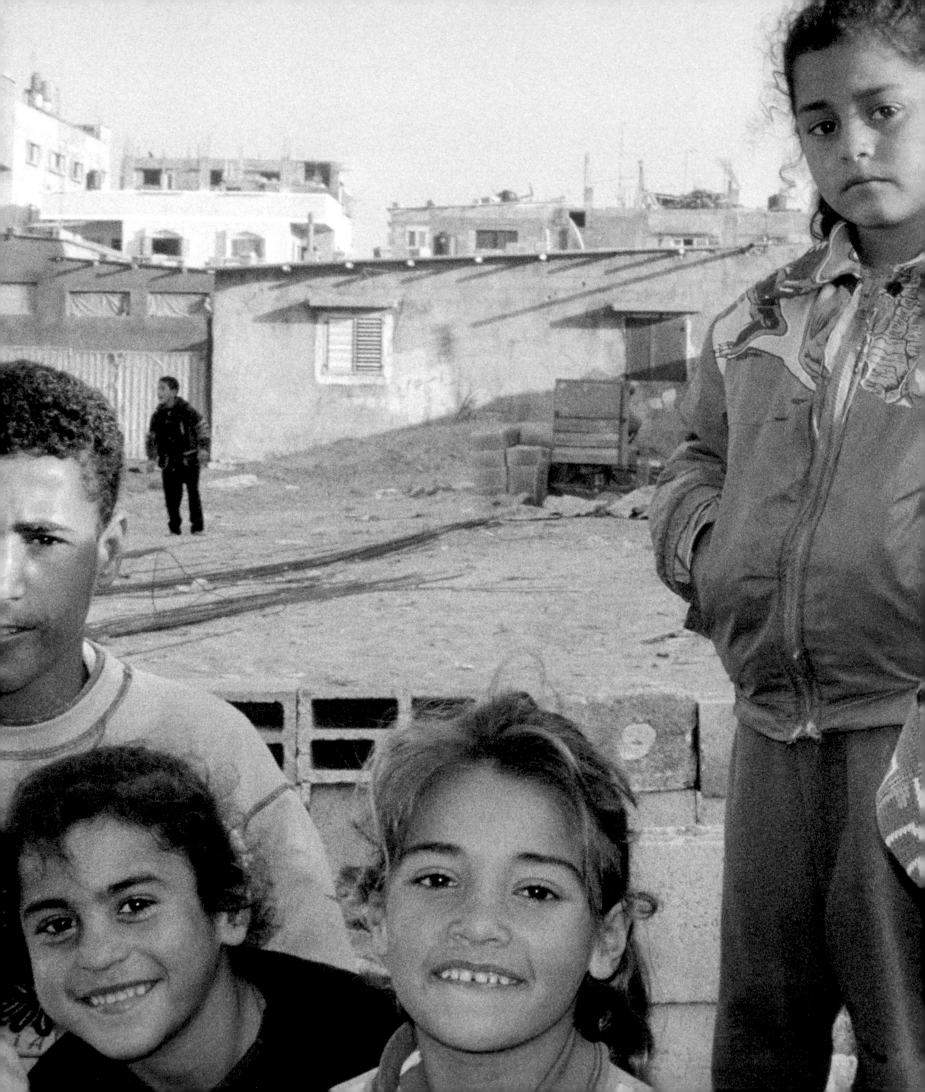

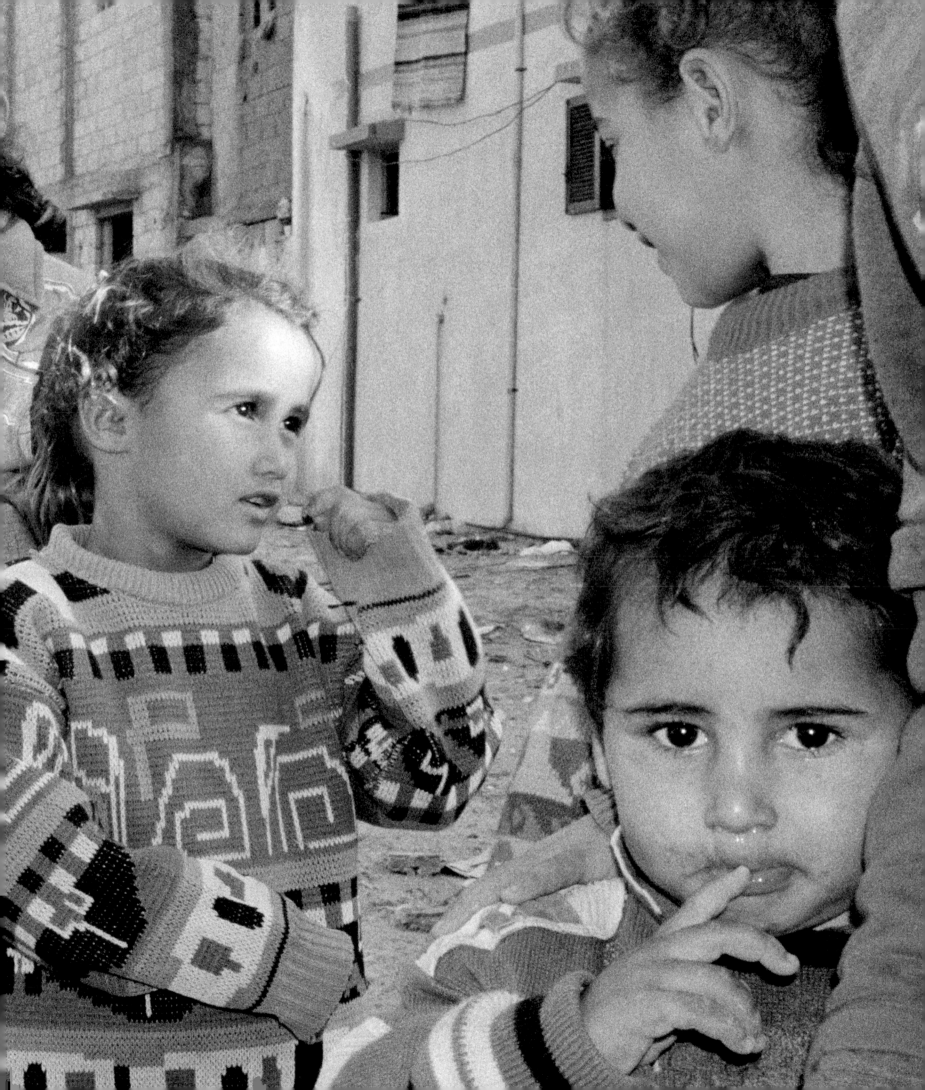

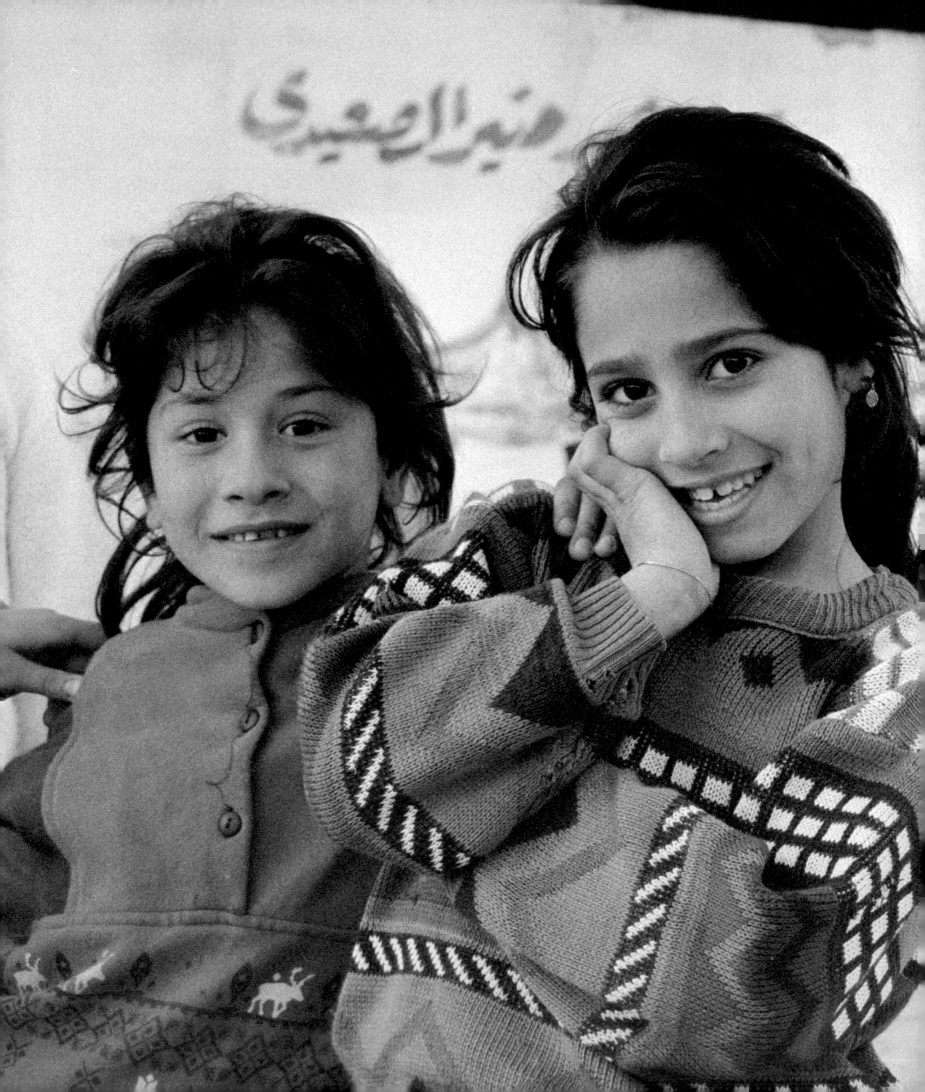

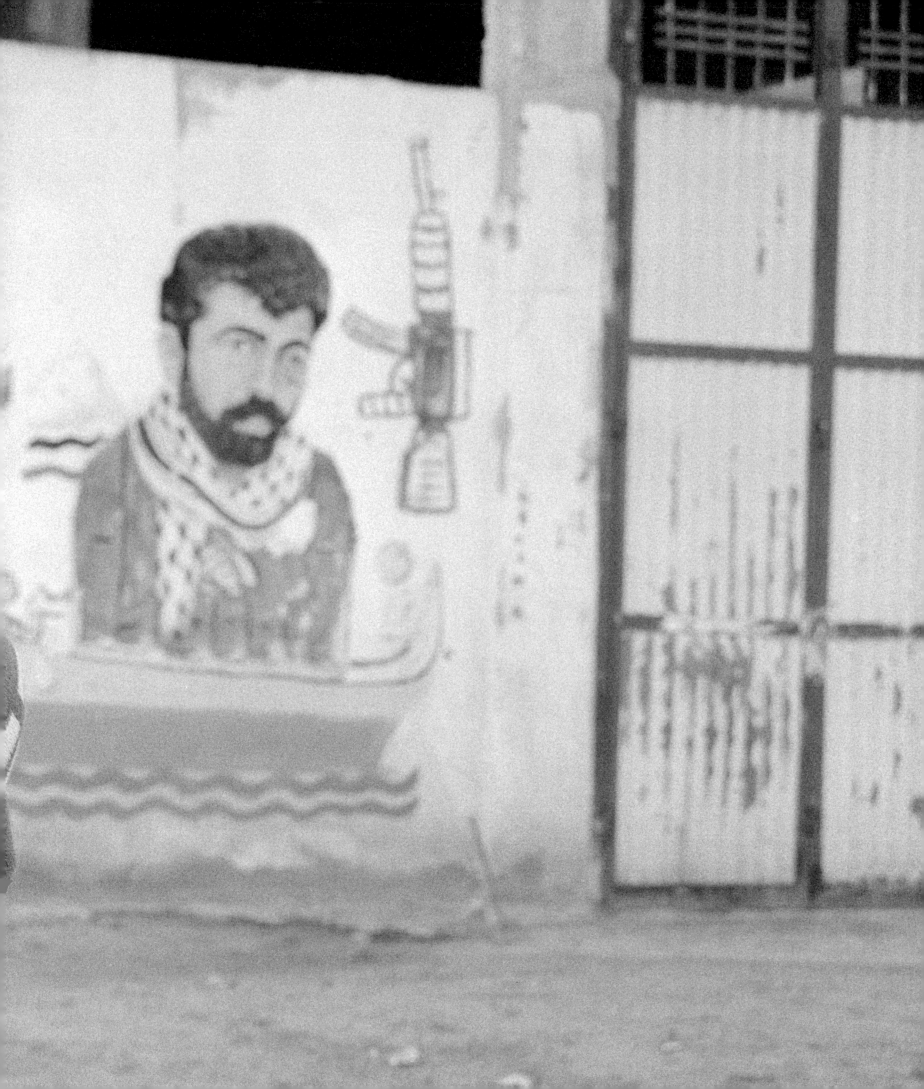

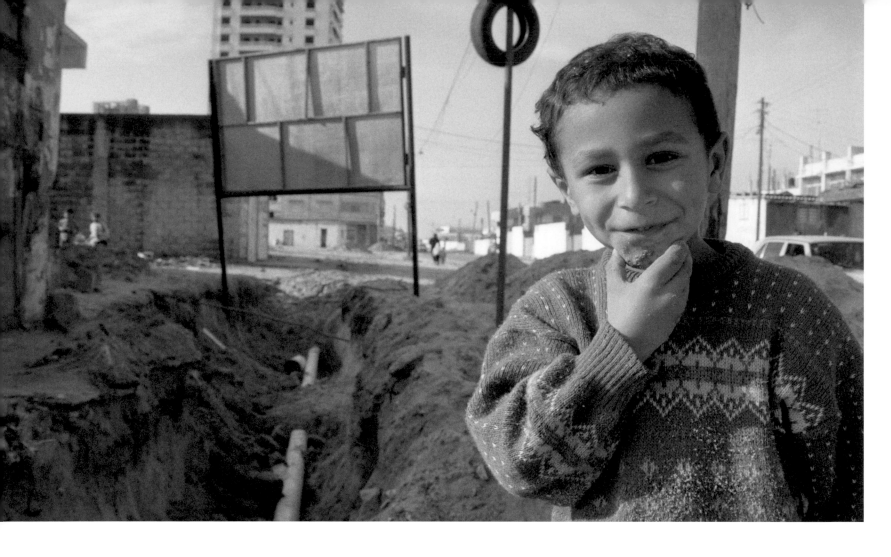

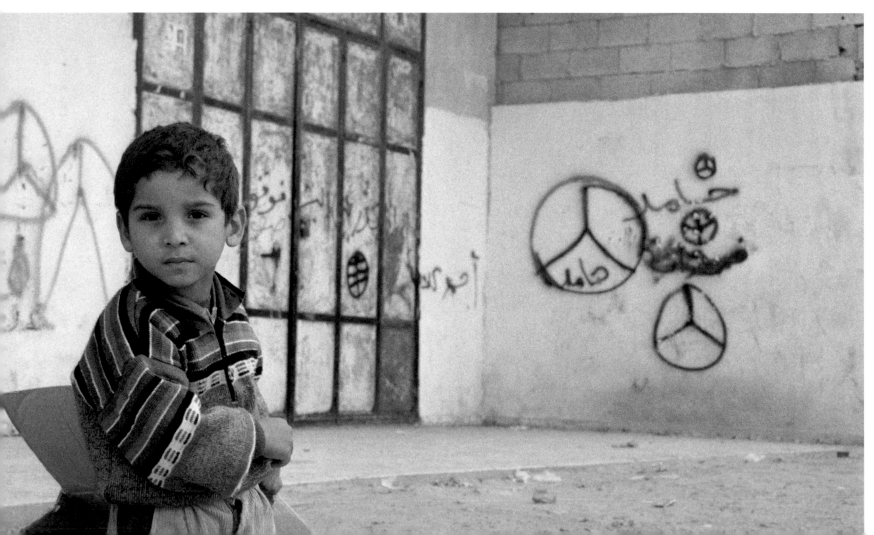

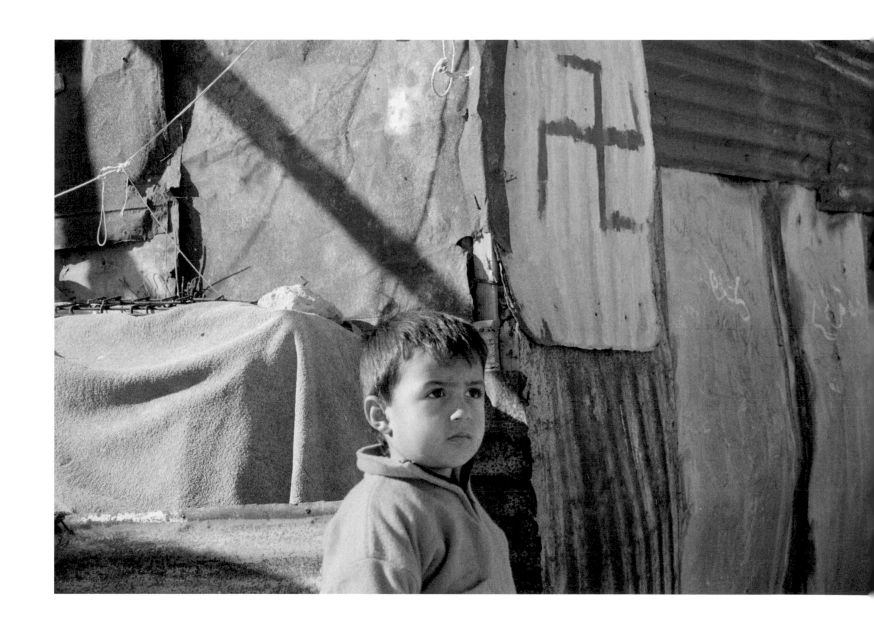

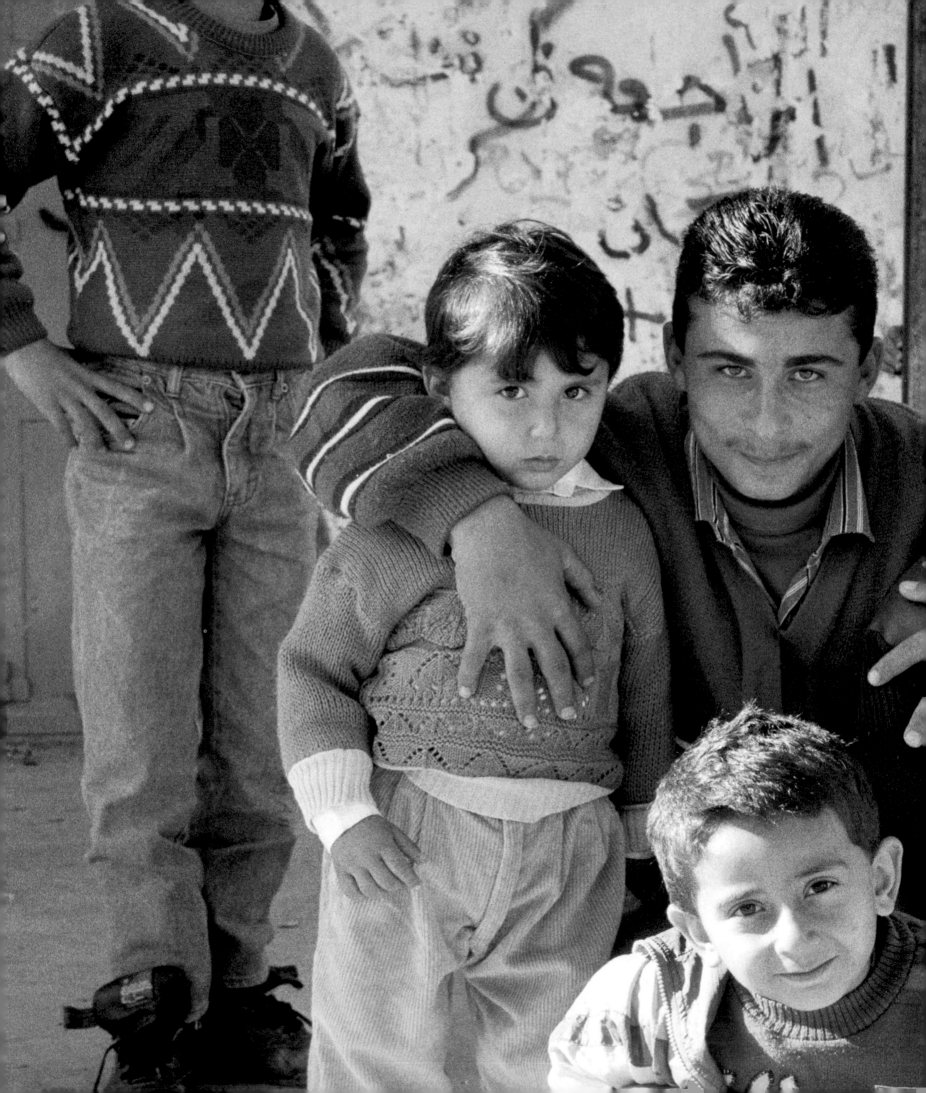

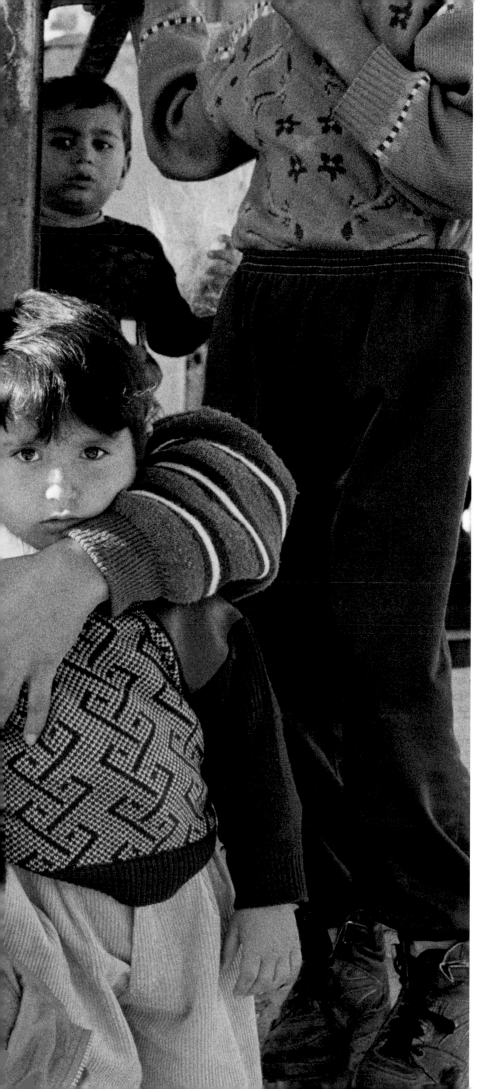

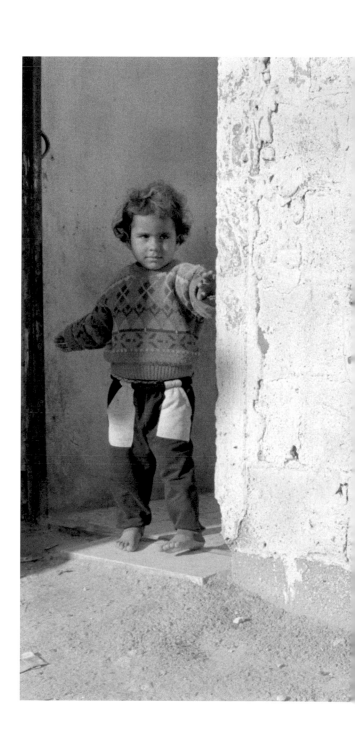

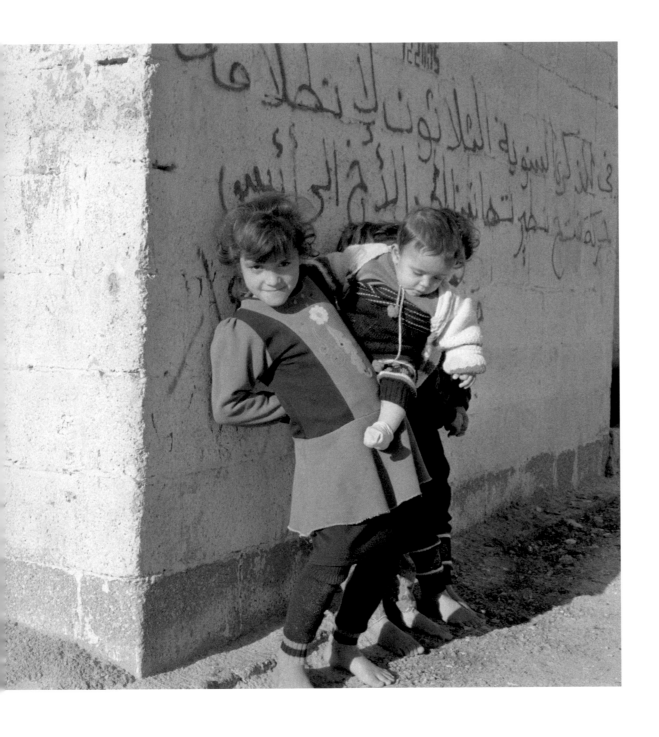
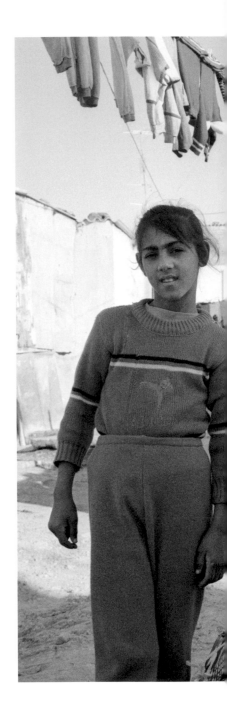

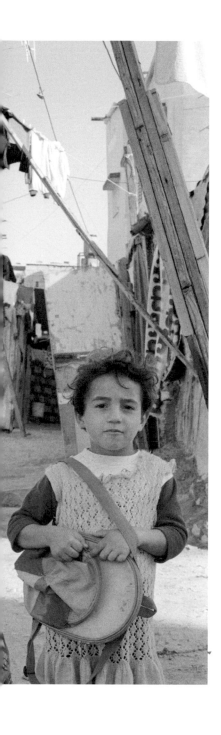

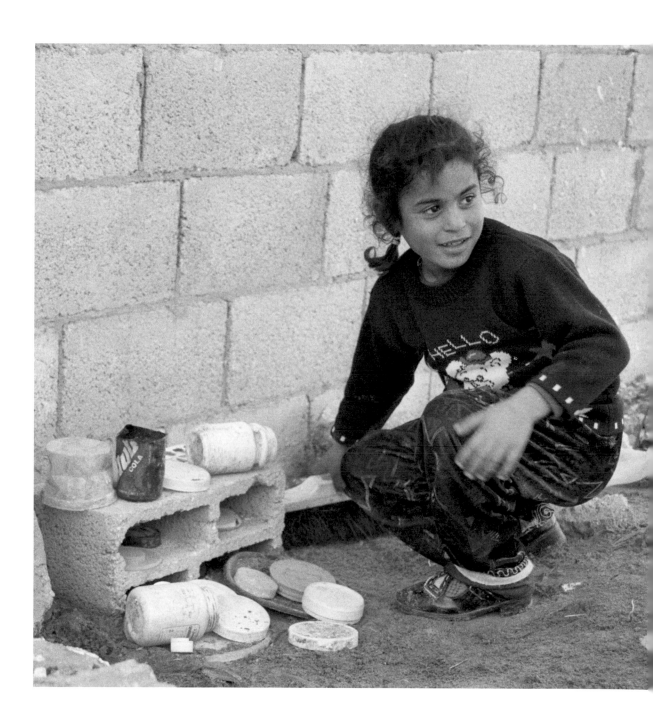

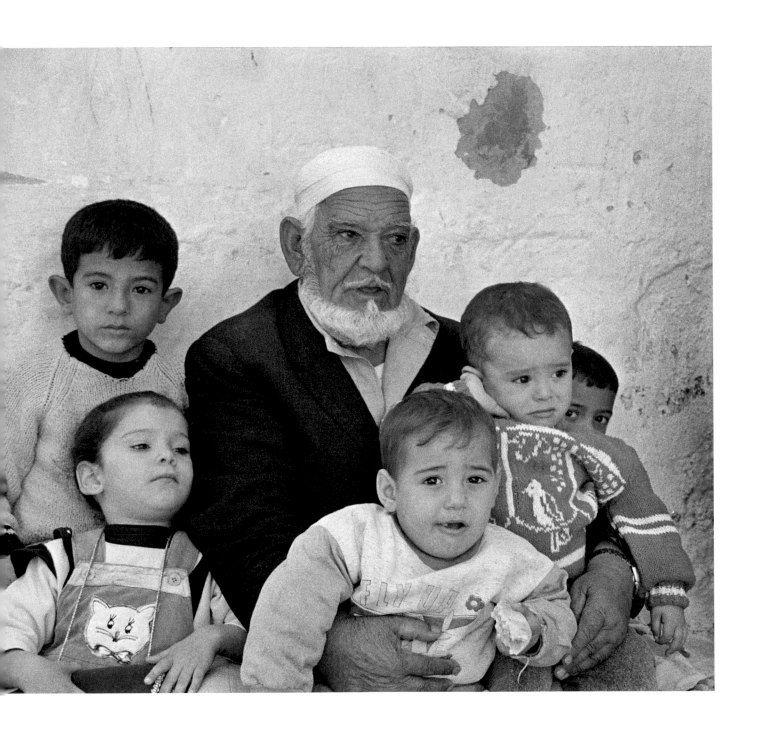

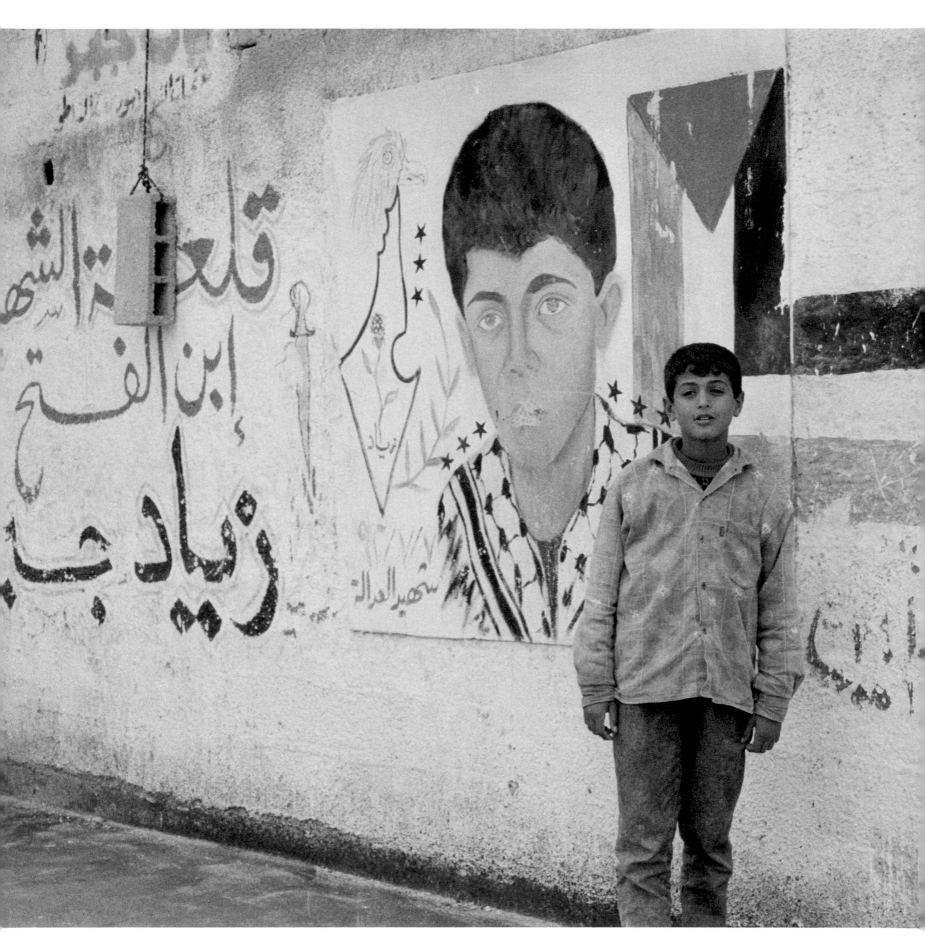

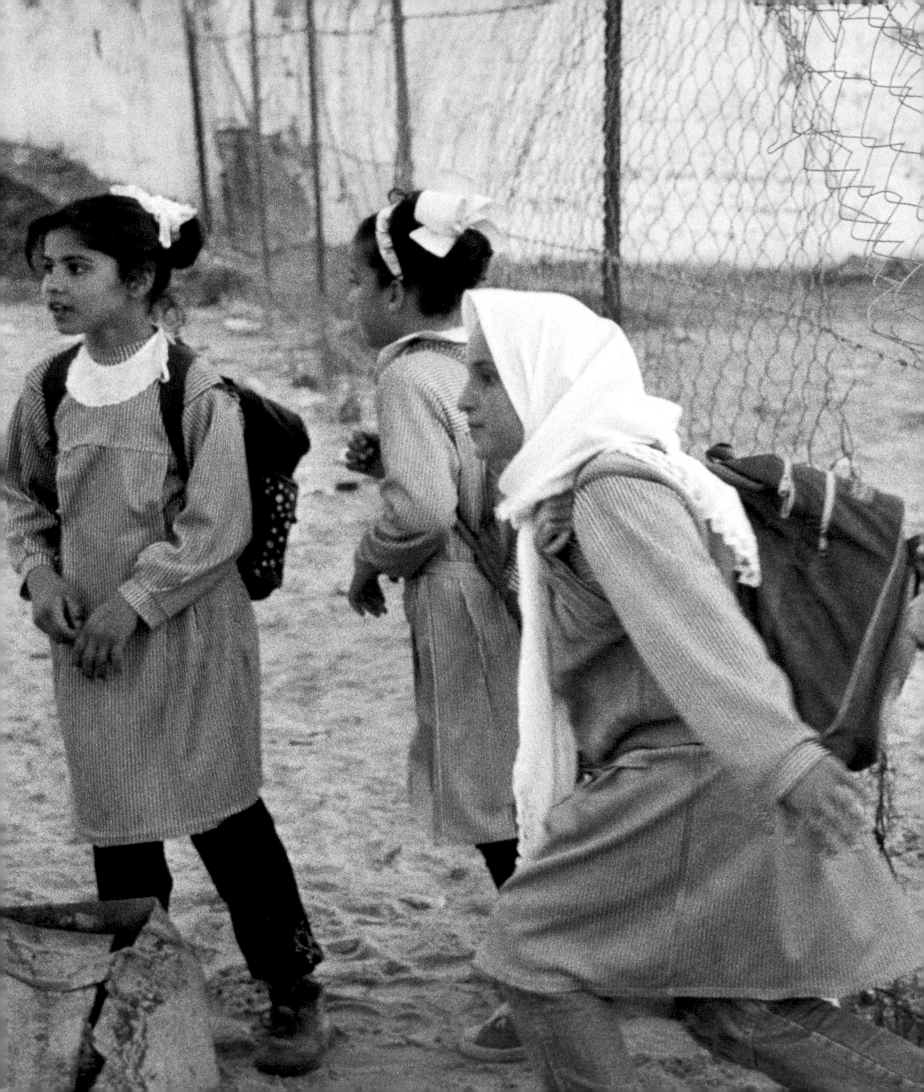

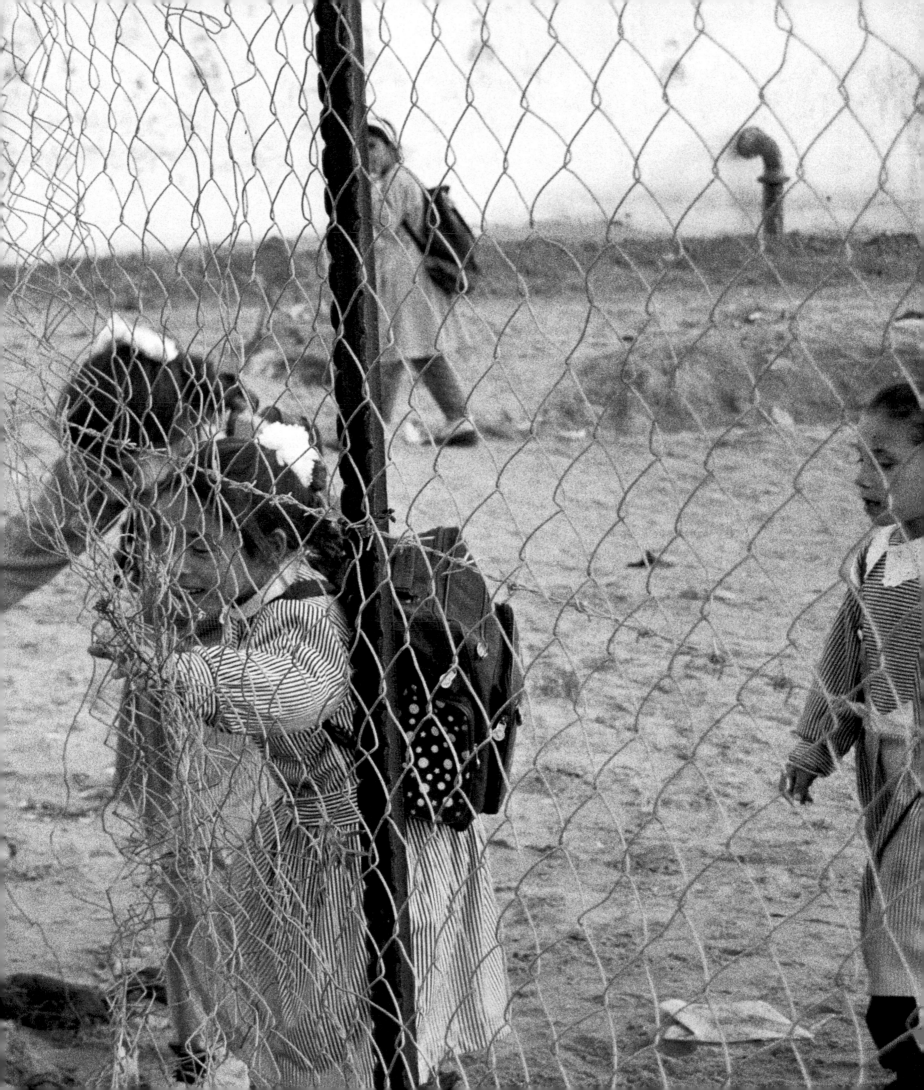

CROATIA

In 1994, I went to Croatia with a professor and several other students to work with the Project for Unaccompanied Children in Exile. Campaigns of ethnic cleansing were ravaging Bosnia at the time, and the project aimed to aid children who had been orphaned or separated from their caregivers during the war. We lived and worked in the refugee camps in Croatia, and in addition to our work with unaccompanied children, we did simple work in the camps. I started a soccer team, helped in the kindergarten, played chess (and was beaten time and time again by eight-year-olds), and talked with the refugees.

Before that summer, I knew that pain and suffering existed in the world; I had seen people who struggled with hunger, poverty, mental illness, and loneliness. But I had never seen or known anything like what I experienced in the refugee camps.

Wounds in the refugee camp were raw and widespread, and the refugees told stories of horrific violence. The details were often so sickening that I found it hard to believe that the person telling the story was in fact the same person who had lived it; the story seemed to come from another world entirely.

I remember one particular day talking with a Bosnian man in one of the shelters in the camp. He told me that his wife had been dragged from their house and later raped. Both of his brothers had been killed. He had heard from a neighbor that one of his brothers had been tortured before he

was shot. His sister and parents lived in a different city, and he was not sure if they were alive. He lifted his shirt and showed me the scarring on his stomach and chest from a grenade that had been thrown into his house. He considered himself lucky that his children and wife were alive. He started to cry. His children—a boy and a girl—sat listening in the corner of the shelter.

As I talked with more people, I heard similar stories. Children weren't spared. Working one day in the kindergarten of the refugee camp, I took a photograph of a girl drawing a house. I wondered what her experience had been.

Many of the families that were victims of the ethnic cleansing had been forced to grab what they could and walk away from their homes. Thousands became refugees overnight.

One night, as buses filled with refugees drove into the camps, a Red Cross worker told me that some of the families had been forced from their homes and then watched as their houses burned to the ground.

We can and must investigate such tragedies, and through our investigations, we can come to understand how events unfolded. We can know how and where people failed in their responsibilities, how and where crimes were committed, how and where people exceeded all possible expectations in their

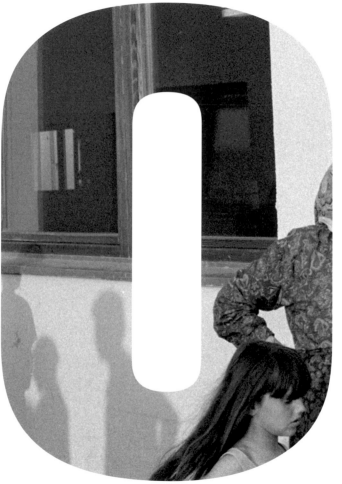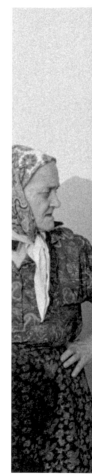

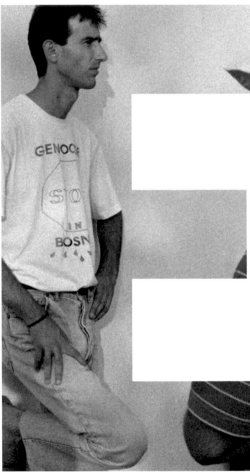

service to and sacrifice for others. But what such investigations have never been able to do is to make the human element of such suffering "make sense."

My experience was that, in the face of the grotesque violence people had suffered, people made few attempts at immediate explanation of the human tragedy. My sense was that people went to their faith and their friends and asked God and each other for solace and for support, but not for an explanation.

People shouted "Why?" not because any explanation could have comforted them, but because they felt then that no adequate explanation was possible.

In some ways, faced with a specific case of torture, or abuse, the very task of explanation seems obscene in the most direct sense of the word. In the Greek plays, violence was never portrayed on stage; it was *obscene*—that which could be reported by an actor but should not be part of the scene viewed by the audience. In the same way, attempts at explanation in the face of immediate suffering are often obscene.

We need to be able to ask the right question at the right time. "Why?" has its place, and in asking "why" we may find wisdom that can sustain us. Yet in the face of present suffering, the right question seems to be not "why?" but "how?" How do we respond?

We do not have perfect knowledge of why human beings suffer, but we do have the capacity to act, and we have each other. It turns out that this is enough to create hope.

People say that tragedy helps us to grow stronger. That's not the whole truth. Suffering can make people mean and bitter. Suffering can lead people to hatred and to false blame. Suffering can lead us to ill-focused violence and to abandon our values; suffering can unleash our worst impulses.

But suffering is also a trial, and in the test of suffering, we can grow. Pain can lead to wisdom. Fear is an opportunity for courage. And suffering presents the opportunity for compassion. We do not choose to suffer, but having been chosen to endure suffering, we can choose to act and grow.

We misconceive of "hope" if we think of it as something apart from ourselves, something out there, something that must be "found" in the world. We create hope through action, and in action, suffering becomes not an end, but a beginning. It can be the beginning of wisdom, the beginning of courage, the beginning of compassion.

In action, we affirm our beliefs, and in authentic action, we create ourselves. These actions do not need to be grand. One refugee knits for another. An elderly woman steps off a bus and into the camp, and a boy gives a hand with her belongings. A child draws a house. These simple actions alone are not enough to fight an army, to protect a home, to prevent a crime, to heal a wound. But they are enough to rekindle the embers of hope. And with hope comes energy, and with energy comes the ability to act again, and then again, and then again, until, ultimately, thousands of individual acts of energy and compassion and daring come together, and we find that we have fashioned a new day.[9]

In the refugee camps, suffering had torn the veil of self-sufficiency away, and people saw clearly one simple truth: they were in this together, and if they acted together, they could create hope.

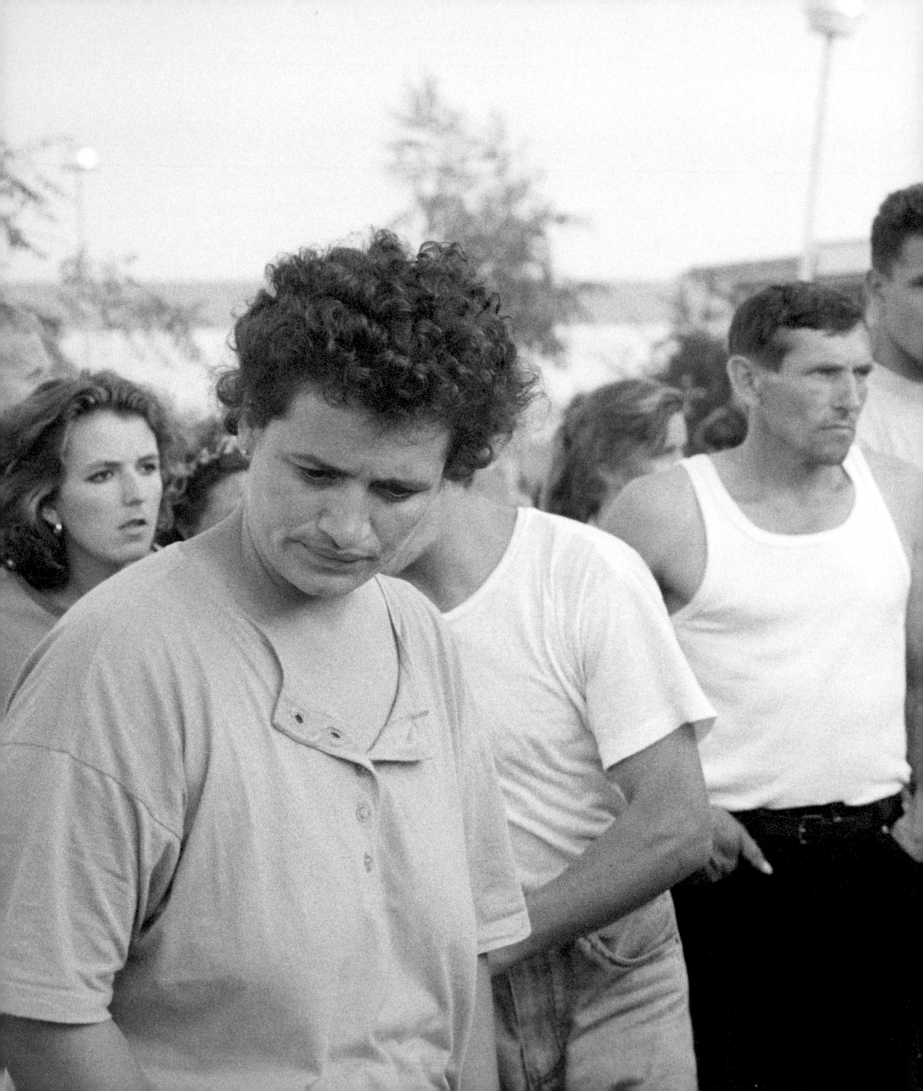

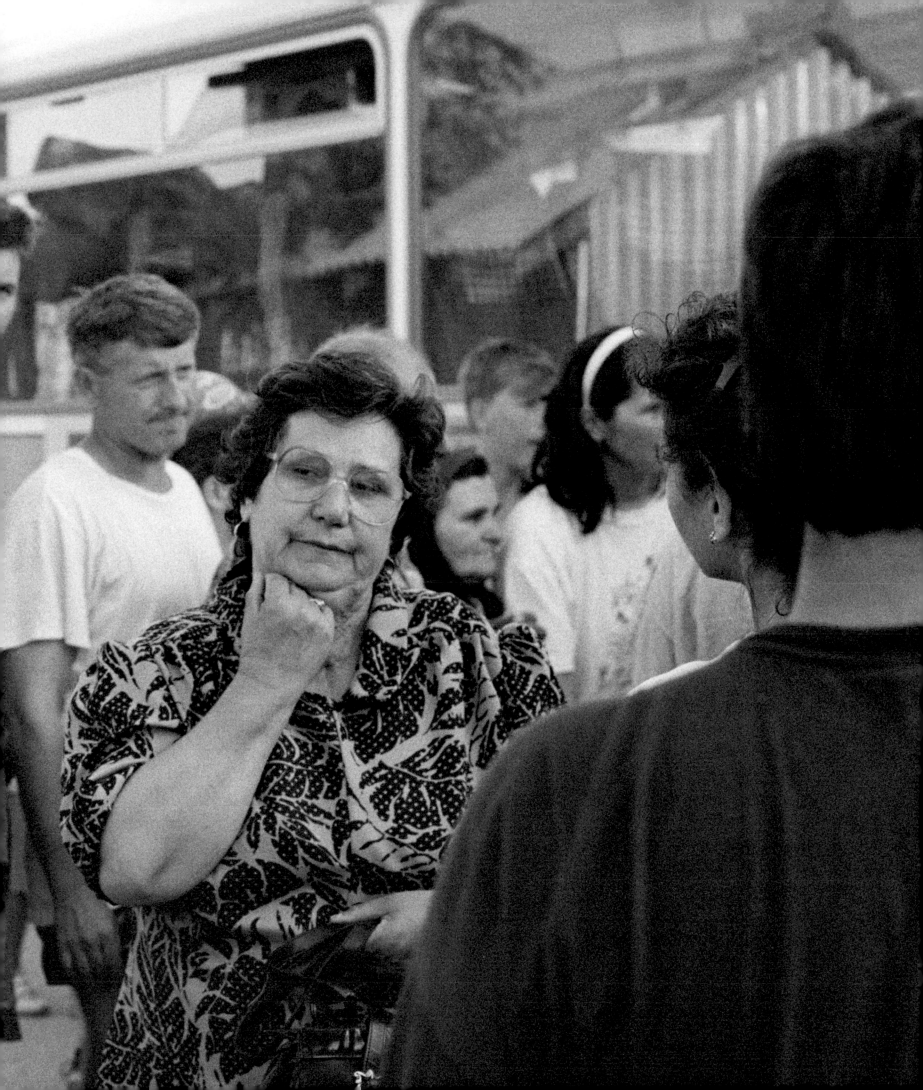

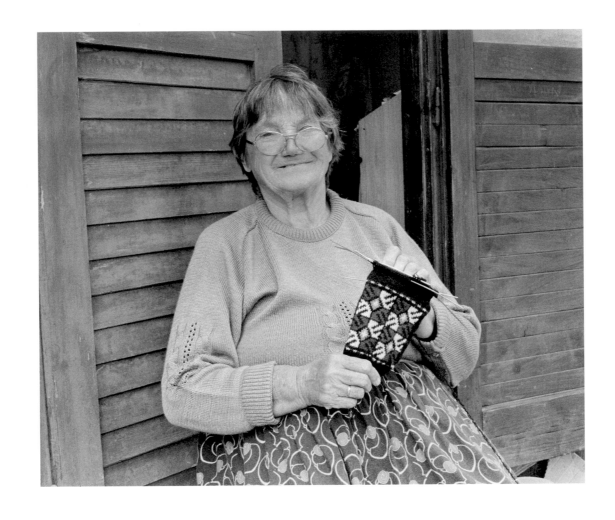

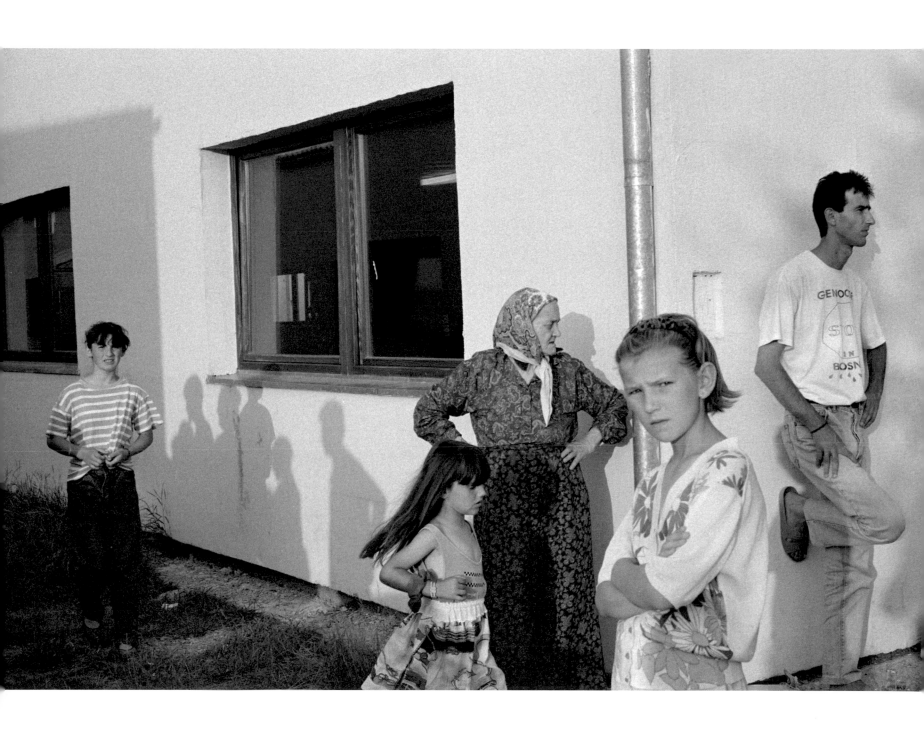

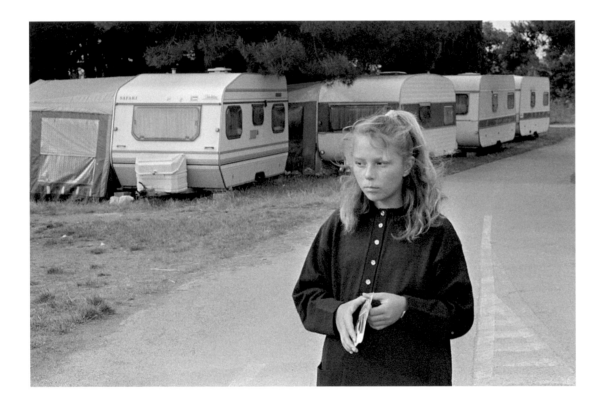

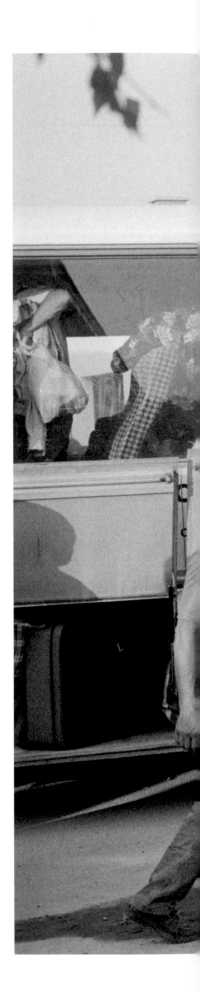

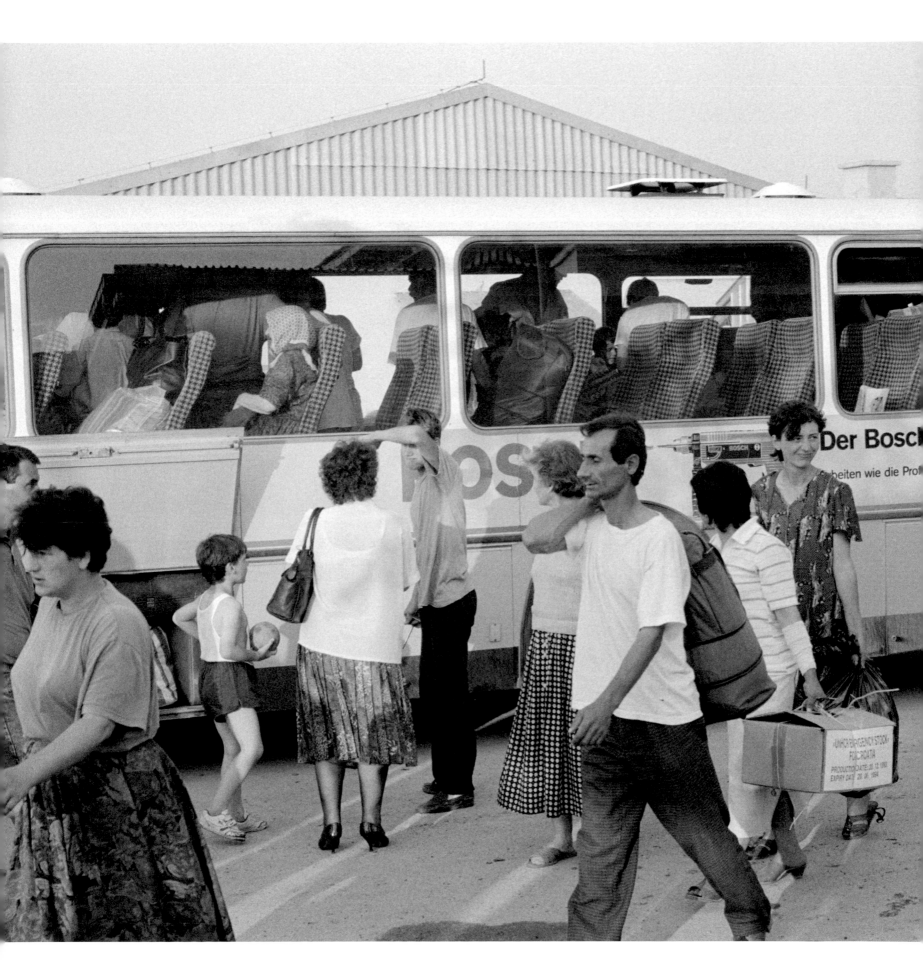

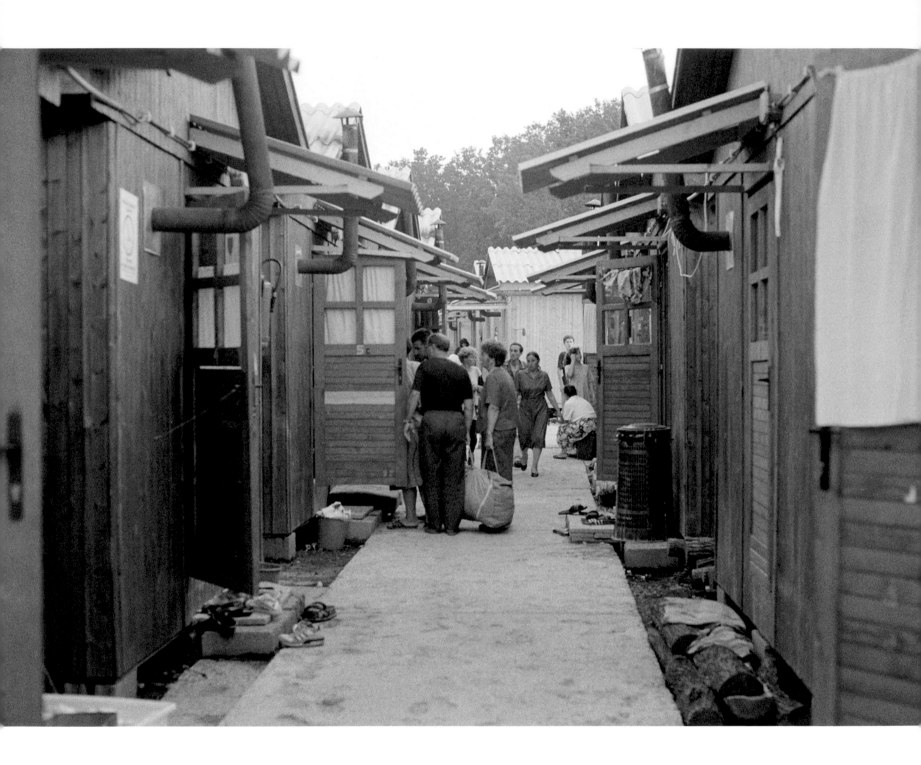

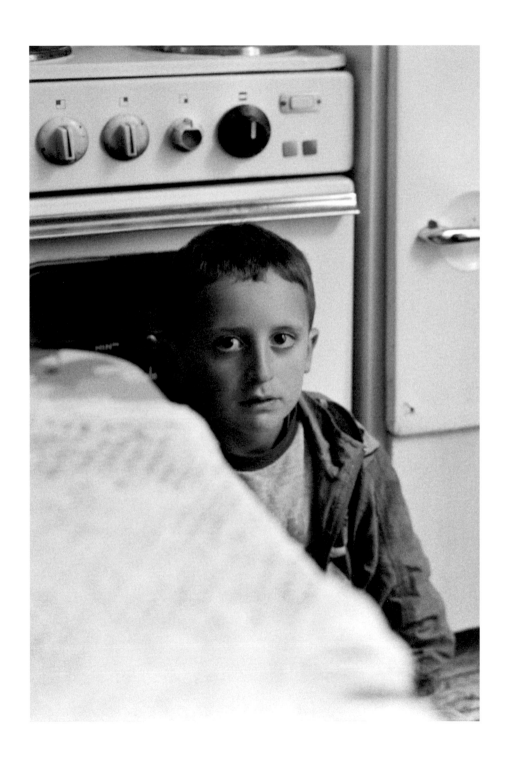

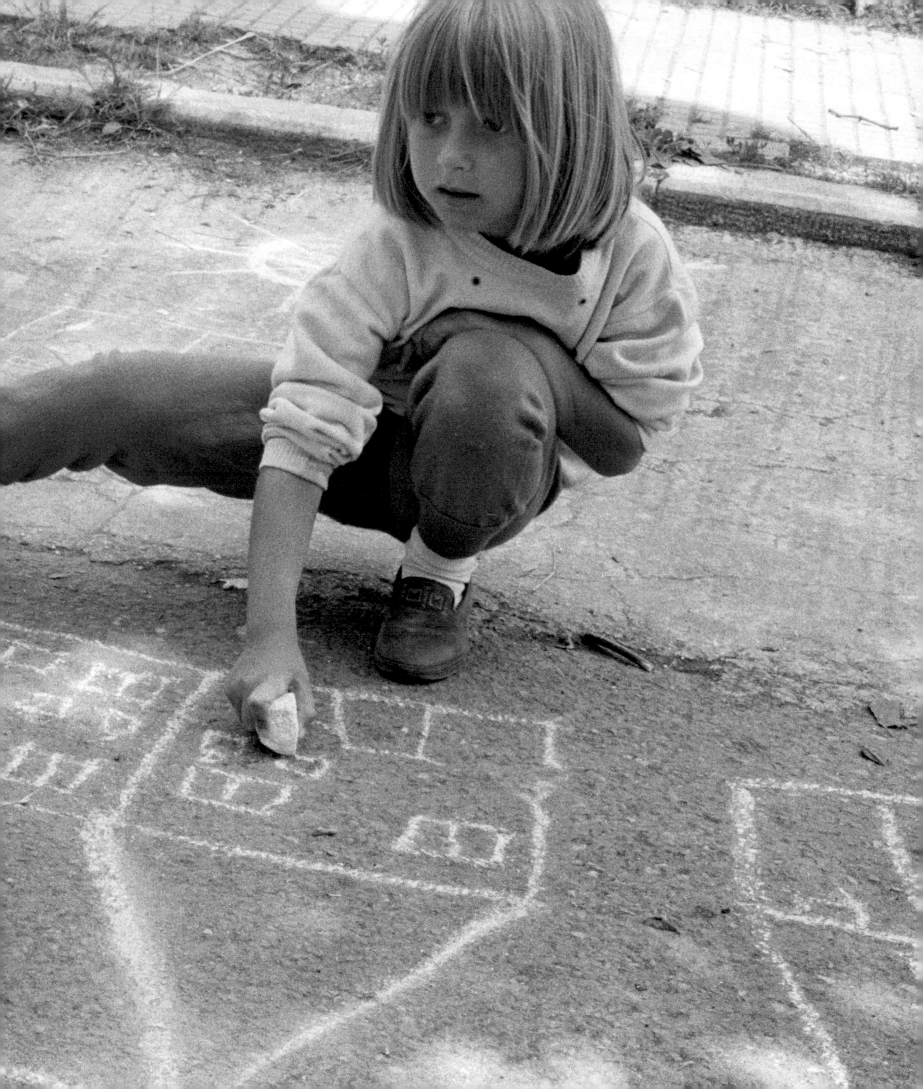

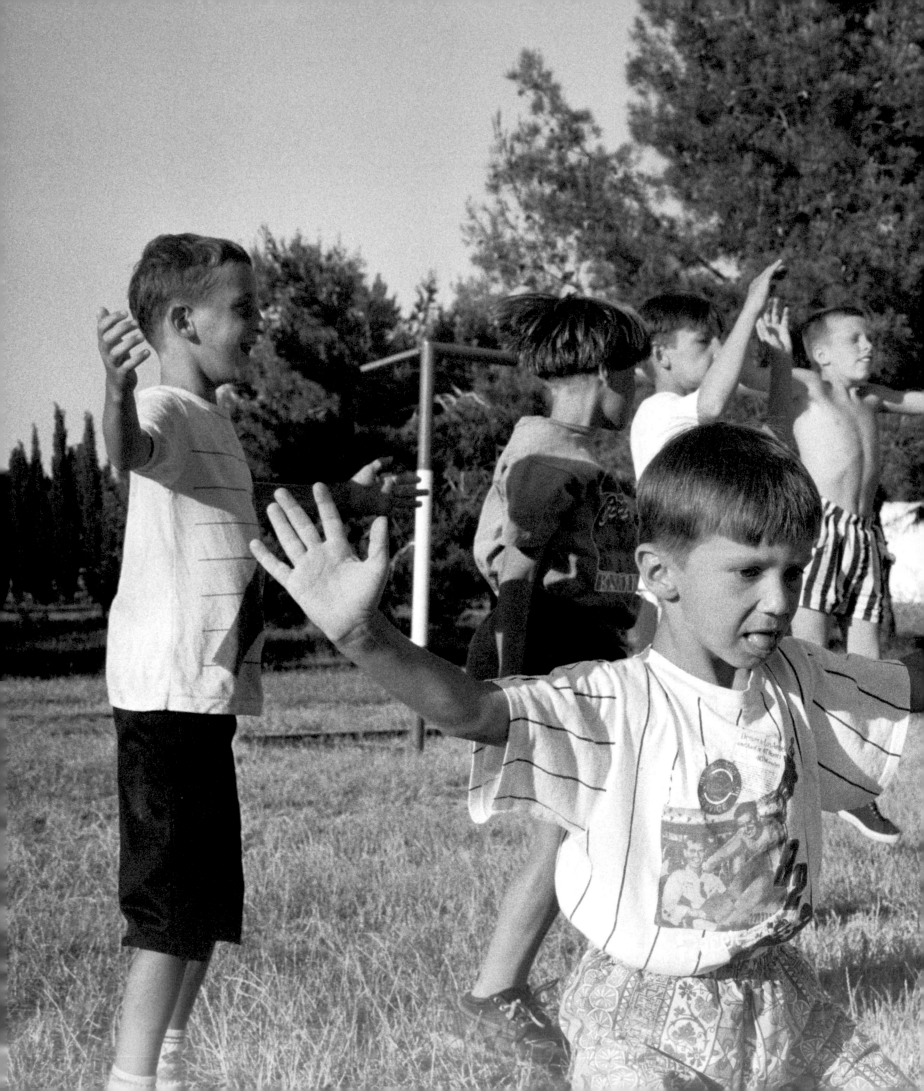

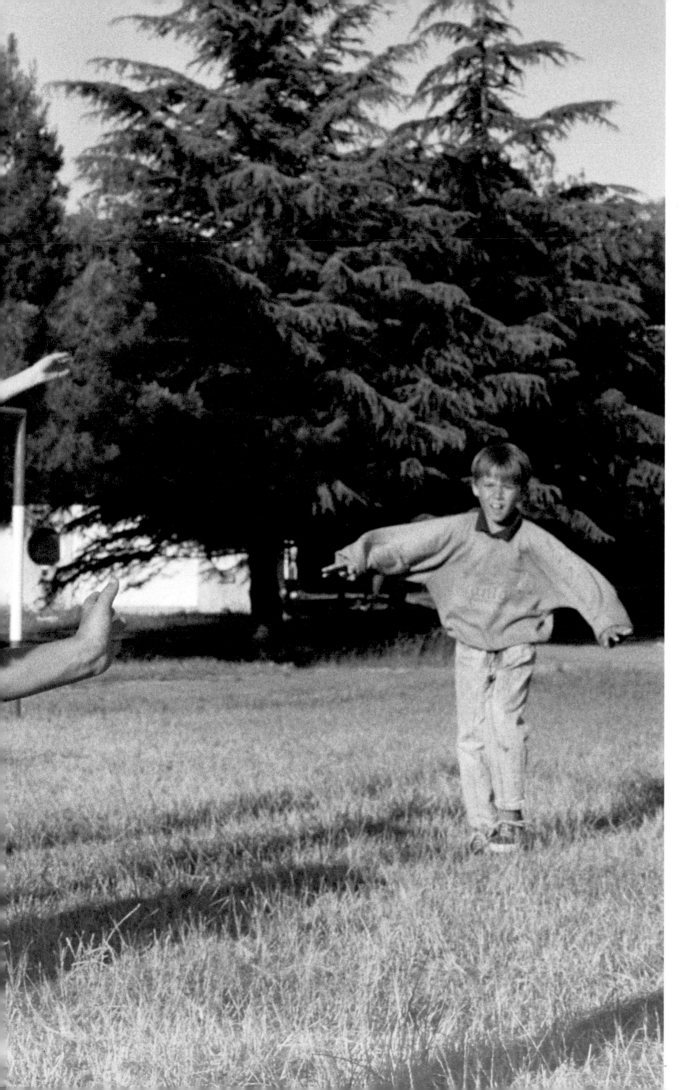

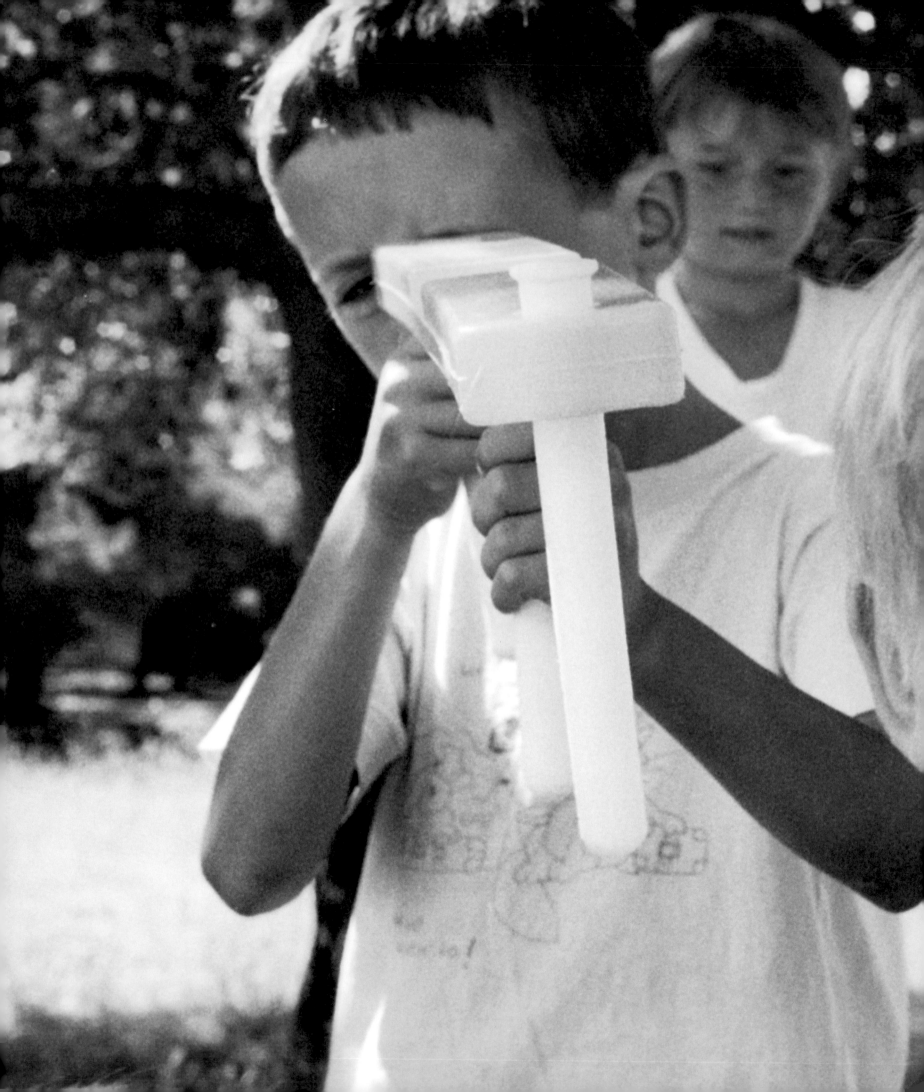

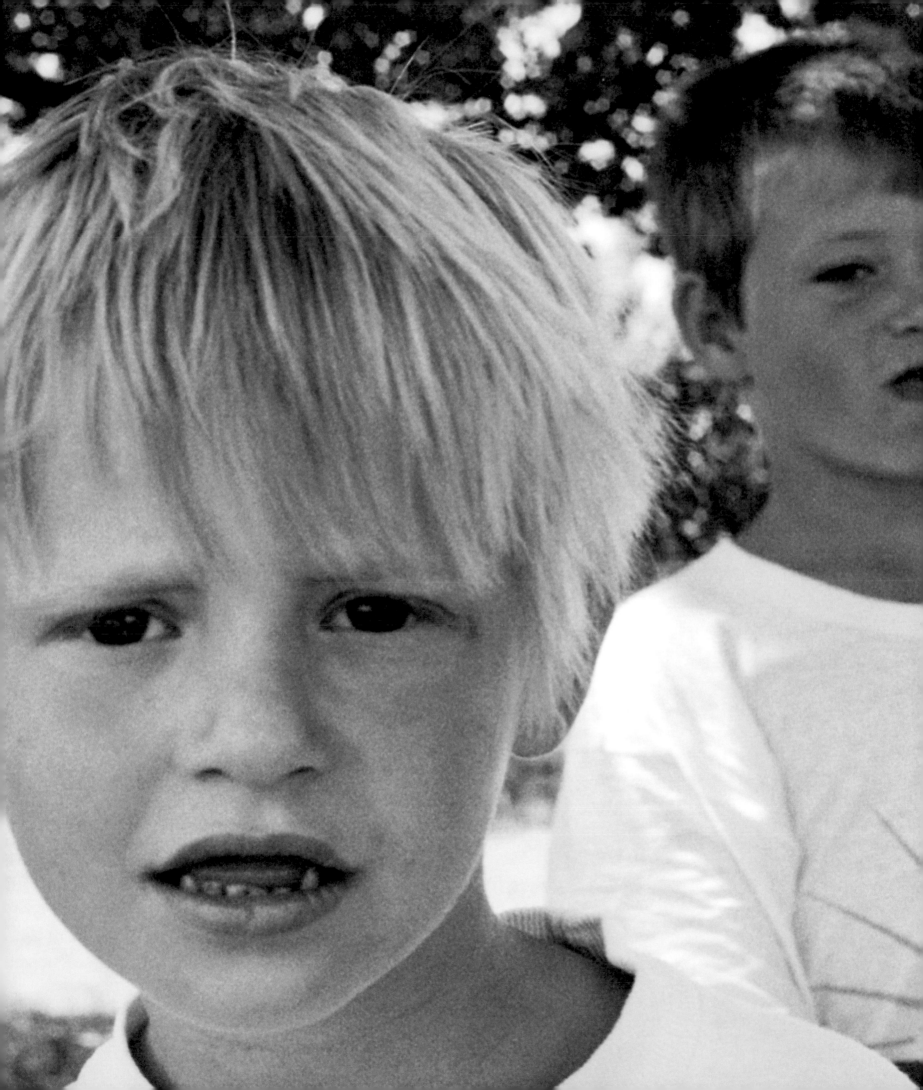

BOLIVIA

Hundreds of children live on the streets of Santa Cruz, Bolivia. Commonly referred to as *niños de la calle* (children of the street), these children spend their days shining shoes, begging, and selling gum and cigarettes. Some of them have small cardboard or corrugated metal shelters where they can sleep at night, usually in groups and often surrounded by dogs for warmth and protection. Some children end up on the street because they are abandoned, but most flee to the street because of abuse and violence at home. Yet on the street, they also find abuse and violence. Young women, in particular, often suffer sexual abuse. Self-mutilation in the form of self-cutting is also common, and many of the children constantly hold small white bottles of "glue" to their noses. Sniffing this cheap drug eases pain and eventually leads to permanent brain damage.

Mano Amiga is a house of welcome for these children of the street which operates with the assistance of international volunteers. When I came to the home, it was run by a young, newly married American couple who had dedicated the early years of their life together to serving children in Bolivia. They spoke Spanish, lived in the home, and gave to the children their tremendous energy and love, receiving in turn tremendous energy and love from the children.

While the children of Mano Amiga still faced great challenges, they were a striking contrast to those who lived on the street. In the home, they had warmth, food, some basic medicine, safety, a little bit of education, and music. The home was a shelter free of drugs and free of physical abuse.

Mano Amiga's facilities were simple, but the children were each given devoted care.

When the children were taught art, it was, for many of them, the first time they learned that they could create beauty in the world. When the children were cared for by adults, it was, for some of them, the first time they learned that strength could be used to comfort.

The harsh reality of deprivation remained, yet in this home the children had begun to learn how to care for one another. One of the boys from a neighboring home for *niños de la calle* was taken to the hospital. His injuries were minor, and he was expected to return quickly, but poor medical care caused complications that led to an infection, followed then by pneumonia, which resulted ultimately in his tragic death. I remember at the viewing watching several older children comfort younger children in direct imitation of the way that they had been taught to care by some of the volunteers in the home.

The home was not primarily a place of charity as we think of charity today, but a place of compassion.

Most of the volunteers in the home were Jewish or Christian, and their practice of compassion is what made the home special. The Jewish word *tzedakah* is usually translated as *charity*, but the word actually has a root that is closer to "justice" and in this sense, tzedakah is understood not as something that is extra, but as something that is required. The allied Jewish concept of Gemilut Chasadim refers to the spirit in which the highest form of tzedakah is given, a spirit of all-loving kindness. We are required not only to repair the world and make it just, but we do this work best when we act with the spirit of loving-kindness. In the same way, the Christian virtue of "charity" does not mean benevolent giving as we often think of it today, but refers to the virtue of "caritas," best translated as unlimited loving-kindness. We often live today with an impoverished moral vocabulary that limits our thinking about charity to questions about what we might do with our spare money, and our thinking about compassion to questions of what we might do with our spare time. There is great virtue in benevolent giving. If we give the resources of our time, our wisdom, and our wealth in the right way and at the right time, this can save lives. But there is a deeper power still.

If we give in the spirit of loving-kindness practiced from one person to another, then we have tapped into an overwhelming power that can change our own lives just as we contribute service to others.

Part of the power of compassion is that it allows us to love others despite their faults, which is at least in part how we each need to be loved. Children of the street are not angels. Some of them engage not only in petty theft, but also in violent crime. Some children abuse other, weaker children. We need to see these facts clearly. Compassion is not blindness. Compassion is, however, a kind of daring. To love is to risk, and in being compassionate, we dare to love even though we know that love will bring with it disappointment and pain as well as joy and happiness.

One of the essential truths about compassion is that compassion requires strength. In its highest state, compassion is a form of courage.

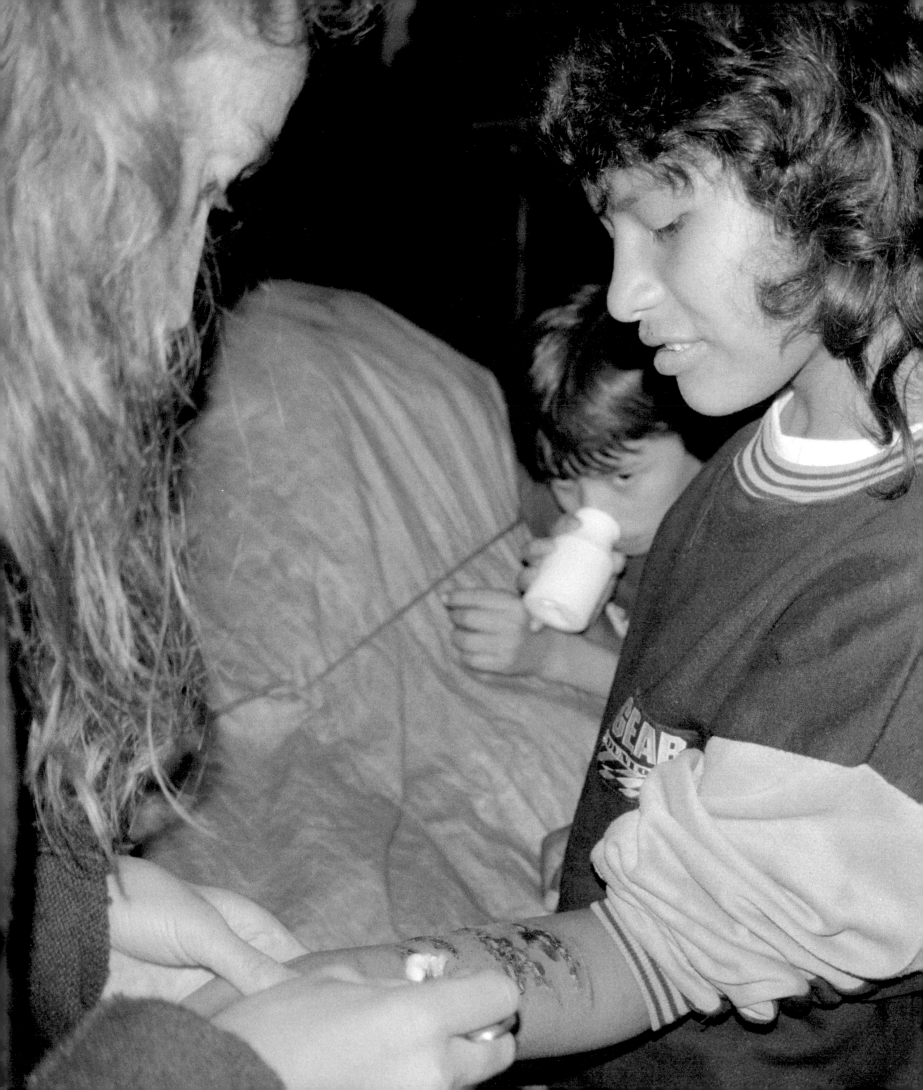

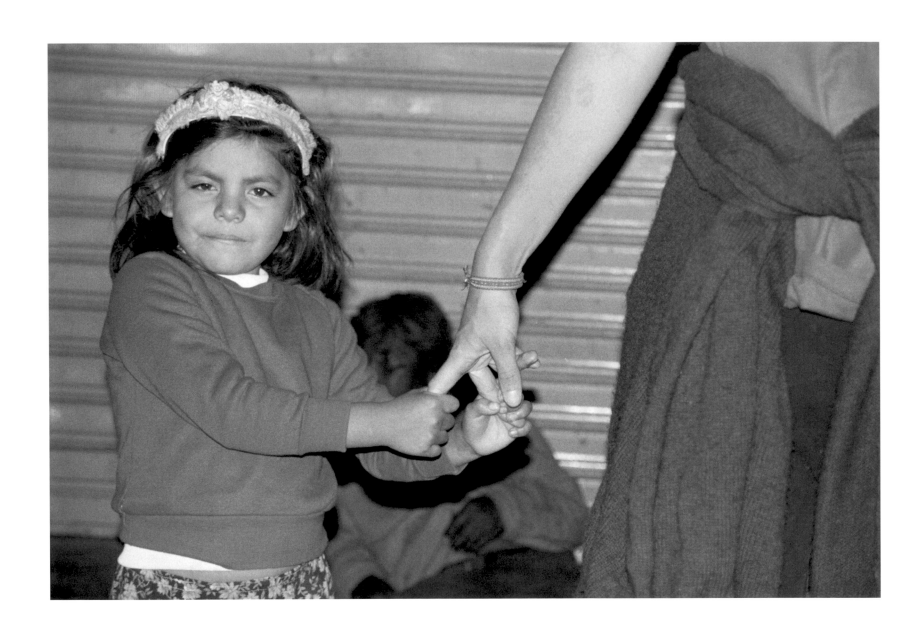

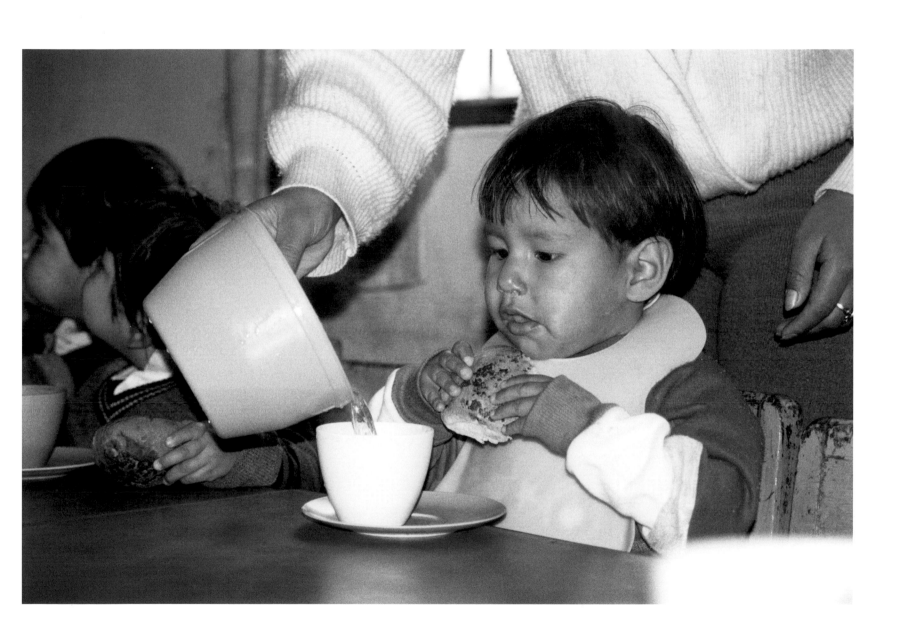

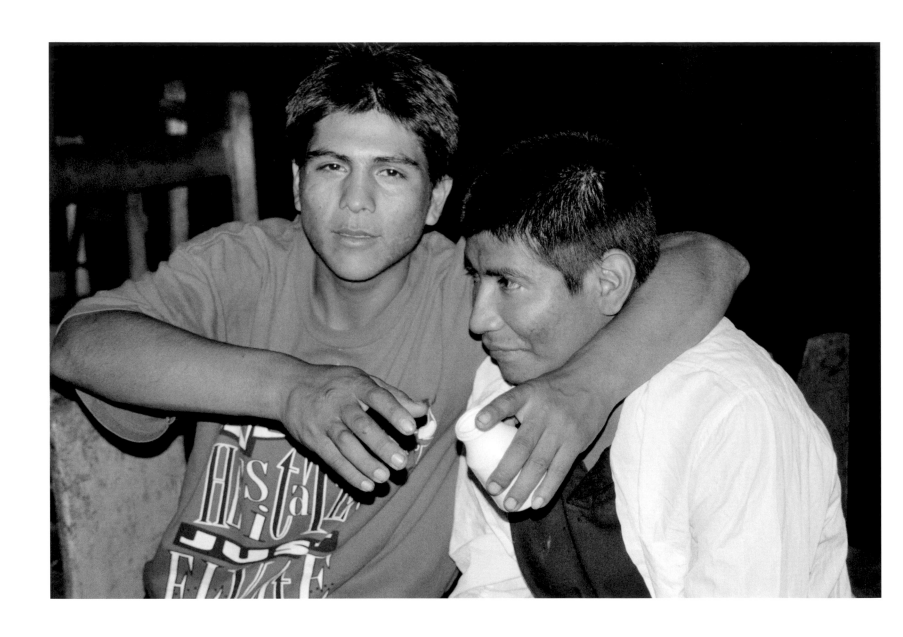

158 Compassion

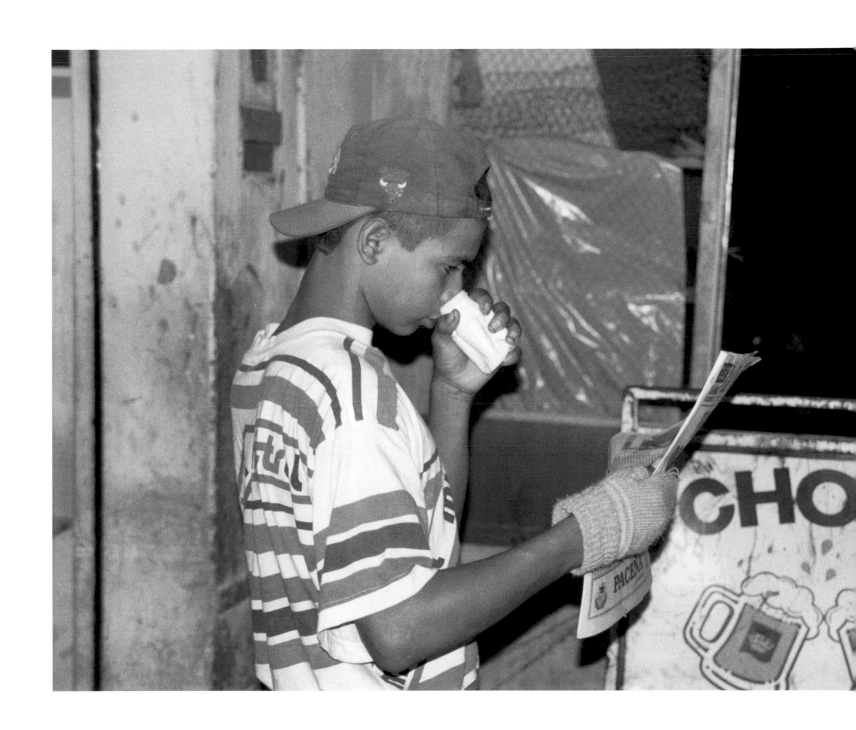

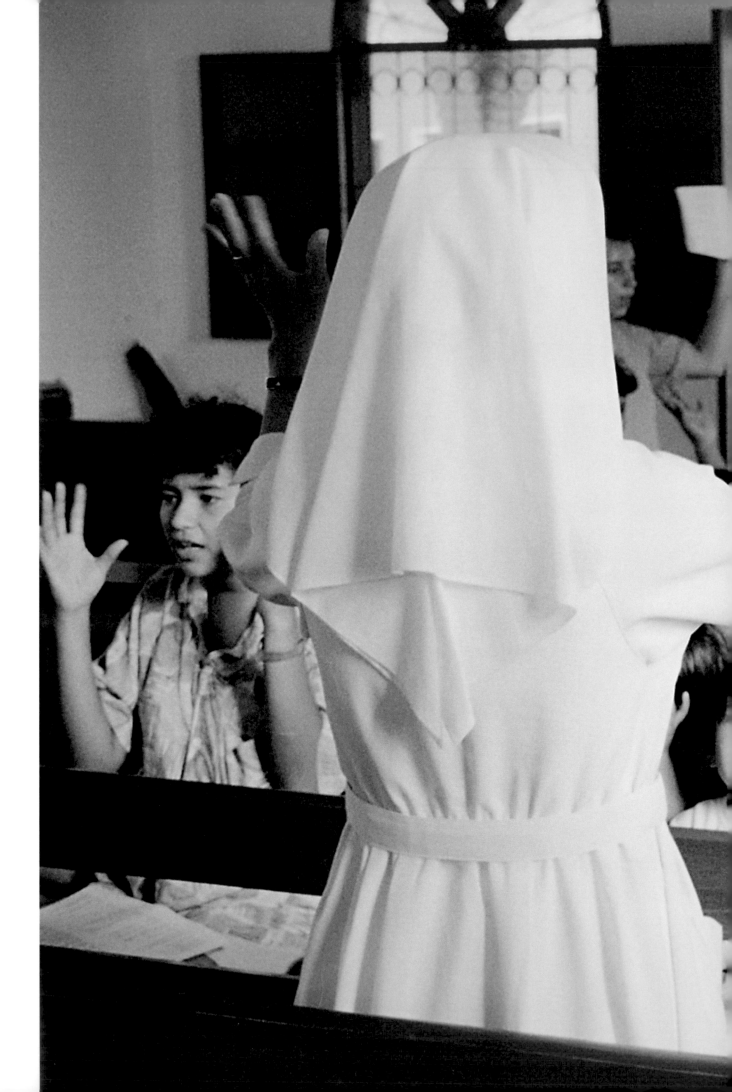

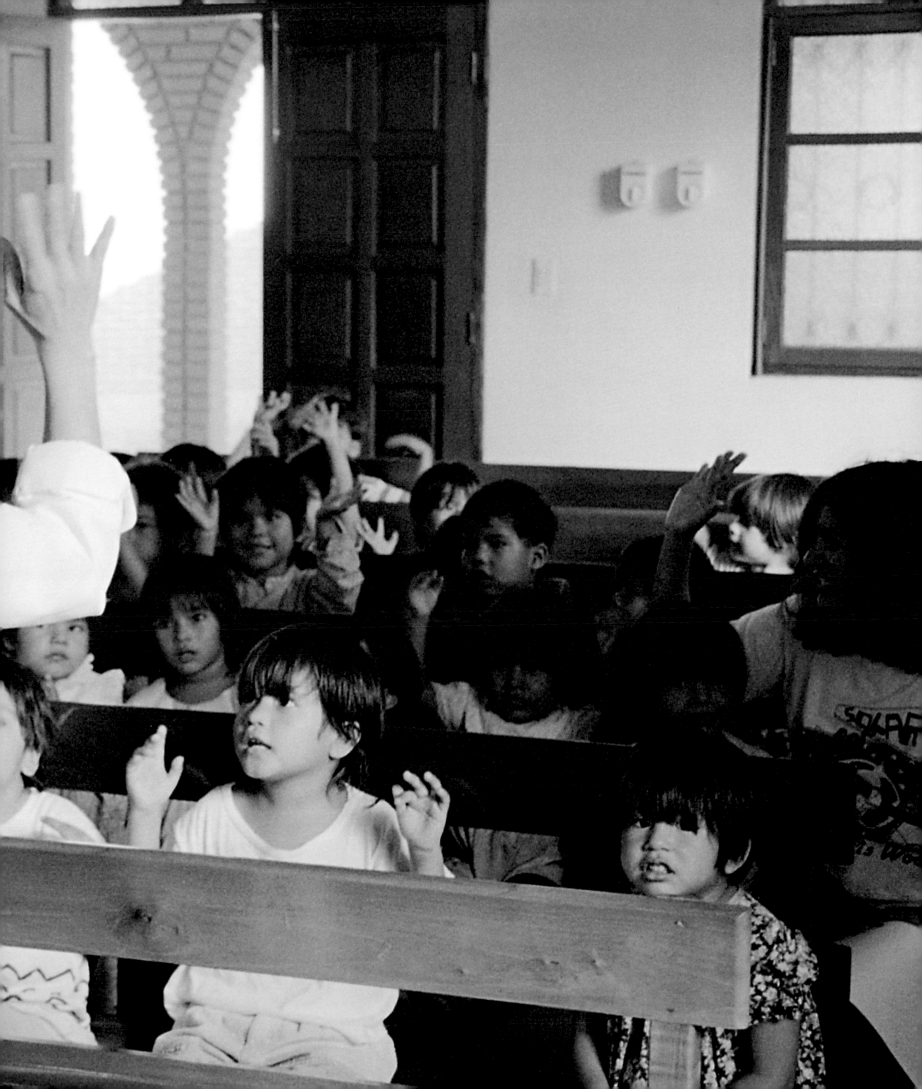

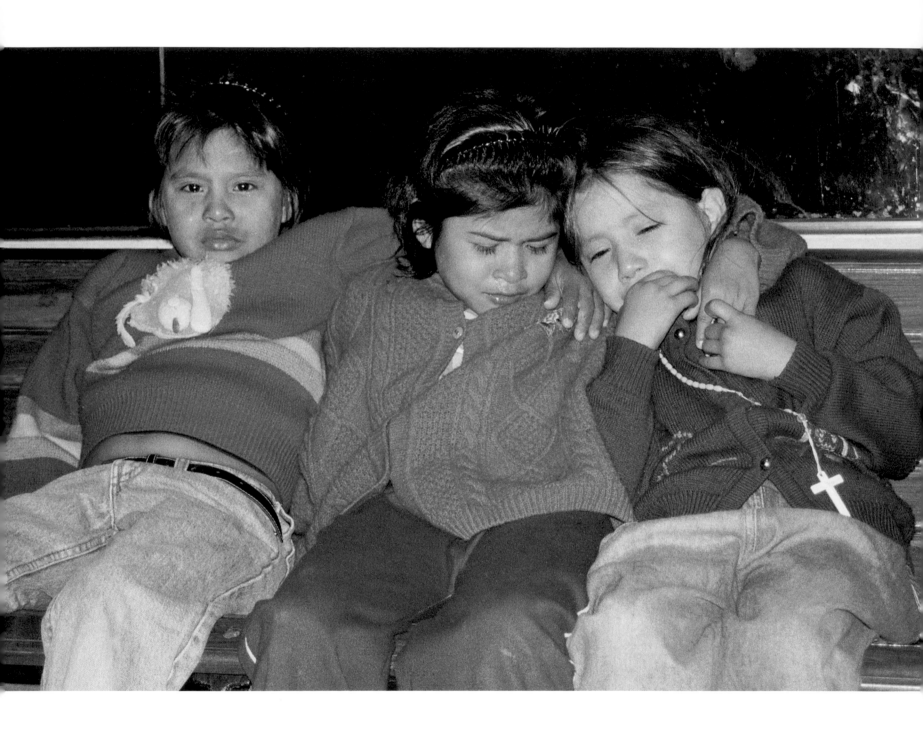

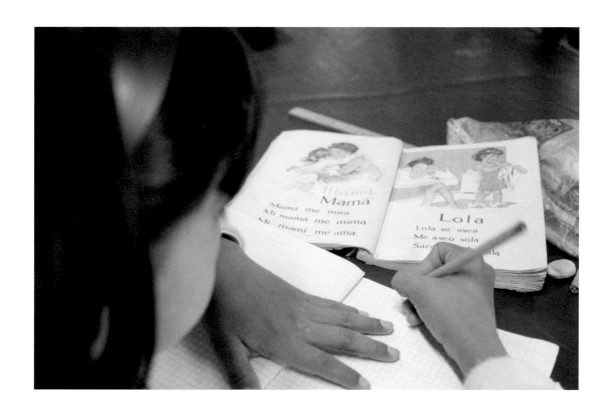

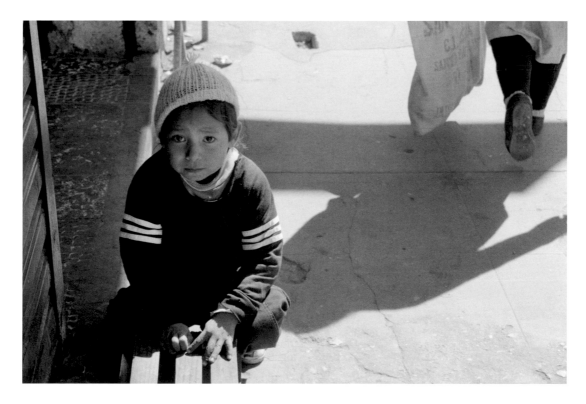

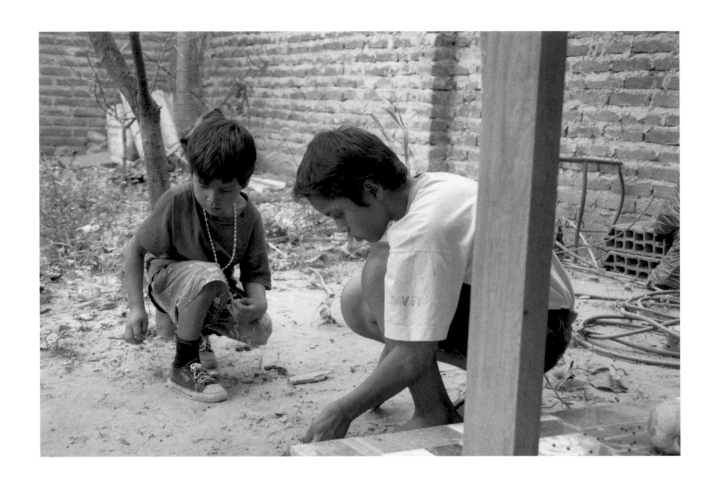

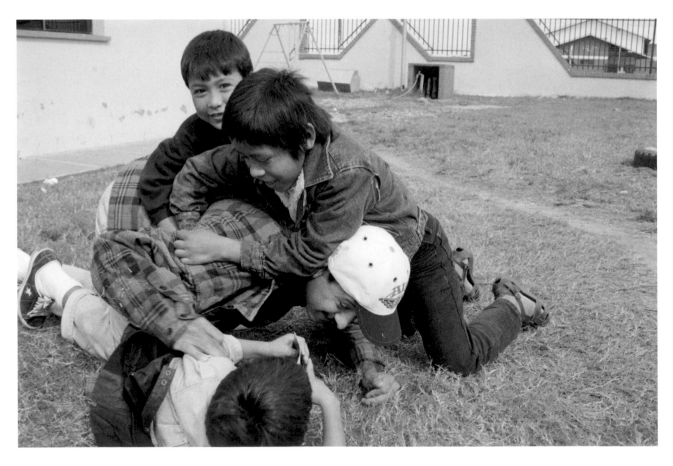

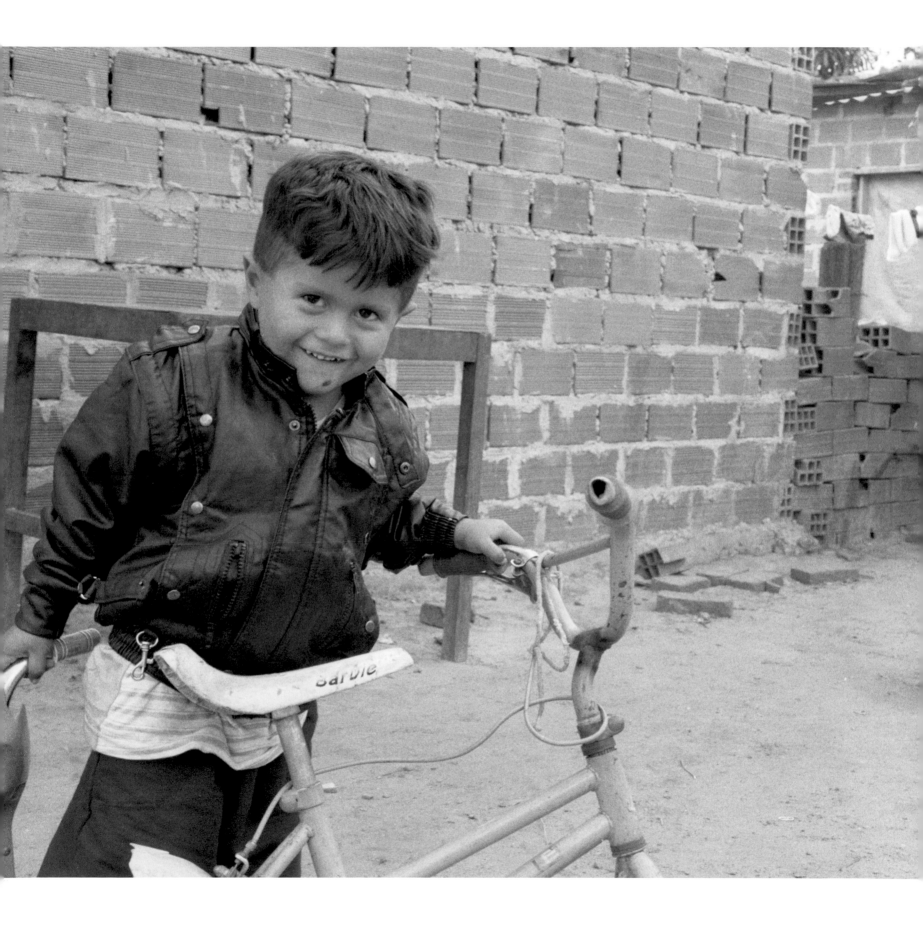

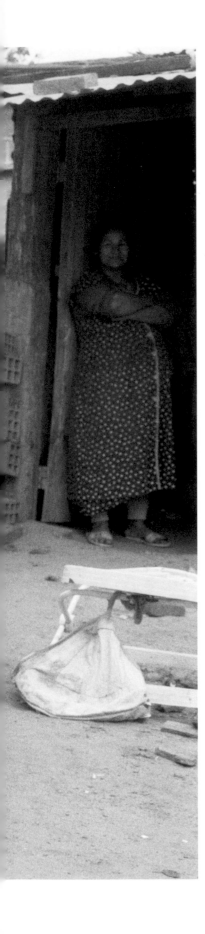

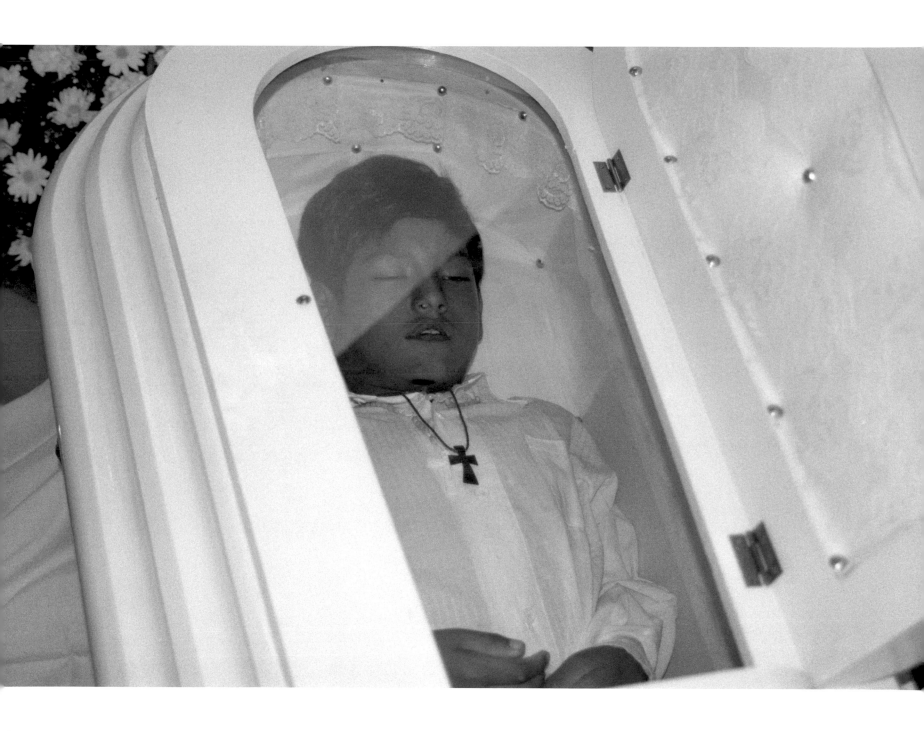

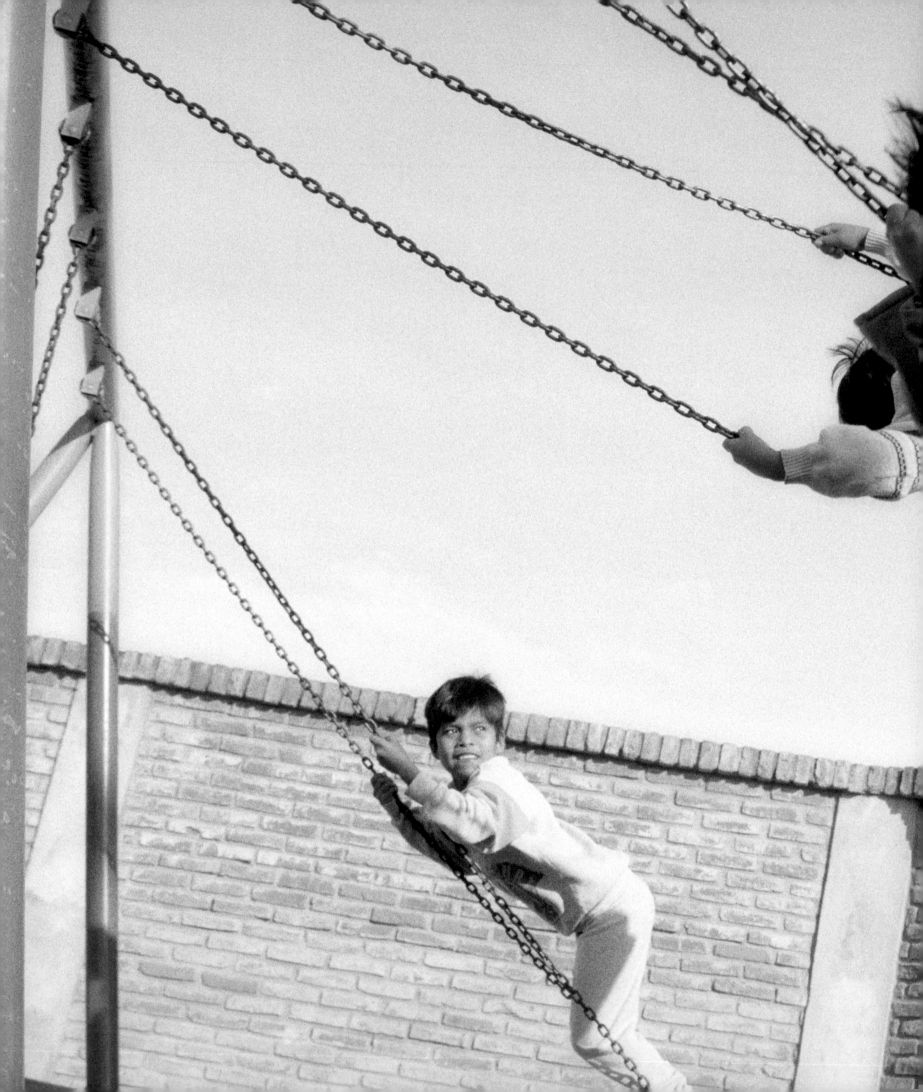

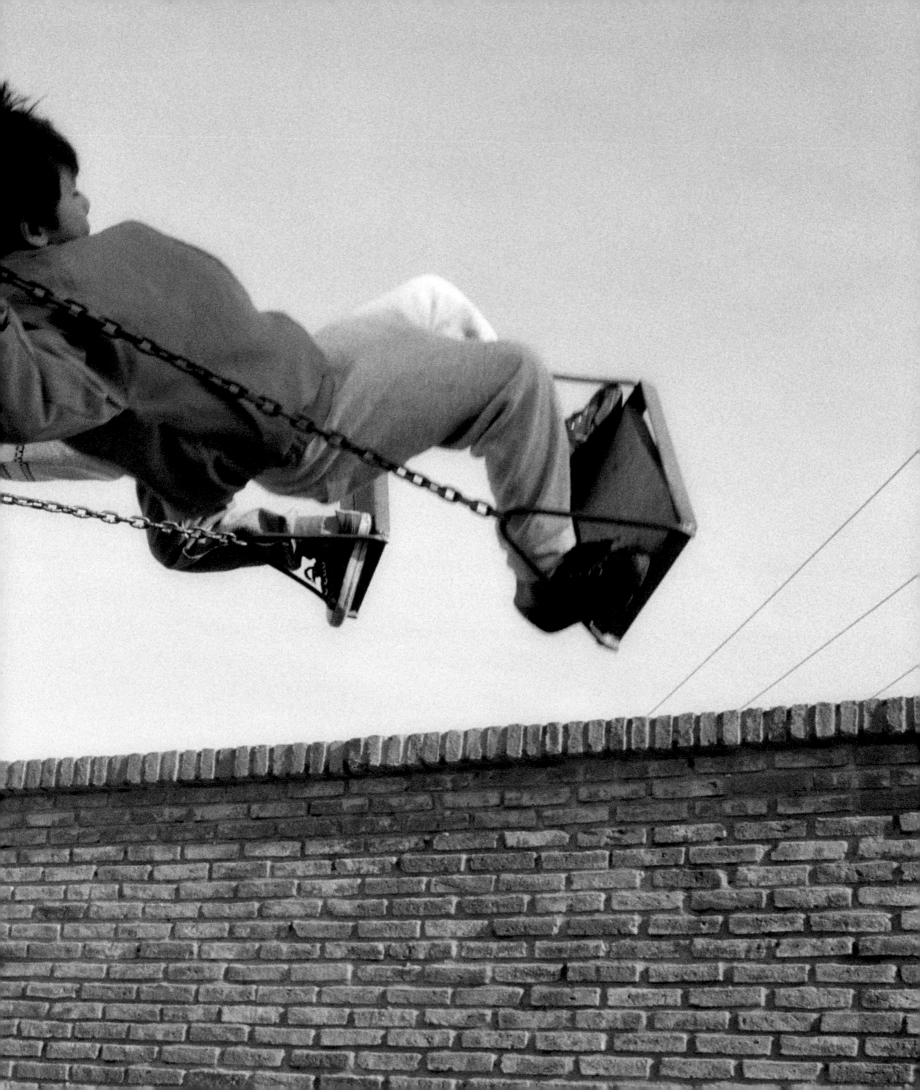

ENDNOTES

[1] Leo Tolstoy, *War and Peace*. Signet Classics, trans. Ann Dunnigan (New York: Signet Classic, 1991), 1223.

[2] Michael J. Fox, *Saving Milly: Love, Politics, and Parkinson's Disease*, by Morton Kondrake (New York: Ballantine Books, 2002), XV.

[3] Samuel Johnson, *Wit and Wisdom of Samuel Johnson*, comp. George Birkbeck Norman Hill (Dearborn, MI: University of Michigan, 1888), 214.

[4] Albert Camus, *The Plague*. (New York: The Modern Library, 1947), 231.

[5] Caroline Moorehead, *Dunant's Dream: War, Switzerland, and the History of the Red Cross* (London: Harper Collins, 1998), 6.

[6] ibid., 3.

[7] ibid., 4.

[8] Václav Havel, *Lend Me Your Ears*. comp. William Safire (New York: W. W. Norton & Company, 1992), 628.

[9] Robert F. Kennedy, "Day of Affirmation Address" (Speech, Cape Town, South Africa, June 6, 1966).

ORGANIZATIONS

Further information on organizations and issues addressed in this book can be found at:

**Cambodia Trust Limb Project
for Mine and Polio Victims**
http://www.cambodiatrust.org.uk

C4 Station Yard
Thame, OX9 3UH, UK
+44 (184) 421-4844

Hope and Homes for Children
http://www.hopeandhomes.org

East Clyffe, Salisbury
Wiltshire, SP3 4LZ, UK
+44 (172) 279-0111

**Hotel Rwanda Rusesabagina
Foundation**
http://www.hrrfoundation.org

PO Box 11001
Chicago, IL, 60611, USA
+1 (312) 498-9279

**International Campaign
to Ban Landmines**
http://www.icbl.org

9 Rue de Cornavin
CH-1201, Geneva, Switzerland
+41 (22) 920-0325

**Mano Amiga Home
for Street Children**
http://www.manoamiga.org

Casilla 1584
Santa Cruz, Bolivia
+591 (3) 541-100

**Mother Teresa's Missionaries
of Charity**
http://www.mcpriests.com

54 A AJC Bose Road
Calcutta, WB, 700016, India
+91 (33) 244-7115

Save the Children
http://www.savethechildren.org

54 Wilton Road
Westport, CT, 06880, USA
+1 (203) 221-4030

Seeds of Peace
http://www.seedsofpeace.org

370 Lexington Avenue, Suite 401
New York, NY, 10017, USA
+1 (212) 573-8040

United Nations Children's Fund
http://www.unicef.org

3 United Nations Plaza
New York, NY, 10017, USA
+1 (212) 326-7000

**United Nations High Commissioner
for Refugees**
http://www.unhcr.org

Case Postale 2500
CH-1211, Geneva, Switzerland
+41 (22) 739-8111